About the Authors

MARY FORSBERG WEILAND lives with her two children in Los Angeles, where she is studying for her certification in drug and alcohol counseling, with a focus on co-occurring disorders. This is her first book.

A former editor at *Esquire*, *Lear's*, and *Good Housekeeping*, LARKIN WARREN was a contributing writer to *Addiction: Why Can't They Just Stop?*, the companion book to HBO's documentary of the same name, and collaborated with Professor Elyn R. Saks on Saks's bestselling memoir, *The Center Cannot Hold*, which *Time* named one of the Top 10 Nonfiction Books of 2007.

itbooks

AN *IMPRINT OF* HARPERCOLLINS*PUBLISHERS*

FALL TO PIECES

a memoir of drugs, rock 'n' roll, and mental illness

Mary Forsberg Weiland

WITH LARKIN WARREN

*it***books**

A hardcover edition of this book was published in 2009 by
William Morrow, an imprint of HarperCollins Publishers.

HarperCollins books may be purchased for educational, business, or sales promotional use. For
information, please e-mail the Special Markets Department at
SPsales@harpercollins.com.

All photos courtesy of the author.

First It Books paperback published 2010.

Designed by Jennifer Daddio/Bookmark Design & Media Inc.

Library of Congress Cataloging-in-Publication data is available upon request.

ISBN 978-0-06-171916-5

HB 06.05.2023

FOR MY MOTHER

&

NOAH AND LUCY

WITHOUT YOU, I'D BE LOST.
THANK YOU FOR KEEPING ME IN THE LIGHT.

I have had to experience so much stupidity,

so many vices, so much error, so much

nausea, disillusionment and sorrow, just in

order to become a child again and begin anew.

I had to experience despair, I had to sink

to the greatest mental depths, to thoughts

of suicide, in order to experience grace.

—*SIDDHARTHA*, HERMANN HESSE

Contents

Prologue 1

ONE Crown City by the Sea 9

TWO Walk Fast 31

THREE "Be a Model or Just Look Like One!" 53

FOUR Love Is the Drug 69

FIVE Trouble 87

SIX Black Again 107

SEVEN Not Dark Yet (But It's Getting There) 129

EIGHT The Chaos Tour 145

NINE Swimming Through Cotton 171

TEN Into Your Arms 187

ELEVEN I Do . . . Again 211

TWELVE *En Fuego* 233

THIRTEEN October Winds 263

FOURTEEN Bye Bipolar 273

Acknowledgments 289

fall to pieces

PROLOGUE

I hate to say this, but, God—what have you sent me to love?

—JOURNAL ENTRY, DECEMBER 1998

I know that in order to stay healthy, I needed to restore some semblance of order to my life, to our lives: get out of bed in the morning, make a schedule and stick to it, go to AA meetings—anything to keep me busy and focused on something else besides the problem. The relapse. The inevitable relapse. But my resolve faded fast when I came home one afternoon and caught Scott standing in the kitchen with his partner in crime Ashley Hamilton, the two of them acting shady. Something was up. I looked into Scott's eyes and saw

immediately that his pupils were "pinned"—shrunken to little black pinheads. Any junkie knows what that means. Damn it, he'd done it. "I can't," I muttered. "I can't handle this again."

I left the house, headed straight for the corner liquor store, and bought a fifth of Jack Daniel's. I stashed it in my bag, went back into the house, walked past the guys and straight up the stairs to the bedroom, where I proceeded to drink all of it. No glass, no ice—just the whiskey, straight, and straight from the bottle. I was sitting on the floor, my back against the bed. There, I thought, feeling the familiar numbness flow through me. That's better.

The relief didn't last long; in minutes, my 113-pound body reacted to what I had just dumped into it. Violent nausea hit me like a wall of bricks, and I started to shake. I got myself to the bathroom, then threw up. I threw up again, and then again. Crawling back to the bed, I somehow got up onto it and under the duvet, burrowing into the familiar darkness, the safe place where I'd taken sanctuary so many times before. I buried my head in the pillow and slept until I could stand again.

Hours later, I woke up and wobbled back down the stairs. Scott and Ashley were still there. I was struck by how content they looked, how comfortable. In the space of an afternoon, I'd been sober, determined, scared, angry, drunk, sick, passed out, and then hungover— and here they still were. And they looked just fine. I wanted that. I wanted to feel what they felt—something and nothing all at the same time.

"No," said Scott immediately.

"Yes," I said. And then I begged. "Come on. I want to know what you're feeling. You have to. You owe me."

He had no more resolve than I did. "Okay, but you're snorting, not shooting. I'll cook it down and water it."

He had a fountain pen he'd long since emptied of ink; it worked like a straw, siphoning up the liquid-dope solution he made. Then he handed it to me.

It's torture, that voice—the one inside the addict's head that's always whispering, "It's okay if you do this. No, really. It'll be okay." Whose voice is that? I guess on some level, it was always my own.

Once I'd snorted the heroin up my nose, I sat down on the couch and waited. It was the foulest-tasting thing I'd ever experienced; even now, I can taste it on the back of my throat. But there'll be a payoff, I thought, and waited some more. Nothing. Had Scott diluted it too much? And if he had, was he trying to save me, or was he just drug-hogging? Given our past, it was likely a combination of both. I wanted something to happen, but long minutes passed and nothing did.

"I have to go home," Ashley said suddenly.

"We'll go with you," we both said. Yes, of course. We got into Scott's BMW and drove up into the Hollywood Hills.

Ashley was sharing a house with a girl I knew, someone who'd been sober in AA for more than a dozen years, but when we walked in, it was immediately clear that she'd relapsed, with pot (the classic first stumble), then cocaine. She had a friend there with her—someone else from the program—and that girl had relapsed as well. Contagious, I guess. Like the flu.

An addict's brain remembers where it left off when sobriety began, and it takes no time at all to get back there—the same train, the same station, with a renewed high that benefits from a period

of being clean. On one side of the room, the two girls were drinking and doing coke; on the other, Scott and Ashley were shooting coke-and-heroin speedballs. I sat in the corner, a little apart from everyone else, drinking and snorting lines. But instead of feeling the edges smooth out, I felt an enormous weight of sadness. Sad for the choices I'd made and the time going by. Sad for Scott. Why did he always go back to this? Didn't he love me? Didn't he want the happily-ever-after scenario we kept trying to write for ourselves? What was it about heroin that could be worth this, that over and over again he would choose it before me? Choose it even before his own life, and his creativity, and the music he loved? I walked into the kitchen, leaned against the counter, and looked at them all.

"I want a turn," I said. For a moment, nobody spoke. I could feel the anxiety pour off the very same people who moments before were feeling nothing at all. And then they started talking all at once. No, I didn't want to hear the consequences. And I didn't want that useless dope-pen rig that Scott offered up, either. "No," I told him. "I want to do it like you do."

He shook his head. "No, baby, you don't. You don't want to."

I moved toward him, as though I were bringing him my heart. "Yes, I do," I said. "I want to feel what you feel. You go someplace else when you do this. I want to go there with you."

I could see it in his face—resignation, a sadness that mirrored my own, and, weirdly, a quick flash of excitement. He couldn't deny me this.

"Okay," he said. "But just once. After this, I don't want you to do it again."

I agreed.

We sat down together at the dining-room table, and Scott began

to organize everything we'd need—cotton, a glass of water, some alcohol swabs, a cigarette lighter, a metal spoon, and what was left of the black-tar heroin. And two clean needles: one for him, one for me.

The table was large and wooden—a family might have sat around it at Christmas, or maybe for someone's birthday party. For a moment, I rested my hands on the surface, wondering about the people who'd built it. What would they think, seeing us?

Scott put the heroin in the spoon, then added a few drops of water; he lifted up the spoon a few inches, moved the lighter beneath it and clicked on the little blue flame. As the water began to bubble, it turned the color of weak coffee. I could not take my eyes away. Scott set the spoon down, tore off a piece of cotton from the cotton ball, and placed it in the middle of the spoon; when he removed the needle caps and began to draw in the light brown liquid, I took a deep breath. This is it, I thought. This will be the only time I'll experience this, just once, and then I'll never do it again.

After each needle was full, he gave it a flick with his fingers, dissolving the few bubbles that came up. Pulling his chair closer to me, he asked one last time, "Are you sure you want to do this?"

"Yes." The word barely came out.

He handed me his belt, showing me how to wrap it around my arm; I slid it up my left bicep, and he pulled it tight. "Make a fist," he said, "and pump it a few times. Hold the long end of the belt in your teeth, and hold the fist." He examined my arm for a good vein and as he did, I looked into his face, trying to get him to look at me. But he didn't.

Once I felt the needle in my skin, I watched the heroin flow into my arm, centimeter by centimeter. When the needle was nearly

empty, a trace of my blood shot into it. The connection between this bloody needle and the very good chance that I was officially on the way to my deathbed never entered my mind. "A few seconds until it hits," somebody said. "Maybe half a minute."

I was maybe at the fifteen-second mark when it happened, and there are no words for the way it felt. I pushed all the way back into my chair—I melted into it. Finally, Scott's eyes met mine. We sat looking at each other for what seemed like a long time. I was closer to him than I had ever been, in a way I'd never known I wanted and could never have imagined.

"Are you okay?" he asked. I knew he was waiting for me to vomit, to be sick. But sick was the furthest thing from the way I felt. I felt normal. Or what I always believed other people felt when they were "normal." I'd never felt normal in my entire life. No matter what I had ever done, what successes I'd had, what drug I'd ever taken or how much booze I'd drank, how hard I'd partied, how much I'd loved and been loved, I could never get to normal. I'd climb and climb but could never climb out—and now, at last, I was there. I nodded my head, which felt both heavy and light at the same time: I'm fine.

When Scott took the belt from me, it felt like cashmere sliding down my arm. He wrapped it around his own arm, picked up the second needle, and shot up. This was the first time he'd ever done it in front of me—before, he'd always done it in the bathroom, with the door closed. Now he didn't have to hide it anymore. I knew now that he did love me, and I knew that he needed this. Not wanted it, but needed it. He needed to feel normal, too. What an odd thing, I thought, that we should have this in common, this little mystery.

I wondered, for a fleeting few seconds, why that was. And then the question simply went away.

I closed my eyes. I don't know how long we sat there. It was peaceful. It was some kind of grace. I felt right and perfect and new, and I didn't ever want to go back. With this, I thought, I will never again have a negative conversation in my head; I will never again sleep for days, curled up in darkness, afraid or unable to get out of bed and into the sun; I won't cry anymore; I will never again feel not normal, or separate from the world, or less than everybody in it.

Addiction—to heroin, to anything—doesn't arrive with a brass band advertising its intentions and pushing you around. It tiptoes in with a small, quiet voice that becomes stronger the minute you let it in. You are going to need more. If you want to keep feeling like this, you are going to need more of what made it happen. Oh my God, I thought. The peace evaporated, replaced by panic. I could not let this go, could not let this be over. To have it and then not have it? No. The voice was right. I was going to need more. Was Scott going to let me do it again? Could he read my mind? Did he know that I would never, ever let this go?

There may be people who try heroin once and never go back for more. There may be people who take it for a test drive, alone or in a room full of friends, and don't become addicted the first time or even the second time, because they vomit or get scared or don't like what they see when they close their eyes. There may be people who aren't addicted in five minutes and completely lost in twenty, blindly walking away from everything in their life and going only toward the next fix. I am not one of those people. My brain—which I know so much more about now—doesn't work like that. It grabs and holds,

like a dry sponge in the rain. I was twenty-two years old, and I was hooked.

I don't remember the rest of that night, and even now, I don't care that those details, the aftermath, are mostly gone. Even today, all these years later, having fought for my health and my peace and my life and my children, I still have that belt, and the memory of those first few moments of heaven on earth. I had never felt anything like that in my life and I doubt that I ever will again. I used heroin many more times before I finally surrendered, and each time I did it, I had a glimpse of "normal"—but I never felt perfect again.

one

ONE

crown city by the sea

When a new patient first checks into a rehab facility, addiction counselors and case managers are required to take that person's medical history—not an easy job, given that in those first few days, the patient is so out of sorts (soul-shattered, ashamed, bone-achingly miserable) that he's often unable to remember even the simplest information about himself. When this happens, the words "poor historian" are inserted into his chart. A label on top of a label.

For most of my life, and for a whole variety of

reasons (many of them listed in medical textbooks), I have been a poor historian. Oddly, what I do remember, I remember with amazing clarity: certain days of my childhood, falling in love at first sight, my wedding day, the births of my two children, and my first highs. So what I'm doing now is connecting the dots and filling in the blanks—who I was, who I am, and who I will be. The process is somewhere between architectural dig and crashed-hard-drive repair. It's all in there someplace; I just have to retrieve it.

When I was a little girl, I had no idea what I wanted to be when I grew up. In spite of the proximity of Hollywood and Disneyland (I lived with my family in Southern California), I didn't dream of being a princess, and I certainly didn't dream of finding Prince Charming. I'm not sure if I dreamed at all.

Mostly, I thought about food. And toys. I had a baseball glove (which was very used before I got it), a Big Wheel (also secondhand), and a Barbie. She, too, was well used before she became mine, and somewhere on her journey to me, all her clothes had disappeared. One day when I was about six, while I was combing Barbie's hair, I became very frustrated with her lack of wardrobe. I went into the kitchen, riffled through the drawers, and found tape, scissors, and some paper. For at least an hour, I frantically cut and taped and cut and taped, but in spite of my efforts, the final result was simply pathetic. I sat on the floor of my room and cried. What good was a naked Barbie to me?

My family didn't have much. Not having much was a daily fact of life. It's why, to this day, I clip coupons, exalt over bargains, and have a complex love/hate relationship with food. I'll clean my own plate and everyone else's (even my children's if they leave anything), and am equally happy at Taco Bell or a four-star restaurant with linen

on the table. Just put the food in front of me and I'll polish it off. I wince every time I have to scrape leftover bits into the garbage.

Some observers might call my family history colorful; others might label it chaotic. Me, I think that on some level, it gave me everything I needed to survive in the world (and to survive what I did to myself in that world). My parents tell stories about themselves these days, to help me fill in the blank spaces. Sometimes their eyes twinkle, but sometimes there is a glimmer of regret in them, as though the memories and the telling come at a price.

My maternal grandmother, Rosa Maldonado, was born and raised in Morelia, Mexico. She moved to Tijuana as a young widow with four kids, looking for an American husband who would somehow get her over the U.S. border. Waitressing in a Chinese restaurant, she met John Jaswilka, a GI from Los Angeles who visited Tijuana on weekends with his buddies. Rosa didn't speak English; John didn't speak Spanish. Nevertheless, within a couple of months they were in L.A. and married, with two of her kids in tow (it took awhile before she confessed to him how many children she really had), and newly pregnant with the baby who would be Maria, my mother. Soon, Rosa brought the other two kids from Mexico to live with them, as well as her own mother, her stepfather, and a couple of nieces. My mother was raised in a two-bedroom house with eleven other people.

When my mother was only fifteen, her father, John, a heavy smoker, died of lung cancer (and, maybe, exhaustion). Immediately after her high school graduation, she moved to San Diego, where she got a job in a local hospital and began to work and save toward her dream of becoming a nurse. She'd never had a boyfriend; in fact, under the strict eyes of her mother, she'd never even dated. Friends at work set her up on a blind date with an eighteen-year-old guy named

Mike Forsberg. Turns out that she'd met him twice before and didn't like him either time; the third time, she changed her mind.

My dad grew up in and around San Diego, and he didn't have an easy time of it; his own father died when he was only seven, his half sister was murdered at eighteen on the day of her high school graduation. His ethnic background is what he always called "Heinz 57"—Swedish, Scotch-Irish, French, Native American, and Russian. In spite of their different ancestry, my parents looked oddly alike in the seventies—both had long dark hair, parted in the middle, and intense dark eyes. In some of the old snapshots, they look almost like twins. Mom's vibe is a combo of Geena Davis and Jaclyn Smith; in middle school, I was convinced that Dad looked like Ian Astbury, the lead singer of the Cult. (And when I actually met Astbury, many years later, I caught myself staring at him, waiting for my dad's voice to come out of his mouth.)

A week before her eighteenth birthday, my mom discovered she was pregnant—with me. "I thought I was hungover," she says now, "but the hangover lasted three months!" Morning sickness hit her hard and fast; she dropped out of nursing school. Although *Roe v. Wade* had become law, abortion was not an option for this good Latina Catholic girl. On the other hand, she barely knew Mike, let alone loved him. For a while, she hoped for divine intervention, but then Dad sealed the deal—if she wouldn't marry him, he threatened to go to L.A. and tell her family that he'd gotten her pregnant. Evidently, the idea of standing in front of Grandma Rosa, pregnant but with no wedding ring, was scarier to her than the alternative.

My parents eloped to Yuma, Arizona, came back to San Diego, and tried to settle down, with lots of family involvement on both sides. They probably should've paid attention to the fact that they

hadn't liked each other in the beginning, because that back-and-forth was the dynamic for the rest of their marriage, which ultimately lasted thirteen years. Dad gave being a grown-up his best shot, bagging groceries during the day and clerking the late shift at 7-Eleven. He sold shoes at JC Penney, he worked construction; later, he specialized in sheet metal, as well as heating and air-conditioning. But he was overwhelmed and unpredictable. He was also battling a crystal meth addiction, which I didn't know then—I just knew he and my mother fought all the time. Dad would punch a hole in the wall and stomp out; Mom would patch up the hole, pack up, and move out. Six months was their average stay in an apartment, and they were separated almost as often as they were together. On Mother's Day 1975, Mom drove herself to the hospital to have me.

When I was a year old, we lived for a while in a tacky motel in Chula Vista. The room lacked many amenities (including a fridge), so Mom kept everything on ice in the sink. My parents' diet consisted primarily of sandwiches made of Goober peanut butter and jelly (the kind that looked striped in the jar); my own diet was primarily Carnation evaporated milk. To supplement their income, during the day Mom would put me in my tinny little used stroller and go out looking for cans and bottles for recycling. One day, she was crossing the street and the stroller telescoped, folding and collapsing with me in it. For a few seconds, she was convinced I'd been chopped in two; once she realized that wasn't the case, she was humiliated because it happened on the corner of Broadway and E Street, one of the busiest intersections in town. Everyone was looking at her; everyone knew that she didn't know what she was doing.

Because of the constant moving, there weren't many San Diego communities we didn't live in—Lemon Grove, Chula Vista, and

San Ysidro, where you could literally walk right up to the Mexican border. I was three when my little brother, Johnny, was born, at which point Dad abruptly hauled us all up to Tacoma, Washington. He had friends there, he told my mother; it would be a new start.

It didn't take long for things to go bad. For one thing, it never stopped raining. My father pulled a disappearing act, and my mother, stuck in an unfurnished duplex with two tiny kids and no one to talk to, taught herself to bake—sugar cookies, from scratch. I loved the ritual of it, watching her put all the ingredients together, rolling the dough, cutting the little circles with a water glass, and then that amazing butter-sugar smell filling the apartment. Sugar was my first addiction; the second was the bottle of codeine-based grape-flavored cough syrup in the cupboard above the refrigerator. I would lean on my elbows, look out at the gray rain, and think, Guess we're not going outside today. Then I'd wait for the chance to sneak a quick swallow or two out of that bottle. I had to carefully hoist myself up on the counter to get it. It just made me feel better. I'm not sure exactly when I started feeling sad most of the time, but if I had to guess, it would be in Tacoma, in the rain, with the cough syrup and the cookies.

One morning, Dad stayed home from work with what he said might've been the flu. "I've got some medicine that might help," Mom told him helpfully, and she gave him a couple of whopping tablespoons of the cough medicine. Turns out she'd been planning our escape from the rain forest for days, and she wasn't going to let him or the flu or anything else stop her. When he was safely in a deep sleep, she hustled us out the door, telling us it was a game, shushing us to not wake Daddy.

A neighbor drove us to the airport in a lime green and white VW

bus. "I feel like I'm helping you cross the Iron Curtain or something," the neighbor said.

By the end of that day, we were back in California, camping at Grandma Rosa's, whose house was always full of family members coming and going, so she didn't seem particularly surprised to see us. Grandma's English was never very good, but Mom helped me understand her Spanish, and soon enough I was hanging on her every word. Her favorite thing to watch on TV was videotapes of the pope saying Mass, followed by episodes of the British comedy *Benny Hill,* featuring a lecherous old guy chasing half-naked women around, which made her laugh until she ran out of breath.

Grandma told me of the myths and legends she held certain to be God's truth, as sure as anything the Catholic Church taught her. If I would only know these things in my heart, she said, I would stay safe from harm. For instance: If you get scratched in the eye by a cat, you'll see ghosts, so it's probably best to avoid cats. Do not go outside and jump up and down, because it will make your guts fall out. Don't ever pick up a solitary baby in the desert with the idea that you're rescuing it; an unfortunate cowboy did this once, whereupon the baby sprouted huge teeth and started talking about hell—it turns out the baby was the Devil himself. And finally, if you are pregnant, always keep a pair of scissors in your pocket in the event of an eclipse; otherwise your baby will be born with a harelip. In Grandma Rosa's world, everything was a potential threat, so the best course of action was to stay in the house with the pope and Benny Hill, and pray.

It wasn't long before Dad came back from Tacoma and retrieved us. He and Mom tried to work it out, then separated again. Too young when they married, and chronically poor, they struggled con-

stantly with the outside world, and with the one inside their own walls. Very early on, I understood the connection between work, a paycheck, a roof over my family's head, and food on the table. The grown-ups were always talking about jobs—who had one, who'd lost one, who knew somebody who maybe was hiring. Describing them as blue-collar is to overstate it; even when they were working, they were the working poor. We "borrowed" the neighbors' cable connection for months; we qualified for food stamps and free lunch at school. And the legendary government cheese line: Just show up and pick up the goods—powdered milk, fifty-pound bags of white rice, and big blocks of cheese with no labels, colored an odd yellow-white or Day-Glo orange. On weekends, Mom had me sit with her while she balanced the checking account; by the time I was seven, I knew addition and subtraction, which bills had to be paid right now and which ones could wait. She kept us in clean, good clothes (I'm remembering a particular striped T-shirt from Mervyns that, by the time they applied the discounts, cost forty-eight cents), and she always made sure we looked presentable.

I knew there had to be another way to live. I wanted more. In fact, I'm pretty sure that WANT MORE! is tattooed somewhere deep inside my brain. I was always trying to make money. From elementary school on, I sold (or resold) whatever I could get my hands on: trinkets, candy, ice cream. I even sold my lunch.

The summer I was nine, I started my own small business, which I operated through the open window in our living room. I came up with the idea one day when my mother and I were shopping at Price Club. When I told her about my idea, she loaned me a little money, which I used to buy chips, candy bars, and frozen Otter Pops. Mom's job was just a block from our apartment; I stayed home to watch

my little brother, and during her breaks or lunch hour, Mom came home to check on us. When TV's *The Price Is Right* was over at eleven in the morning, that was my cue to open the window and wait for my customers. After checking out the local ice cream man who drove his truck around the neighborhood, I lowered my prices by five cents an item and made a tiny fortune.

In the summer, different public libraries had reading events for kids and rewarded you with fast-food coupons or tokens to a nearby arcade. This was great incentive, since the only way my little brother and I ever got to play arcade games was scrounging for dropped quarters between the games tables. I actually read *James and the Giant Peach* from start to finish in one day while sitting in a tree on a very uncomfortable branch. I also went through a phase where I read anything I could find on gymnast Nadia Comaneci. I thought it would smooth my way when I moved to Texas to work with Comaneci's famous trainer, Béla Károlyi. I believed that with the fierce Béla at my side (plus blood, sweat, tears, and tragically being separated from my family), I would someday win a medal. I had a Mary Lou Retton red, white, and blue leotard, and I was ready to wear it for my country. It was sadly true that I had no gymnastic skills whatsoever (and in the fourth grade was already five inches taller than most retired gymnasts), but that didn't stop me from picturing myself on the podium, waving after the national anthem played.

For a while, my mother didn't have a car. She walked to the grocery store, walked back and unloaded the groceries from the shopping cart, then walked the cart back to the store. She took a six-week class in medical procedures (walking to and from school, about a mile away) and did well enough to qualify for a job in a local podiatrist's office. Dad took a course in night school; he says now that

it's because I corrected the spelling in a note he'd left me, and he thought he'd better get back to school so that he could keep up. Dad got me into Little League, too; we even collected baseball cards for a while. He didn't want me to be that girly girl who yelps, "Oh, no, a ball is coming at me—what should I do?" When we played catch, he fired the ball at me like crazy, hollering, "You better learn to catch it, Mary, or you're gonna get hit!" Wise words.

Mom was the queen of coupons and a master of strategy: she knew how to squeeze a nickel to the squeaking point, and could plan a menu for a month at a time and never bend the budget. When we got to the market, she'd pull out her list, give me a handful of coupons, give my brother, Johnny, another handful, and the three of us would fan out, then go through separate checkout lines to get even more discounted multiple boxes of Wheaties and Cheerios.

There was a point when I insisted we take the food stamps and coupons to grocery stores far away from where we lived, so I wouldn't see anybody I went to school with. One day, the government cheese line was very long, stretching out into the parking lot under the hot summer sun. "I can't believe we have to do this," I whined.

"Be glad that we can," said my mother calmly. "We don't waste money; we don't waste food."

I may still have the coupon-clipping habit, but I cannot go near a box of Wheaties, and I would rather mix rat poison with water than ever again drink powdered milk. Whenever there's a food drive in my neighborhood, I buy and donate the best vegetables, the best sauces, the top-brand fruits and juices. When I think of someone who's poor, struggling, or sad because they have to eat generic crap and Day-Glo cheese, it just makes me angry.

In spite of their hardships, my parents had music playing all the time: in the house, in the car—the radio was free. On my fifth birthday, they gave me the coolest fold-up portable record player that played 45s. The label on the inside read, DEJAY HAPPY TUNES/ PHONOGRAPH PLAYER. It was covered in a denim print, and when you flipped it open, a little cord came out of a hole in the back and plugged into the wall. Along with this beautiful piece of art came three records—"Pac-Man Fever," "867-5309/Jenny" (Tommy Tutone!), and my favorite song ever, Joan Jett's version of "I Love Rock 'n' Roll." That song had me playing air guitar and flying off my bed like Eddie Van Halen.

A few years ago, I actually met Joan Jett. Despite that I was well into adulthood, I thought I'd pass out from excitement. I managed to hold it together and blurt, in a super-fan kind of way, " 'I Love Rock 'n' Roll' was my first record!" She smiled and looked at me with that pleasant but safe-distance expression that most celebrities wear when someone's blurting at them. It's the "Hmm, she's just a little bit bananas, isn't she?" look.

No artist was safe from me and my little denim record machine. Madonna, New Edition, the Cure. Yes, I know these artists don't belong together—even now, my iPod looks like some kind of cyber malfunction downloaded the history of all music but in no particular order. It's not my fault that I have no musical boundaries: My father's favorite record is still David Bowie's *Diamond Dogs;* my stepdad's is Prince's *Purple Rain.* Most nights, I fall asleep with headphones on, and before my eyes are 100 percent open in the morning, I've already inhaled at least three songs, the majority of them ridiculously loud rock. I require large amounts of caffeine and an earthquake of

music to get going, and I am filled with gratitude every day for all the artists who get me out of bed and back into the world.

I never played dress-up when I was a kid, except for the times Mom and I played rock star, taking turns wearing her special Saturday-night outfit, the burgundy wrap skirt with the matching long-sleeved leotard. We'd put on layers of her mascara and the pink cheek stain from the little pot she carried in her purse, then stand in front of the mirror and wail like Stevie Nicks into our hairbrushes. My air guitar was, in fact, all air. I would've played with a tennis racket if I'd had a tennis racket, but I didn't; I had a hairbrush and Joan Jett.

Accessing memories is so much easier when there's a soundtrack attached—for example, I recall riding in the back of an old van (not only were there no seat belts, there were no seats), with Blondie cranked on the radio. I can't remember where we were going, but even now, Debbie Harry's voice makes me think something fun is going to happen.

Second example: I was riding on the freeway in a station wagon, the kind where the last seat faced backward, and you can wave at the car behind you. We were on a family road trip that day, and a song about kissing came on the radio. For some reason, I decided in my head that the song was about sex. I was so embarrassed, I couldn't listen. My face was hot, I knew it was red. All I could think of, was: Don't look at me, nobody better look at me. I was being a prude and didn't even know why. When you're a kid, you're convinced everybody knows what you're thinking, when in fact, they're distracted and busy with their own lives, trying to keep their eyes on the road.

Third example: Guns N' Roses' *Appetite for Destruction*, specifically "It's So Easy." I hear the opening chords, and my blood races—

it's about a wild ride I took for years, all twisted up in love and heroin and destruction and waste. And yet I'll listen to that song every time. It's like that stupid old joke about why the guy keeps hitting himself with the hammer—because it feels so good when he stops.

In 1910 My parents divorced. Then, true to form, they reunited, re-marrying in 1984, this time in a formal Catholic Church ceremony presumably meant to lock it down. In 1986, when I was eleven, my little sister Julie was born, and that was the end of my mom's office work for a while. She began to run a licensed daycare center in our house and suddenly, there were babies and toddlers everywhere. Aunties and cousins dropped in and out, the TV was always on, the voices of people coming and going went on for hours. In 1989, after another long separation, my parents divorced for the second—and final—time. Mom packed us up again, and moved us to Coronado Island, one of San Diego's most affluent neighborhoods. Because of this, it was also home to a very good public school system. "This is going to be our chance," Mom said. I had no idea what she was talking about.

Coronado Island is separated from San Diego by a long blue-and-white bridge that has five lanes of traffic and is high enough so that huge aircraft carriers can go under it. I think it's meant to blend into the sky, but for anyone with a height phobia, the journey across the water is an invitation for a full-blown panic attack. Even today, driving over that bridge freaks me out. I say a prayer every time I do it. I wasn't surprised years later to learn that it was the third-deadliest suicide bridge in the United States. I couldn't know then that once

we crossed over it, everything I knew was nothing; my childhood was coming to an end, and not in a nice way.

The island is about seven square miles in size, ringed by beaches, mansions, a naval base, and the Hotel del Coronado. When you come off the bridge, San Diego Bay is on your right, the Pacific Ocean is right in front of you, and a massive, perfectly manicured golf course is on your left. There is no unbeautiful view, from any direction.

When we first moved to Coronado, you had to pay a dollar to cross over the bridge. The tollbooths are abandoned now, but when I was a kid, I was convinced that was why everyone on the island was rich—once a month, everybody lined up at the mayor's office for their share of the cash. That first day, Johnny, Julie, and I sat squashed together in the back of the little Corolla, peering through the windows, waiting for our new home to reveal itself. Our tiny house was on El Chico Lane, almost in the shadow of the bridge. Just because it had an actual name doesn't mean it was a street; it was an alley. But it was a house, and it was on an island. It was a start.

Thanks to the domestic adventures of Mom and Dad, Coronado Middle School was my seventh transfer since first grade. Vista La Mesa Elementary, Baldwin Park Elementary, Rosebank Elementary, Vista La Mesa again, San Miguel Elementary, Lemon Grove Middle School, La Mesa Middle School. I should've been an old hand at being the new kid, but it was agony. And the seventh grade is its own kind of weird: you're not quite a teenager, but you're not a little kid anymore, either.

The next morning, as my mother drove me to school, chatting about "Oh, isn't this exciting," "Isn't everything pretty here," "It's

going to be great!" I felt only growing dread: Everybody would be rich. Later, I found out that many students were from military families, far from wealthy, and that there were a lot of middle-class kids as well. But that first day, I knew in my heart that my mother was about to drop me into a scene right out of *Heathers*.

I'd carefully chosen an ensemble I was certain would win me new friends and influence new people: a mint green sweater under mint green overall shorts, and black high-top Reeboks with yellow laces. My hair was long and dark, the top half pulled back leaving just my bangs, which hung down to my chin. I spent a good ten minutes each morning leaning upside down with a curling iron, shaping my bangs so that they would resemble a wave (in fact, they more closely resembled the Nike "swoosh"). Upside down, I teased it at the roots, coated it with Aqua Net, and blew it dry with a hot hair dryer. When I stood back up, so did my hair. Hard as a rock, too—it wouldn't have moved if I'd run straight ahead at warp speed. The look was a dead giveaway: poor Mexican kid from a crap neighborhood which, more or less, is what I was.

The school was a short walk from the beach, and the main building was two stories high. I'd never been to a two-story school. Mom took me to the guidance counselor's office, wished me luck, then took Johnny to his school. The counselor, a soft-spoken woman who seemed not much older than my mother, walked me to my first class, already in session when I arrived. After an introduction—you know the script, right? "Boys and girls, may I have your attention? This is Mary Forsberg, who's just moved to Coronado. I'm sure you'll all give her a warm welcome, answer any questions she may have, and help her be a part of our community! Right? Okay? Have a nice day!"—I was assigned a "buddy" to show me around school and get

me from class to class.

As I walked to my desk, I heard the giggles and the tittering; I guess, had I been them, I might've laughed, too. This was a room full of kids with a laid-back California beach vibe—Esprit khakis, sun-faded Izod polo shirts—and I looked like a circus clown.

During the break before my next class, a few girls came up and introduced themselves. One girl gave me a hug. Oh, that's nice, I thought—at which point she yanked the back of my sweater, revealing the tag inside the neck: fake Guess that my mother bought in Tijuana. Even my Reeboks were fake, also from Mexico. All the girls were laughing. Red-faced and nauseated, I couldn't decide whether to deal out a beat-down or sprint for home. My faux-bok'ed feet wouldn't cooperate with either option. My helpful new "buddy" then escorted me to my next class, where I sat barely able to concentrate, making eye contact only with the chalkboard. Up until then, lunch was always my favorite part of the school day. At every previous school, I lined up with everyone else in the free-lunch line. Your family has to make next to nothing to qualify for free lunch, and nearly everybody I knew made the cut. No one was ashamed; we were all in the same boat. But here? The free-lunch line was out of the question. I will starve before I go stand in that line, I thought, and that's what I did. It may have been the first time in my life that I turned down food. The rest of the day, my stomach growled in stereo in every silent classroom. One more reason to laugh at the new girl. When the bell rang at the end of the day, I flew home to inform my mother that she had ruined my life and that I would not be returning to school the following day or, for that matter, ever again.

Even now, my mother still believes that PMS is responsible for all

of our fighting when I was a teen; whatever the cause (nature, nurture, screwed-up biochemistry, or genetics), I really think it was that first day of school in Coronado that kicked off the chaos that soon followed. Later that night, once I'd calmed down a little, she gave me the earnest "Mary, you're not a quitter, we are not quitters" speech, and then promised to buy me something from the Gap (if we could find something on sale). This was of no comfort. I spent that entire first night wide awake and stressing—how could I revamp myself in less than twelve hours?

The next morning, I let my hair dry into natural waves, then put on jeans, a white T-shirt, and flip-flops. I packed a lunch so I wouldn't have to stand in the free-lunch line, and before I walked out the door, I threw up. I threw up nearly every morning for almost a month.

I was so mad at my mother. It took me a long time to understand why she had brought us to this place. Every day our conversation was the same: "How could you do this to me? Can't we please move back?" Her response was consistent: "Don't be ridiculous." Every night I called friends in Lemon Grove to see whose parents might let me come back and live with them. No one volunteered.

One thing that became immediately clear was how far behind I was in class. Until Coronado, I thought you went to school because you had to; you passed, you got out, you got a job. College was something other people did, to become doctors or lawyers or teachers, professions I was pretty sure were out of my reach. Learning for its own sake never entered anyone's conversation. I didn't like being behind. I didn't like not having the answers. I didn't like that I was surrounded by kids who had actual plans for their lives. I have to make a plan, I thought.

It took a couple of weeks to work up the nerve to speak in class.

Eventually, sarcasm and a sense of humor helped me make some friends. Long story somewhat shorter, I guess I worked it out. Nevertheless, I fiercely hid my family's financial situation, and worked like a dog in class and at night to make up for being so far behind. Soon, I was able to go to school without vomiting.

In time, a couple of generous girlfriends let me borrow their clothes, which boosted my comfort level at school. But the mall on weekends still sucked. My friends shopped at Nordstrom, the Gap, Contempo, and Nine West; I hung back and watched. One day, a friend's father handed her a hundred-dollar bill just before he dropped us off. I had to clench my jaw to keep it from dropping open; I had never even seen a bill that large before, let alone had one to spend on myself. But I wasn't stupid. I knew I had to suck it up and learn to be content with enough pocket change for Hot Dog on a Stick. "I forgot my wallet" or "I'm saving for something really expensive" worked most of the time; other times, I made up excuses to just not go.

When I started modeling a few years later, I worked for Nordstrom, the Gap, and Contempo, which went a long way to help erase the hurt and resentment those mall trips had created. For a long time, my picture was on Contempo's glossy shopping bags. Revenge is sweet. And childish. But even now, I can't pretend it didn't matter.

I was thirteen, my parents were definitely finished, and on weekends, my mother went out with her girlfriends. She even started dating. I was dumbfounded by this. She'd always been the stable one, the reliable one—my *Knots Landing* buddy on Thursday nights, my

rock-out-with-the-hairbrush singing partner. Now that was over.

I didn't want my parents to get back together. I knew enough to understand why my dad lived on the other side of the bridge. But now my mom was gone, too. This was the only time in my entire life (and for that matter, in hers) that she ever left the house at night. She'd never dated before she got pregnant and married my dad, she'd never gone out with girlfriends. She was thirty-one and yet, she said, it was as though we were both thirteen going on fourteen. She was trying to find her way, and I was certain I'd lost mine.

I couldn't fall asleep at night, woke up angry almost every morning, and could not haul myself out of bed. Mom was defensive, trying to be independent while managing a family with little financial help from my father. The fighting between us accelerated to something ugly. She wanted me to babysit. She wanted me to clear the table. She wanted me to dry the dishes or keep an eye on my baby sister while she ran to the store. There was always a daycare baby in my room, taking a nap.

"This is bullshit," I said.

"Don't take that bullshit tone with me," she said.

"Fuck this, I'm moving in with Dad," I said.

She called my bluff. "Look, Little Miss 1975. I could've been a nurse now, if not for you. You think it'll be better living at your dad's? Be my guest."

Dad was living in a small, ugly apartment on the same street where he and my mother had lived when I was born, and the only thing in the fridge was potato bread and orange Shasta. "All these years we spent getting away from that place," my mother said, "and he goes back to it."

When I got to Dad's, there wasn't a houseful of daycare kids, but

nevertheless my routine was complicated. In order to stay enrolled in the same Coronado school, I had to wake up at 5:00 A.M., walk a mile to the trolley station, go to downtown San Diego, then take the bus over the bridge to the island. So I moved back to my mom's. Johnny and I did this moving-back-and-forth thing periodically, playing our parents against each other, using one to manipulate the other. I'd feel the words coming to my mouth, hear myself say them, and all the while, I'd stand outside it somehow, witnessing, unable to stop the scene. Then it would somehow blow over. An hour or day would go by, and the surface appeared calm again. But the ugly moment never felt fully gone.

I wandered around wrapped in a thick black cloud, my own personal bad-weather system in sunny SoCal. For hours, I rode my blue beach-cruiser bike all over the island or walked barefoot through the sand on the beach. Often I pretended to run away, rehearsing for the day I'd do it for real. I'd go to my school friends' houses, try on their clothes, making believe that I lived there, until Mom tracked me down and ordered me to come home.

Time and again I found myself at the Hotel del Coronado, which sits on the beach, a ten-minute bike ride from our house. The Del is a magical old sprawling place, with painted white wood and red turrets. It's haunted, somehow, and elegant. Many movies have been filmed there—Billy Wilder's *Some Like It Hot* is probably the most famous. I'd walk right in and stroll around the lobby. Nobody ever paid much attention to me. I wondered what it would be like to be a guest in such a place, to actually sleep in those rooms and eat in a dining room with glasses and silver and flowers on the table.

Sometimes laughter came from the restaurants or from the patio, where people sat by candlelight with the last traces of the sun going

down behind them, and it made me want to cry. I'd go out to the pool, stretch out on a lounge chair, stare at the sky, and shake—it was cold at night, always. I wrapped my arms around myself and stayed there until I couldn't stand it anymore. I didn't want to walk out of the fantasy; I didn't want to go home.

TWO

walk fast

In those first weeks at Coronado Middle School, I was determined not to be that solitary geeky girl alone at the lunch table. I made friends. But I never made a best friend. Always the new girl, the third wheel, to girls who had known one another forever and already had best friends. When opportunities arose to become close with a girlfriend, I didn't know quite what to do. It was like I was wearing something great that didn't have pockets, and I didn't know what to do with my hands. These days, I'll buy almost anything as

long as it's black and has pockets. I still like the comfort of giving my hands a safe home.

The first time I put my lips around the icy green glass of a beer bottle, I was thirteen years old, in a girlfriend's house where the grown-ups were rarely around and the big brothers always made sure the fridge held plenty of beer. The bubbles went up my nose, the taste went right to my gut. By the time I'd finished the second bottle, I knew I'd found my best friend. No more third wheel. The way this felt was all mine, and I was in charge of it. My instant affinity for booze explained the purple cough syrup, although it took me a long time to make that connection. I'm drunk, I thought—and simultaneously realized that if my mom found out, there would be hell to pay. I delayed going home until I figured she was safely asleep, then started walking. This was Coronado at the time when a girl could walk through the streets at night without an ounce of concern. And sometime during that short walk home, the Oh-my-God-how-can-I-make-this-happen-again? drumbeat began. The noise that filled the space between my ears that night has never gone away. For some brains, once that demon moves in, it never fully moves out.

Carefully opening then closing the front door, I silently crept into my house, into my room, and into my bed. The slow movements of my water bed (cut me some slack here—it was the eighties!) lulled me almost to sleep until I realized I needed to go to the bathroom. Tiptoeing down the hall again (and triumphantly past my mother's room), I sat on the toilet for what seemed like a very long time. I'd had a lot of beer. When at last I opened the door—quietly, carefully—there she stood, her arms folded. I wondered how long she'd been standing there. She looked me straight in the face and said, "Jesus, Mary, how much did you drink?" I was busted, wobbly

drunk, starting to slide into the morning after, and Mom decided it would be a great idea to take pictures of me so that later she could show me what an ass I had made of myself. They were not pretty, and neither was I.

My real punishment began the next morning, when Mom woke me up early. "I'm going to make you the foulest breakfast you've ever had," she said, "and you're going to sit in front of me and eat it." Fried eggs, swimming in bacon grease. Black coffee that could have peeled paint. And a bowl of soggy Lucky Charms, little pastel marshmallowy things floating in milk. "Eat it," she commanded. She knew I would hate it or vomit. She was right on the first count, nauseatingly close on the second. If it was meant to serve as a deterrent, it didn't.

I don't know how much I actually drank that first night, but I soon learned that no matter the circumstances, I could always drink most people under the table and keep on going, even if I wasn't sure quite where. The ultimate goal, whatever it was, seemed always just a little bit out of reach. Maybe having more, just a little bit more, would take me there. Getting a buzz was the perfect excuse not to care about anything anymore.

I know that a hangover is the body's way of fighting off the toxins, but something else always accompanied the physical aftermath—a letdown, a darkness, a frustration that replaced the high from the night before. It was hard to get out of bed not just because I'd been drunk and was now sick, but because even when I was sober and *not* hungover, I just did not want to get out of bed.

For an underage girl looking to get into trouble, the key to success is the college-age boy. It wasn't difficult, in a Southern California beach town, to find one. Flirting without following through became my strategy for getting access to a party and a six-pack. A few weeks

later, I was with my girlfriend Sloane at our friend Hardy's house. Hardy was older than we were and had a few of his friends over. Hanging out with Sloane was always kind of exciting. Her dad was an officer in the navy, and she seemed well-traveled and worldly to me. She knew what to wear, how to put on makeup; at thirteen, she could easily pass for eighteen, and she often did.

Hardy's parents ran a local restaurant, and there were a lot of kids in his family. They all went to parochial school, which I'd thought was stricter, more straitlaced, than where I went to school. So I was very surprised when somebody brought out a large bong, fired it up, and began to pass it from person to person at the party. It was the first time I'd ever been in the presence of drugs. The bong made its way around the room to the strains of Bob Marley and the Wailers and "Waiting in Vain." When it got to Sloane, I watched with shock as she took in a lungful of smoke. Then she handed it to me. I almost dropped it; I had no idea what I was supposed to do with it. Panicky and embarrassed, I pulled both Sloane and the bong into the bathroom and shut the door behind us. "I don't know how to do this," I whispered, "and I don't want anyone to know that."

Carefully, she gave me a step-by-step introduction: inhale, close your eyes, hold, exhale slowly. I blinked, my throat burned, my eyes watered. Seconds later, we were outside the bathroom and I was on my own. I inhaled again, and nothing in particular happened. I wondered if maybe I was doing it wrong. I decided that maybe more would be better. Inhale, exhale, inhale, exhale. Still, not much of anything. I just felt a little sleepy.

Sloane decided it was time to go home. I walked with her to her apartment (a bland, nothing-beige building that suddenly made me wonder if she ever felt like she was living in a Band-Aid) and then

I continued on to my house on El Chico Lane, a couple of blocks away. As I was walking, I found myself stepping over water hoses on the sidewalk, snaked out in front of nearly every house I passed. "What's the matter with these stupid people, leaving hoses out all night?" I muttered. "Don't they know that anybody walking along could trip and fall and break a leg or something?"

And then I realized that there weren't any hoses. They were shadows on the sidewalk, made by the overhead telephone wires in the artificial light of the streetlights. I was high. I stopped in my tracks, peering around me, trying to take inventory of every house, every front lawn, the sidewalk ahead of me and behind me. Nope, no hoses. I wondered what else I had gotten wrong, and it made me laugh so hard I had to wipe the tears from my eyes. Must've looked pretty silly, I thought, high-stepping over imaginary hoses all the way home.

It turns out that I fall into the category of funny stoner. I've never been paranoid or immobile, just wildly entertained and (I was always convinced) entertaining as well. Laughing, and laughing hard, at everything. It was so light and fun, being up there, with the black cloud lifted away. And then I'd get hungry. Not just hungry, but starving. Ravenous. Raid the refrigerator, order Chinese, somebody get in the car and go get me something. Good thing I eventually quit. Otherwise, I'd probably tip the scales at half a ton today and be working at a 7-Eleven to keep up with my insatiable stoner snacking.

I was the last of my friends to drink, smoke pot, or kiss a boy. It sounds funny now, but at thirteen, it seemed like I'd been waiting forever for something to happen. And until I started getting high, nothing did. But the escape never lasted long enough. Getting

drunk, getting high, riding my bike alone—nothing stayed. I felt like I was pushing through something thick, something that pushed back and made my body hurt. I was sure the blood in my veins was made of something sludgy and leaden.

Every night I turned off the light and pulled up the covers, and within minutes, every stupid thing I'd done or said all day long repeated itself inside my head. How could I go back and face it all again tomorrow? Sometimes sheer exhaustion worked in my favor and I finally fell asleep at some long-past-midnight hour; sometimes I cried myself to sleep. Then came the morning. I know some people are afraid of the night, of the dark; I was afraid of the light. Should I tell my mother I was sick and plead to stay home from school? Should I deliberately oversleep and blow off the first half of the day entirely? Most days I went to school late and sat near the tennis courts eating a donut and drinking hot chocolate, wanting to turn around and run. Even skipping school a day here, a day there, was only a temporary reprieve; there was always the next day to come, and the one after that. So one night, I called the suicide hotline.

Every time I went over the Coronado Bridge, I made a point of reading the posted suicide hotline sign, coming and going: SUICIDE COUNSELING CRISIS TEAM 24 HOURS 1-800-479-3339. Some people hold their breath or pray when they drive through a tunnel or over a bridge; I memorized the hotline number. And one night I called it. I don't remember what specific thing had set me off; it could've been the wind, or the way the morning dew blanketed my walk to school. I don't believe even now that I had an actual idea that I wanted to end my life. I just knew the people who used that number probably felt as awful as I did. Maybe whoever picked up that phone would have the answer to why I felt this way. My heart raced as I dialed.

I was afraid that somehow our number would be traced and then they'd call my mother and report on anything I said. I didn't want her to know—she had enough to worry about.

The phone rang more than once, which I thought was odd. Wasn't this line reserved for people practically standing on the bridge railing? You'd think they'd have someone with one hand on the receiver at all times. A woman answered the phone; I could tell that she, too, had a sadness in her. Maybe this was why she volunteered there. My voice cracked as I attempted to spit out the words. "I think I need some help."

She told me her name, which I can't remember now, but whatever it was, I decided a name like Phyllis would suit her better. She asked me a couple of simple questions, and I told her what a difficult time I was having just trying to move through the world. "It's so bad, I just can't seem to get out of bed in the morning," I said.

As Phyllis led me through the conversation, I decided that she was a good listener. Easy to respond to, sympathetic, sort of like somebody's nice old aunt who lives across the country and calls to check in every once in a while. I wasn't thinking of actually killing myself, I told her. It was just that some days, suicide sounded like an easier alternative to getting up and getting dressed. I thought of it every time I crossed the bridge.

I tried to imagine what Phyllis looked like. About fifty-eight, maybe. Short, grayish hair. She hadn't aged well, I guessed, most likely due to the sadness that she carried and the two-pack-a-day smoking habit that gave her a deep voice, a little hoarse and scratchy. She kept clearing her throat. I'm not sure now what time of year it was, but regardless of the season, I pictured Phyllis in jeans and a holiday sweater. Greens and reds, a little Christmas tree, maybe

some holly. Matching ornament earrings. Phyllis has probably heard some bad things in her day, I thought, from people who were in way more serious trouble than I was. Maybe my call was nonsense. Maybe I shouldn't have called. "The main thing is, I just can't seem to get out of bed in the morning," I said again. "Do you think you maybe can help me figure out a way to do that?"

I paused, and into that pause she dropped the magic words: "I think I might have a solution for you, honey."

Oh, thank you, God! Phyllis has the solution! I'm finally going to get out of this funk and get moving. I won't dread the start of each day, the end of every weekend, the knowing that no matter what I do, every morning the black cloud reappears and pushes me back under the covers. I waited.

"You need an alarm clock."

What? I wasn't quite sure what I'd heard. "I'm sorry, what?"

"Really, honey," she rasped. "An alarm clock. That will get you up in the morning, right as rain."

It took a few awkward seconds for me to understand that she wasn't joking. When the reality sunk in, I got mad. "Thank you," I said through clenched teeth, and hung up. She's the one who needs suicide assistance, I thought. Someone to push her off the bridge.

It was terrible. What if another girl, sadder than me, someone more than ready to drop off the bridge and into the water, called in a moment of true desperation, and she got Phyllis? An alarm clock. Who could bear to live in a world full of idiots like Phyllis? If I hadn't grasped the gravity of what I'd been thinking before, I now had the full picture. How simple that last straw could be.

A day or two later, in science class, I went up to my teacher and asked to be excused to go to the restroom. Once in the hall, I went

to the water fountain and swallowed a whole box of Benadryl. I already knew that one made me sleepy; a fistful should put me away for good. I did not think: I want death; I embrace death; I'd like my life to be over now, thank you. At thirteen, I had no idea what that meant. I hadn't buried anyone; no one I loved had yet died. Dead, gone forever, the end—that wasn't it. What I was actually thinking was, I'd like not to feel like this. And when I'm asleep, I don't. So I'd like to go to sleep for a very long time.

When I got back to the classroom and sat down, it was only moments before I did indeed get quite sleepy. I rested my head on my hand, and my head got very heavy. My eyelids just wanted to close. The teacher said something to me. A question about whatever we were studying. Then, "Mary, are you okay?" I tried to sit up, to look straight at her. Couldn't do it.

"Mary, what's wrong with you?"

In about two minutes, I found myself in the nurse's office, where they peppered me with questions, which I could not get my mouth to answer. Finally, "I took Benadryl."

"How many?" the nurse asked.

"A lot. The box. All of them."

The slower I felt, the faster everyone around me moved. I don't know how much time passed between that moment and the moment I was strapped on a hospital gurney—my mother's pale, scared face hovering somewhere on the periphery of my vision—while ER docs forced truly foul liquid charcoal down my throat. My stomach was churning, and I couldn't seem to get any words out to explain what I'd done or why.

A couple of hours later, they released me to my mother's custody only on her pledge to get me to a therapist. They gave her the name

and number of someone who could see me as soon as possible. What had just happened?

It took my mother and me a very long time to actually talk about this event in any linear way; it was simply too surreal. Between us, even now, we cannot come up with an itemized list of who did what and when: what the people at my school said when they called her, what she said to them or me, what I said, what came next. It was a horrible, blurry time that hurt us both. And now that I know what it is to have children, to nurse them through illnesses and feel every pain they feel, I don't know how my mother got through it without collapsing on the ER floor.

I do remember going to the therapist afterward. I do remember sitting in a swivel chair and swiveling, swiveling, swiveling. He had a kind of blank face and glasses; he sounded like the grown-ups in *Peanuts* cartoons, whose words basically come out as *Waa waaa waaa waaa waaa*. I didn't want to tell him all my private feelings and thoughts and dreams—I wanted only for him to tell me how to not have them. This is going nowhere, I thought. Why should I come here if you're not going to tell me what's wrong with me and how I can make myself feel better? What good are you, anyway?

Bipolar disorder—a biochemical mood disorder in the brain, which is more familiarly known as "manic depression"—often begins to show itself when the hormone storm of adolescence kicks in, although it's often not diagnosed until much later. Sometimes it's not diagnosed correctly, and when medications are prescribed, it might not be the right combination. Gain ten pounds, lose ten pounds, and the medicine has to change. Have a baby, bury a parent, miss

your flight, lose your job, and the stress makes it all go sideways again. Focus, says a coach. Shape up, says a parent. Get yourself an alarm clock.

There's a lot of controversy about diagnosing kids with bipolar disorder. And what kid wants to be "diagnosed" anyway? You may also have every good reason to be angry at your parents, to genuinely be too tired to drag yourself out of bed in the morning, and be either giddy or painfully self-conscious at a party. Isn't that just the way adolescence goes? Or is that mental illness?

Had my parents not divorced, had there not been all the resultant chaos, had I not inherited a complicated set of genes, had I never taken a drink or a joint, would everything that happened to me have happened anyway? Is bipolar disorder what I was experiencing when I swallowed a box of Benadryl or wandered through an old hotel's beautiful lobby? There's no way to know. And hindsight, of course, is twenty-twenty. But back then, there was one fact not in dispute: I was a mess.

One night—I was not yet fourteen—I was finally given the green light to a total meltdown by a man my mother was dating; let's call him Bob. Bad Bob. I didn't like Bad Bob much; he wasn't good enough for my mother. A navy helicopter mechanic, he was something of a control freak. But he had a black Corvette, which he let me drive once. I almost drove it into the Burger King by the bay. As cool as the car was, I knew he'd only let me drive it to get to her (why else would you let a rude thirteen-year-old get behind the wheel of your black Corvette?).

This particular night, they'd just come back from Imperial Beach, then famous for being a rowdy surfer-biker hangout (HBO's series *John from Cincinnati* was filmed there). Bad Bob was so drunk that

how he made it home without killing my mother or getting an escort from one of San Diego's finest still baffles me.

Chances are I was listening to Metallica in my room when they got home. Not two minutes in the door, Bad Bob yelled something at me—ordering me to turn it down, probably. I yelled something back, at which point he swooped in, picked me up, and lifted me as high as he could over his head; when his sweaty arms couldn't take it anymore, he simply dropped me.

If a full-grown man raises a dinner plate above his head (seven, maybe eight feet high, depending on how tall he is, and Bad Bob was feeling pretty tall) and then drops it, odds are the plate breaks. I instinctively put my arms out in front of me to keep from landing on my head. The shock of the physical pain made me see stars, but the fear that he'd do it again was worse. In an adrenalized rush, I somehow got to my feet and ran. He cornered me in the kitchen. My heart was pounding—I was sweating, sobbing, and in pain. He took a single step in my direction and I grabbed the first thing I could reach for protection—a large knife from the butcher block. Waving it at him and screaming, I backed him up just far enough to get myself to the front door, flew through it and down the alley. Once I realized I was actually out of the house, I dropped the knife and ran some more. I was that idiot girl in the horror movie who drops the knife and runs hysterically down a gravel road, crying, hurting, being chased by a lunatic. And barefoot. If you ever find yourself running for your life barefoot on gravel, just give up. Dead or alive, your feet will thank you.

This particular gravel road was only two blocks from Coronado Hospital. My entrance was far from casual. I don't know if late-shift hospital ER staff are hard to jolt or if this was just the end of a long

night for them, but no one found it odd that a young girl was running barefoot and screaming for help. Not five minutes behind me, my mother came running in as well.

The ER provided no safety and no hope of shelter that night; I was released to go home with the diagnosis of a "hurt arm." Home was the last place I wanted to be, and I had no intention of going there. Once outside the hospital, I told my mother so. Defeated, she took me to one of my girlfriend's, where I spent the night. The next morning, we rode to school on her bike. Now this truly *was* a criminal act—"doubling," or riding a bike with someone on your handlebars, is ticket-worthy in Coronado.

All through first period, my head ached, my stomach roiled, and my arm was killing me. I couldn't believe that Bob or any other man would be allowed to drop a kid headfirst onto the floor and not have to pay the consequences. The first chance I got, I went to the school office in search of my guidance counselor.

Her office was in a tiny room just behind the secretary's desk, with a big old-fashioned wooden desk and chair. From my first day at that school, there was something about this woman that made me believe I could trust her. She was small and quiet, she actually seemed to be listening to me, and when she finally spoke, it was in a soft voice that reassured me that I'd done the right thing to come to her. Actually telling an adult released some kind of pressure valve inside me; I went back to class feeling like I could breathe. And then the police arrived.

It turns out that they'd been called to my mother's house the night before, after my speedy exit; they'd instructed Bad Bob to leave the house and not come back. So there was police report number one. My guidance counselor's call to them was police report number two.

When she called me out of class and we walked back down to her office, the counselor explained that she was required by state law to call the police whenever a student reported a case of abuse. All they wanted, the policemen said, was to hear my side of the story. After they listened to my account of what happened, they sent me back to class and went off to track down Bob and my mother.

As expected, Bob had a completely different story to tell. His version had me chasing him with a knife, threatening to slice him up. He couldn't imagine why I would do such a thing, he told them, and my arm injury resulted not from any harm he had done, but only from his trying to defend himself. My mom couldn't tell them anything for sure, she hadn't actually seen what happened; she'd been in the bathroom, heard the yelling, heard the door slam, came into the living room, and realized I'd taken off down the road.

My seventh-grade history class was in the library when the two uniformed police officers came back to school, walked into the library, called my name, and escorted me out to their car. Before they opened the car door, they turned me around and handcuffed me, in full view of anybody who happened to be looking out the school windows. The charge, they said, was assault with a deadly weapon. I was shocked, yet on some level it made sense: This was my mother's way of getting back at me for drinking, for getting stoned, for being rude and disrespectful, and a general pain in the ass. It's not as though she didn't warn me. It didn't occur to me to panic. There was even something funny about it—the police station was just across the street from the school. Handcuffed in the back of the car, I was about to go for a big ride of barely a block.

Once at the station, I was told to sit and wait. I asked to use the restroom and had to be escorted by a female police officer. Still in

handcuffs, I struggled to get my jeans and underwear off in front of her. I was horrified; I hadn't peed in front of anyone since I was three years old.

When we came out, a policeman actually said to me, "Okay, now we're going downtown." To juvenile hall. That's when it hit me: This is not a joke. As we rode over the bridge I caught yet another glimpse of the suicide hotline sign.

At juvie, I was led into the building, uncuffed, and taken to what I was told was the holding tank for girls. The smell was foul, like feet. Unwashed feet that had been trapped sockless in sneakers for weeks. The main room was configured in the shape of a circle, with the desks in the middle and the boys' and girls' holding tanks on either side. Light filtered in from dirty windows. There were overhead lights, too, the fluorescent ones that blink and buzz if they're about to burn out. My arm hurt, my chest hurt, but I knew I had to get a grip or I'd simply hurl myself to the floor and start kicking. Then I had a bizarre movie moment, when I glanced across to the boys' holding tank and caught a glimpse of one of my cousins. I had no clue, then or now, what that was about.

The women who worked the holding tanks were very kind to me. They told me I was the youngest girl there. While they were processing the paperwork, somebody gave me a couple of Creamsicles. Food always helps reduce anxiety. My relief was short-lived, though, since a few minutes later a matron took me from the holding tank and into another room, warehouselike, with extremely high ceilings and giant plastic bins against the walls. These held clothes: shoes, shorts, undergarments. I was asked my size, and told to pick out a white button-down top, royal blue gym shorts, socks, generic Keds-looking white tennis shoes, giant white panties, and a bra that looked

and felt as though it were made from Styrofoam cups. Then I was ordered to grab a towel and follow my tour guide, Ms. Hospitality, to the showers.

The true moment of humiliation was the pat-down—in my memory, it was a grab-down, although there was no cavity search, the only thing she skipped. No one but my mother had ever touched me. I had never even kissed a boy, had my hand held, or been seen in anything less than a bathing suit on the beach, and even that had been rare. She sat in a metal foldable chair, silent and impassive, and carefully watched me as I undressed and stepped into the shower. Showers are meant to be relaxing—this was the most unrelaxed I had ever been in my life.

The next stop on the juvie tour was my cell. My roommate was sweet-faced and very pregnant. I had never met a pregnant teenager before and had to stop myself from staring. I was shown around and given a rundown of the rules. My mother and I were always looking at model homes and attending real estate open houses; this felt a little like that. I pictured myself purchasing the property. Our suite consisted of a metal desk and two steel beds. The mattresses, no more than an inch thick, were covered in plastic. My bed hovered just above the floor. That smell of feet had made its way into the room.

The open-house fantasy was shattered as I was led into the community bathroom. The words *community* and *bathroom* should never be linked together. The first section was a wall of stalls—the stall dividers only stood a few feet tall. In fact, they were even in height with the toilets. I would be hip-to-hip with anyone else using the facility, and anyone who wanted to get a closer look could easily do it. I vowed never to step foot into the bathroom again, no matter

what. I don't do well in a one-ply-toilet-paper situation. This is why you will never find me camping. Well, that and snakes.

I was taken back to my cell and my roommate offered me a magazine. *Cosmopolitan* magazine. Another first for me—I'd never seen it before. I was amazed at the way those women looked, with wild hair and breasts popping out of their dresses. In that moment, if someone had told me that within a few years I would grace those very pages, I would've laughed in her face.

Ms. Hospitality came to escort me back into the main room near the holding tanks, where I was asked a laundry list of questions, not unlike the ones Phyllis had asked: Are you on drugs? Are you pregnant? Have you ever tried to commit suicide? My "yes" to that last one opened up a barrage of other questions related to my mood and mental health. They got me with this one: "How are you feeling right now?" Are you *kidding* me? I had been dropped on my head by a crazy man, I had just been naked and somewhat fondled by a woman I'd never before seen in my life. I was wearing a Styrofoam bra, I was trying to figure out how I was going to avoid the community bathroom in the foreseeable future, and oh, yeah, I was in jail. So, no, I was not feeling well. My circumstances were depressing. I felt no joy, and I said so. This got me an instant reservation in the suicide tank, a metal-and-concrete room where I was stripped of all my nice new institutional clothes and given a scratchy gray army-style blanket. And then the door closed.

I stood there naked, stunned, and totally alone. Besides my naked self, the only other things in the room were a metal toilet and another thin plastic mattress. There was a small round hole in the door, and I tried desperately to get the attention of anyone in earshot to tell them that this was a massive mistake. No one responded,

although I suspected I was being watched. I was clearly stuck there for the night.

It made no sense to me, this notion that the way to keep someone from feeling suicidal was to remove every piece of clothing and whatever remained of her dignity—what, did they think I was capable of killing myself with the socks? Now I really *was* suicidal. I was so disgusted and couldn't bear to touch anything in the cell. I wrapped the horrible blanket around me and sat on the mattress, dangling my feet over the side but making sure they didn't touch the ground. I began to think of all the ways I actually could hurt myself and came up with the following courses of action: I could bang my head against the metal toilet; I could dive headfirst off the bed onto the concrete; I could use the blanket to scratch myself to death; I could hold my breath until I passed out; I could use the plastic mattress to suffocate myself. My least favorite possibility: I could drown myself in the toilet. It was my second night in a row with little or no sleep. And people wonder why I'm crazy.

The next morning, a caseworker came to speak with me. In spite of being tired, dirty, cold, hungry, and demoralized, I summoned enough energy to somehow convince him I was just fine. I got my uniform back and was allowed to return to the general population. I am proud to report that my new homies were impressed. I was thirteen and being held for assault with a deadly weapon. This was the big time.

I had to take some state-mandated tests to see where I placed in school; when I passed them all, I was told I could go watch TV. All the other kids around me had been given a book and some schoolwork assignment—I had a chili cheese dog and *All My Children*. I put my feet up on a chair and began to enjoy my stay.

Meanwhile, my mother was frantic. From what the cops had told her, she'd been under the impression that they were just going to scare me a little—drive me past juvenile hall and then bring me home. After my behavior the previous few months, this sounded like a plan she could live with. But clearly, the plan went horribly wrong. Later that day, after I had already been processed in, she received an urgent phone call from a man who was handling my case. "Please come and get your daughter. She doesn't belong here." He kept his voice hushed throughout the entire conversation as though he didn't want to be overheard, and then in an even quieter yet more insistent whisper, he said, "I could get in trouble for doing this, but please come and get her. I'll let you get her."

When Mom finally arrived, wild-eyed and obviously not having slept, my reaction was to do a Bob—just pick her up and throw her. How could she let some asshole have me arrested? I gave her the silent treatment all the way out to the car and then started hollering.

"I don't want to go home with you," I announced. "I want to go to a hospital." I was gratified by her protests and the horrified look on her face. "Just take me to a hospital."

My request had a certain logic—to me. In a hospital, I could stay in bed. Food would be brought to me and I wouldn't have to stand in the free-lunch line to get it. I could wear a gown and not worry about what my classmates thought of my clothes. I wouldn't have to help Mom with her daycare kids, I wouldn't have to watch her interact with her boyfriend. More than anything, I didn't want to spend another day being me. "In fact, take me to a mental hospital."

"All right," she said. "I will."

I look back at that woman and that little girl, and I ache now for them. How lost they were.

I rested my head on the passenger's-side window, and my mother kept her eyes only on the road as we drove to the county hospital in San Diego. I remember nothing of the building's exterior; the minute we walked in, I had goose bumps. The Japanese call it "chicken skin"; I call it intuition. The building was huge and freezing, even the air felt gray and old. If I'd had the energy, I would've made a dash for the door. But the black cloud was in charge. I imagine that a homeless person living under a freeway overpass lacks inspiration and some get-up-and-go, too; living with constant racket, whether it's in your mind or under the freeway, separates you from your body and separates you from the world. This ugly building seemed as good a place as any to hold up the white flag of surrender.

Without speaking, my mother and I kept on walking, right up to the reception desk, where she signed in. We sat down and waited to be called. There wasn't anything to say. We were still mother and daughter and loved each other, but we had terrified each other; we had betrayed each other. She's supposed to be the grown-up, I thought. Why didn't she protect me? I know now she was asking herself the same question.

We may have brought in with us the only silence in that building. The ambient noise coming down the various hallways was deafening. I'd always been under the impression that crazy people were drugged-up in their beds, but no, here they were, walking around in regular clothes, howling and shouting and laughing. I was never a fan of horror movies; now I was in one.

Our number was very close to being called when a blond woman dressed in a draped and tattered Stevie Nicks–esque outfit suddenly

appeared. At first, you could only hear her boots—high-heeled boots—the rhythmic, echoed clacking sound of her footsteps on the hard floor made me feel like a tourist in a disease museum. When she opened her mouth, the intensity of her words and the way she delivered them was beyond frightening. She wasn't screaming, but you could hear the insistent desperation in her voice as she asked for her medication. "I need my medication," she said to the women behind the desk. "I need my medication. I need my medication." Then she half-turned and opened it up to the room at large. "I need my medication!"

For the first time in nearly seventy-two hours, a glimmering in my mind warned me that being here, giving up, giving in, was maybe not such a good idea. My mother sat up straight in her chair and grabbed my arm; I looked at her, she looked at me. It was as though we'd both been in some kind of zombie state. And then Mom said the two words for which I will be grateful for the rest of my life: "Walk fast."

We sprinted for the parking lot, then raced out of it in record time, relieved to look back only once and see that there were no white-jacketed men coming after us. It was a mess, and we were battered. But we weren't broken. Somehow, we would figure it out.

We took the long way to get there, as many families do. But even now, at times of stress or upheaval, all either of us has to say is "I need my medication!" and the laughter starts to roll.

THREE

THREE

THREE

"be a model or just look like one!"

After the first big manic episode of my life, I have to admit that for a while, I looked back on it with a certain amount of affection. Yes, there were some frightening moments: the handcuffs, the lack of privacy, the cold-metal reality of the suicide tank, and the level of anger I felt toward both Bad Bob and my mother. That anger worked just like jet fuel—it literally blew me out of my home and into the justice system, even if only for thirty-six hours.

On the other hand (I'm good at looking at the

other hand), it was an adventure, a walk on the wild side. It had serious risks, but it also had a couple of rewards: for one, it got rid of Bad Bob, who was never seen around our house again; for another, I was the center of attention, especially my mother's. All that time I was so busy telling her I didn't need her—until the day I discovered that I did.

And the image of that young pregnant teen stayed with me for a very long time. I often wonder what happened to that girl and to her child.

When I was very tiny, my mom took me to a photo studio to have baby pictures taken. When she returned to pick them up, she was surprised to see that one had been blown up, framed, and put on display. There it was, my very first modeling job. It would be about fourteen years until my next one.

I didn't think of myself as pretty, and for a long time, I wasn't. I had huge lips on a little face, crooked teeth, and big feet. I wasn't tall, I wasn't short—if I thought of my appearance at all, it was average, especially compared to the blond, blue-eyed standard of beauty of the popular girls at my school. I cringe now whenever I hear a model or actress talk about how difficult it was to grow up different (too skinny, too tall, too other), because I've learned that even the most confident, cool-acting kids are sometimes shaky inside—awkward, about to be found out. Doesn't everyone have a story about being that solitary teenager who basically held up the wall at a dance or a party? And addicts always speak of having felt like outsiders long before they ever used anything to help them feel better. And honestly, who wants to hear "poor me" from a model?

In any case, worries about what I looked like weren't at the top of my list—I was too busy trying to hustle my way somewhere. I didn't know where, just somewhere else. And I knew that money was central to getting there. I was never a job snob. I cleaned yachts at the Glorietta Bay Yacht Club, I cleaned bathrooms at the public restroom facility on the bay where the boats were docked, I helped my mother clean the doctors' offices where she worked. God bless housekeepers (and I bless them, too), but even now, I've never seen a kitchen or a closet that I couldn't make better, especially if I've got a caffeine source. Call it OCD, call it ADHD, call it a defiant echo of Scarlett O'Hara's "As God is my witness, I'll never be hungry again!" Work *works* for me.

When I was fourteen, I began hearing ads on the radio for the Barbizon Modeling School. I had no conception of actually being a model—my mother didn't have fashion magazines around our house (my brief glimpse at *Cosmo* in juvie was actually kind of horrifying), I had never been to a fashion show, and I wouldn't have known a supermodel from a shrimp fork. But Barbizon's ads talked about teaching poise and etiquette, about confidence, assurance, and self-improvement. These were powerful buzzwords to me—I was eager to learn anything that would help me be a success at something.

Barbizon had an office in San Diego (I learned later that they have offices all over the country—and more than two hundred locations today). I begged Mom to take me there so we could find out more. Finally she said okay.

Barbizon's San Diego location was on the far end of the Fashion Valley Mall. JC Penney was at the other end. Fashion Valley wasn't a frequent destination for me and my mother, so it took us about a half hour to get our bearings. But when we walked through those

doors, everything changed. The woman in charge, Candice West-brook, was petite, with a short blond bob and direct blue eyes. I was never good at guessing ages (when you're a kid, the world is divided into three parts: other kids, grown-ups, and old people), but I think Candy might've been forty when we first met. She reached out to shake my hand (I don't think, until that moment, any adult had ever shaken my hand), and at that moment, she became a friend for life to both my mother and me. There was no way we could've known that then—all we heard was "fifteen hundred dollars' tuition" and "She's going to need braces." Well, that's the end of that, I thought, and the look on my mother's face said the same thing. "Wait a minute," Candice said. "I think maybe I can help."

She told us she saw something in me. Something in my bones or in my face. I had no idea what she was talking about. But I certainly saw something in her—a way of speaking: direct, straightforward, with something warmer and kinder just beneath it. I immediately trusted her, and so did Mom. A payment plan was negotiated—basically, she loaned us the tuition. Not long afterward, I had a mouthful of braces. Candy helped me get a part-time job at the San Diego Zoo, as a Teenage Mutant Ninja Turtle. The costume was big and hot: I felt as though I'd wrapped blankets around my body and head, then tried to breathe while the summer sun beat down and parents took pictures of me standing with their awestricken little kids. For fifteen dollars an hour (which went toward my braces) and a free lunch, it was a good job and a fine alternative to cleaning bathrooms.

I know there are families, and kids, who get the "I'm going to make you rich, I'm going to make you famous" pitch from modeling "schools" and "agencies" everywhere, in exchange for a big check and

a signature on a dotted line. That is never what Candy, or Barbizon, said to me or my mother. We were not hustled. What we were offered was an opportunity—access to information and instruction, to be better, to go forward and out into the world in a way that didn't seem otherwise available to me. "I want you to know that this is okay with me," my mother told me. "As long as you're willing to work for it. Nobody ever let me do the kind of things that I ever wanted to do. But now, you—if you're willing to work for it, I want you to try."

Every Saturday morning for six months, I took the bus to Barbizon for a four-hour class with six other girls. We worked on everything from applying makeup (not clown makeup, but look-a-little-better-than-you-normally-do makeup) to walking across a room without falling over our own feet. How to speak to one person, how to speak in front of a classroom of twenty-five. How to stand, stand still, and stand up straight. How to smooth your skirt under your butt when you sit, so that a cold folding chair doesn't surprise you. Where your hands go when you're talking to someone (hint: not in, on, or near your mouth). How to smile. How not to laugh at someone, but laugh with them. Manners: Please, thank you, excuse me, no, thank you, I don't care for seconds. That last one was hard. The more the teen hormones kicked in, the curvier I got. Cleavage not so much, but the hips, the ancestral Latina hips—it was clear early on that my heritage was going to fight me pound for pound.

Candy introduced me to a photographer in San Diego who agreed to take my pictures. We shot on the beach in Coronado. I was able to calm my nerves by focusing on the professional makeup artist who was working on my face—this was a first, and I was fascinated. When I looked in the mirror afterward, I couldn't believe Mary Forsberg

was looking back at me. That was the first time I remember thinking, I might be pretty. Even with braces and crooked lips, maybe I had potential.

I don't know if Barbizon actually made me more confident or taught me how to convince people that I was. Whatever the case, with my mother's trust and Candy's guidance, I slowly began to move into the world of my Hotel del Coronado fantasy.

Barbizon holds its annual "Model of the Year" competition in a different city each year, and each regional school chooses which of its students to bring. The year Candy took me, it was in Washington, D.C. I had never been east before—except for the disastrous trip to Tacoma, I'd never been out of San Diego—and I was excited, nervous, and scared. I knew I would fall off the runway or, worse, walk straight off the end of it. I had to do some serious slimming down, too, and my wardrobe needed adjusting, since shorts and flip-flops were not an option. "Why can't I wear what I want in between competition events?" I asked.

"Because it's just not a good look, Mary," Candy said. "The whole idea is to impress and intimidate the competition when you're off the stage as well as when you're on it." That had never occurred to me (I'm glad it occurred to Candy, since the Texas girls brought their A game). The flight was exciting, the images outside the car window were amazing as we rushed from the airport to the hotel, but it was hard to register the details, since everything went past like a video on fast-forward. Although I'd spent time in between homes at motels, I'd never been in a real hotel—the one in D.C. loomed

at least twenty stories into the sky. I stared, gaped, and gawked so much I wouldn't have been surprised if the soundtrack to the *Beverly Hillbillies* started playing in the background. When I saw some Girl Scouts standing next to a table piled high with boxes of cookies, I loosened up a little. Candy saw my eyes grow to the size of Thin Mints, and she bought some. "For later," she cautioned. "Once the competition is over, you can eat nine boxes if you want."

There were perhaps three hundred other girls in various rooms, in various stages of excitement and preparation. I can't remember actually stepping onto that first runway. That fear has never gone away (full disclosure: I've always been relieved that I was often considered too short for runway work). I don't recall making eye contact with the audience or the judges—I just thought about falling and not falling, and keeping my lips safely clamped down over my metal mouth. And then there were the 1980s outfits that I wore. The funniest was my "athletic look"—a one-piece electric-blue leotard with oversized white leg warmers and a white tank top tied to the side in a knot and slightly cropped. And real Reeboks, with white rolled-down socks. A Sheena Easton/Olivia Newton-John hybrid. I thought I really rocked those poses, alternately bouncing and vamping from one corner of the runway to the other. Only later, when I was a professional myself and actually judged model competitions, did I realize that a *Charlie's Angels* pose did not scream high fashion.

There were three different prize categories based on height: petite, tall, and me in the middle, at five foot seven. When they called my name, I caught Candy's eye—she was just as surprised as I was. I headed back to the stage (yet one more chance to fall down) and stood between the two winners from the other categories, holding

on to my trophy like it was a newborn baby. The announcement for Model of the Year was moments away, and honestly? I couldn't give a shit. I was so excited I'd actually won something! I had a trophy! And I knew Candy was happy, too. Plus there were Girl Scout cookies waiting back in the room.

The judges, modeling agents from many top American agencies (most of them based in New York), took their time scanning us, whispering to one another, and taking notes on their little notepads. When the emcee started to ask us questions, I started shaking—how did I not know this was part of it? For days, I'd kept my braces a secret; now, I had to open my mouth and speak. When the microphone met my lips, as if on cue, the judges all scootched closer to the little TV monitors they had on the judging table. Their double takes couldn't have been more obvious than if I'd been wearing a big gold rapper grill.

I didn't win, but after the judging was over, there was a sheet with agent requests posted on the wall. Nearly every agent had asked to see me. One of them was Karen Lee, a scout from Pauline's Model Management in New York. "I want to stay in touch with you and Candy," she told us. "I'd like to take another look at you once you've grown another inch or two, and after those braces come off. You've got . . . something."

In the short time we had remaining, Candy and I walked around the city. I knew the smart thing would be to look at the Capitol Building, the Washington Monument, the skyline, the White House. But I was totally inside my head, spinning a vision of what was going to happen next. Gassy city buses, government cheese, and little San Diego would be replaced with planes, money, and big cities around

the world. How could it be otherwise? Hey, I had cookies, and I had a trophy.

Candy told me that *Seventeen* magazine held an annual teen model contest, and JC Penney was one of the sponsors. Was I interested in going for it? Yes, of course.

Ten girls were picked to participate in a back-to-school fashion show at the Chula Vista mall; I made it onto that list. I don't remember what I wore, but I do remember that the creative concept was to show the clothes on the carousel, not on a runway. Ten lanky/awkward girls, in coordinates we'd most likely never wear, walking to the beat of Bobby Brown's "My Prerogative," stopping to strike poses on a unicorn or a pastel-colored pony with tassels in its nose.

After the fashion show, I was selected to go on to New York City for a shot at a cover. A national magazine cover. I was told that *Seventeen* had more than forty thousand other "finalists" to choose from across the country, and only eight of us had been invited. I'd thought the JC Penney gift certificate was great, but this was astonishing. There were gift certificates if you won and introductions to big modeling agencies—and there was a car! A Geo Tracker. I wanted that car. And then I remembered that none of the pictures I'd submitted for the contest actually showed my braces. Should I tell somebody, or should I keep my mouth shut and just go to New York? Be serious: I was going without my mother, I was going without Candy. I would be staying in a beautiful hotel. We would see the sights, go to a real Broadway play, and be taken out to restaurants. Not in my wildest dreams could I have imagined this.

When we arrived in New York, we were met by some staff members from *Seventeen* and a stretch limo. I had never seen a limo up close—now I was riding in one. We pulled up in front of the St. Regis Hotel, in the middle of Manhattan. Walking into that lobby, I was Dorothy in Oz. I dropped my pitiful suitcase at the desk ("We'll bring it up, Miss." Miss!) and headed for my room, which was beyond my imagination. I walked around touching everything. A TV! Fancy cashews for five dollars! I wanted to eat them. The bathroom was as big as a station wagon and had white makeup lights all around the mirror. The beds (I had a roommate, another girl from San Diego) were pure luxury, piled high with pillows and comforters that looked like silk. There was gold-embossed stationery in the little desk drawer. Now I knew why the rich were so happy. They had comfy beds, pricey snacks, special paper to writer letters on, and someone to carry their luggage. I tried desperately to sleep but could not. How could I go home with this knowledge and be content? Was it even okay to want a life that looked like this? Was there a way to actually work for it, even if I lost this contest? I started preparing for the crash. I would lose, I would be sent home. It would all become a memory, and when I was old, I'd question whether it really happened at all.

In the next few days, as the *Seventeen* contestants moved through the city together, our every move was captured by a photographer for the magazine. We went to the Hard Rock Cafe, we went to the musical *Grand Hotel*—I sat through the performance in stunned silence. I had never questioned how TV came to be, how movies came to be, or if acting was an actual job, but there it all was, right in front of me. I wanted in, I wanted access. Not as an actor (I knew even then

I'd never have the chops to be an actor), but to be part of putting all this magic together—I wanted to do that. I didn't expect anyone to hand it to me, but I was frantic to know how to ask for the job. Or what job to even ask for.

As thrilled as I was by Broadway, I was just as thrilled by the food. It was everywhere, and there was a lot of it. Salty pretzels and Italian ices from sidewalk vendors. Hot dogs with mustard and relish from flirty old guys with striped umbrellas over their carts. My favorite eating adventure was at Tavern on the Green, right in the middle of Central Park, rising up and twinkling in the darkness like something Walt Disney had created. Everyone around us was so dressed up, I just knew that people at every table were talking about fascinating things (the fact that many of them were tourists like me never entered my mind). The menu was out of a fairy tale. Baby vegetables. Fancy potatoes, sauces with cream, butter, and wine; herbs and spices I'd never heard of. How long had people been eating like this? How could I decide what to eat? What was foie gras? What was beef en croûte? What was escarole, or shiitake or mascarpone or passion fruit or Napoleons? Why would anybody voluntarily eat raw oysters or snails in a little shell? I ordered an appetizer and an entrée, then I ordered more. Some duck. Some lamb. I wanted to taste everything. I was far, far away from the free-lunch line. When the waiter asked, "May I interest any of the young ladies in dessert?" I answered yes before he even got the entire sentence out. The *Seventeen* staff was cracking up; this was not typical model behavior (or typical magazine editor behavior either, I'd bet).

While we were there, Kathleen Turner walked in. *Jewel of the Nile, War of the Roses.* The first celebrity I'd ever seen. She was regal,

glamorous: it was as though light radiated all around her. In that moment, I knew I'd move to New York one day. There was so much to learn.

The next day, one of our stops was the famous Louis Licari salon for haircuts and color. I had long hair with sun-drenched highlights courtesy of Mother Nature. The *Seventeen* people told me to sit for a while and wait for the other girls to finish up. I'd never had a professional haircut or color, and there was no way I was leaving without a full makeover. I begged, insisted, and then fought with the hair stylist and the staff from *Seventeen*. They finally gave in. The sensation of having your head shampooed by someone else—scrub, rinse, repeat, condition, rinse—is unlike any other. I felt like a princess. In the studio the next morning, being photographed for our cover tries, I kept staring at myself in the mirror. That girl, braces and all, was beautiful. Not only that, they even liked my braces—they told me to keep smiling a big smile "until your cheeks hurt." Who knew smiling could actually hurt?

On our last day in New York, we met for breakfast in the Rainbow Room, on the sixty-fifth floor of Rockefeller Center. The ride in the elevator made my ears pop; the view of the city from those windows made my eyes pop. On one side, the East River; on the other, the Hudson River. A ship on the Hudson looked tiny; the Empire State Building, twenty blocks south, looked like a toy. I kept waiting for somebody to wake me up and tell me it was a school day and if I didn't move it, I was going to be late.

All the top agents in New York came to meet with us that day. Representatives from top agencies like Ford and Elite talked with me, and once again, I spoke with Karen Lee from Pauline's. After Washington, she'd kept in touch with me and Candy just as she'd

said she would, and now, she said, it was time—I was ready. There was a comfort level with Karen. She took an obvious personal interest in me. I knew I was wading into big waters—I'd need someone to play the same role with me that Candy did.

Ultimately, I was one of the finalists in the *Seventeen* contest. I didn't make it onto the magazine cover, and I didn't win the Geo Tracker. I told myself it was probably just as well—at that point, my mother couldn't even afford driving lessons for me, what would we have done with a car? I won another JC Penney gift certificate (which I traded in for cash when I got home, and then went right to the Gap and spent it). Candy got me more local modeling jobs. And my *Seventeen* adventures made it into every publication in Southern California. This had little effect on my social status at school. Well, maybe in the boy department—the Mary in those pictures was not the Mary who sat next to them in class. If anything, it made me even more self-conscious. Modeling school, the work that came out of it, and my dreams for the future—all of that was very private, like something breakable, and I didn't want anyone near it.

The universe plays tricks. Had I won that car, I never would have met my future husband. That little Geo Tracker would've significantly rerouted the course of my life.

My mother's wild single days (which weren't wild at all, of course) lasted barely a year. She met and fell in love with someone, and that someone fell in love with her. His name was Mark, he was a career navy guy—he worked on the flight deck of a carrier at North Island Naval Base in Coronado—and their decision to marry came (it seemed to me) very quickly. My father had remarried as well.

Johnny had a bigger struggle with this than I did, since he'd been living with my dad (and had a much closer relationship to him than I had at that point), and the new stepmother came with two teenagers. My reaction to anything Mom and Dad did increasingly was, "Oh God, whatever."

I liked Mark. He steadied my mother, he loved her, and it was obvious to anyone who saw them. He, too, had gone through a difficult childhood, with most of the responsibility for his own siblings—to this day, the man won't eat pancakes because they were a primary food group for him growing up. There seem to be two schools of reaction if you come from that world—you either get stuck in it, or you get up and run. Going back is not an option for us runners. With Mark, I knew that we were safe and that my mother would be cherished for the rest of her life.

Soon after they were married, however, he learned that he was being transferred to Lakehurst, New Jersey (point of interest: this is where the *Hindenburg* went down). Predictably, I threw a fit, which lasted about half a day—Johnny threw one, too, because Mom wanted him to move east with us. The other news came not long after that: Mom and Mark were expecting a baby. That information was hard to take in at first. It was more family (although with the various aunts and uncles and cousins, there was never any shortage of family), but it felt like a different family, and it was all going to happen in a different place. My mother's last name was different; my new baby sister, a blue-eyed blonde named Suzy, would have a different last name, too. We would be three thousand miles away from where we'd started. And then I heard the thunderclap: New Jersey was just across the river from New York City! Duh.

The new house was standard-issue military housing: two-story

brick, with three bedrooms, and houses just like it up and down the block. Almost immediately after we settled in, I started plotting. I didn't give much effort to fitting into my new school, and I got a part-time job at Burger King to put more walking-around money into my pockets. Train money, subway money, taxicab money.

Mom and I took the train into New York, where Karen Lee introduced me to Pauline Bernatchez, the agency's French founder. She had started it in Paris, they told me. All around us, photos and blown-up magazine covers of the world's most beautiful women graced the walls. The agents gave us a rundown of how things would work; almost immediately, I was sent out (alone) on my first shoot for a teen catalog. I did some fashion shoots for *Seventeen*, I did more catalog work—but the one that amazed me the most in those early days was for gloves. Just my hands in gloves. For one hundred fifty dollars an hour! This is genius, I thought.

Then came winter: dark mornings and short days and navigating my way around New York City in a coat that didn't protect me. I was always cold, was always being weighed and measured, and was always hungry. I actually believed Fig Newtons were health food— the package said so. My romance with the city wore off quickly, and I pleaded to go back to California. My mother decided that both Johnny and I should go back (primarily, I think, because we were both a pain in the ass). Julie, then only four, and Suzy, the new baby girl, would of course stay with Mom and Mark. The plan: I would live with Grandma Rosa in suburban L.A. (where the model- ing agency assured me I would have plenty of work) and go to high school there, and my brother would again live with my dad.

Mom got a cross-country itinerary from Greyhound (not for the most direct route, as we would discover) and put together a suitcase

full of groceries; tearfully, we all said good-bye. I was fifteen, John was twelve. We'd both been working very hard for a couple of years to get away with something and now, it seemed, we'd finally done it. Together, we ate our combined weight in Bugles and Fig Newtons as we made our way west.

Within days of our arrival, Johnny was in San Diego at my dad's, Candy had cleaned me up and was taking me to modeling open calls, and I finally settled on Bordeaux Model Management for L.A. representation. And I was once again plotting—this time, how to get out of the horrible high school near my grandmother's. That dear, befuddled woman. I talked her into signing a paper that she didn't really understand, which stated that I was transferring to another school and needed my records. I then presented the school officials with the paper, they released the records to me—in effect, they released *me*—and that was it. I was done. I packed my bags and took the bus to the Greyhound station without telling my grandma. Then, like a B-movie cliché, I got off at the Hollywood station and never left.

It would take me another ten years of correspondence school to get my high school degree, but before my sixteenth birthday, I was living in a models' apartment on Hollywood Boulevard and taking care of myself. Well, sort of.

FOUR

love is the drug

A model's apartment (most agencies have them, all over the world) is a far cry from a suite at the St. Regis, but the concept is somewhat the same—you come in from out of town, you stay there while you work, and the agency that either rents or owns the apartment (or, more accurately, rents or owns you) charges your rent against your earnings. The apartments vary in size and quality, but at least you're always assured of a place to sleep and a fridge to store diet soda, morning-after chilled eye packs, and leftover takeout food.

Our apartment had two bedrooms, and most of the time, I shared one with Luis, a young booker from the agency. Luis loved us girls, but not girls in general, if you know what I mean. He taught me a lot about being a woman. When I first moved into that apartment, I was wearing slip-on Vans; thanks to Luis, when I moved out I was wearing five-inch Vivienne Westwood platform heels.

There were three twin beds in the other bedroom, plus a pull-out couch. The roster of girls camping there changed every few days, and most of them were less than stellar in the housekeeping department. In my experience, there are three main reasons why models don't make great housekeepers: (1) they usually leave home at a very young age and miss out on Mom's homemaking tips; (2) they are constantly traveling, and when you don't stay in one place long enough for the dust to build up, you don't know it exists; (3) they're fucking models and they don't give a shit. They'd wear dirty clothes for days, never wash their bedding, use towels to remove their makeup and then leave them on the floor. Luis and I were tidy in our own corner, but maybe twice a month we'd lose it and take that apartment down. In fact, forget the St. Regis comparison: The models' apartment was more like the Bermuda Triangle. Agents were scared to step foot in it for fear of disappearing. Some girls slept in their designer clothes, otherwise they'd never see them again. High-end cosmetics evaporated; so did expensive shoes. Food was the biggest mystery of all—you'd get up to answer the door and return to an empty plate that just a moment before had been occupied by a slice of pizza.

My modeling assignments covered the whole range of the junior category in print—catalogs, newspaper circulars, and all the teen magazines, including *Sassy, YM,* and *Seventeen*. I sent all the pictures and magazines to my mother, and called her as often as the scary

long-distance phone charges would allow, reassuring her that yes, I was working hard; yes, I was behaving myself; yes, Candy was still keeping an eye on me; and yes, I was putting all my money into the bank. She had her hands full with two little girls, and I'd become very practiced at BS-ing her. I had an agency allowance of seventy-five dollars a week, appointments almost every day, and no homework. Nobody to tell me to go to bed at a reasonable time at night, nobody to suggest I take a look at the salad and vegetable choices at the diner. Probably just as well—I couldn't have made healthy choices on that budget.

Los Angeles may have had a weather advantage over New York City, but it did not have New York's public transportation system and it didn't have an actual city center, either—it sprawled in all directions. I was always late, or heading the wrong way on a bus or in a cab I couldn't afford. I got to know some of the local models (or "L.A. girls," as we were called, because we never wanted to leave L.A., even though L.A. modeling options were and still are crap), and sometimes one of them drove me to and from jobs or castings— Cameron Diaz, Amy Smart, Charlize Theron, and Ali Larter were all starting out at the same time I was, and each was kind enough to let me hitch rides with them. But the agency bookers decided I needed someone reliable to pick me up and deliver me. There was this musician guy, they said. He was in some band trying to make it; in the meantime, he needed a day job. They would pay him eight dollars an hour to ferry me around. Wow, my own driver and a limo, I thought. One day I walked into the agency, and there he was.

It was not a limo; it was an old, boat-sized Chrysler with a bad leak on the passenger's-side floor. I can't tell you how many of my shoes that car destroyed. The driver was not Prince Charming or

Sir Lancelot; he was a quiet, soft-spoken young guy with grin lines radiating from his blue eyes. He wore a white T-shirt, Levi's, and motorcycle boots. And sometimes a jacket, like something a delivery guy would wear: vintage, faded green, with a 7 Up insignia on the front. I still have that jacket. I won't give it up. His name was Scott Weiland. I had just turned sixteen; he was twenty-three.

Along with the usual assortment of earthquakes and fires, L.A. was experiencing a series of heat waves that made asphalt melt and the horizon shimmer. Looking at Scott as he spoke, I felt my body sway, as though I'd brought the weather inside with me. I was torn between running back around the corner to my apartment or inching my way closer. It wasn't something that he did or did not do. There was no special look or exchange between us. What I felt, instantly, was unlike anything I'd experienced before, yet I knew exactly what it was. I was hit, and hit hard, with the immediate knowledge that he was the one. I didn't question, then or now, whether those feelings were a good idea. They just were. Maybe it was the click that comes when you recognize your soul mate, the click that doomed Romeo and Juliet. Maybe I saw something in his face that asked me to love him. All these years later, I lean more toward the latter.

Every day when I knew Scott was coming to pick me up, I talked to myself: Pull it together, Mary. Try to make yourself look at least eighteen. He's coming, he's coming. Flipping my hair, I rehearsed dialogue in the mirror. In the mirror, I was always smart and funny and cool. In the car, I went mute. I couldn't speak; I couldn't look at him. I'd stare out the window, with my stomach looping up and over. Or I'd have the *Thomas Guide: Los Angeles* open in my lap as we figured out where my appointments were.

Neither of us had any real money. For lunch, sometimes we went

to a little Thai restaurant and split a plate of fried rice for a dollar, drowning it in chili sauce to make it taste like anything other than rice that had been in a pot since the night before.

When you sit across a table from someone and share food, you actually have to look at him and, eventually, say something. We talked about music—the Seattle grunge scene was exploding on mainstream radio, so Nirvana was generally the headliner for our conversations, with Alice in Chains a close second. His band's name was Mighty Joe Young, and they played anywhere they could around L.A.; this is what he'd always wanted to do, and they were working hard to get noticed, to get a record deal and move up to the next level. From the music talk, we went on to share the personal things—how I got to L.A., how he did, and all about our fractured family trees, both of us with remarried parents, siblings, stepparents, stepsiblings, and half siblings. He had a serious girlfriend, he said. I heard that information, filed it away, and did everything I could not to think about it again. Everything else I committed to memory.

Scott's parents, Sharon and Kent, were California kids, like mine, but Northern California, near Santa Cruz. They, too, married young and divorced young as well, when Scott was only three. His dad was a surfer, and a little wild and crazy. His mom remarried; his stepfather, Dave (who was the furthest thing from wild and crazy, Scott told me—a Notre Dame graduate who worked for Lockheed Martin), adopted him when he was five, and the family moved to Chagrin Falls, Ohio, outside of Cleveland. He had three brothers, all younger, and he actually sang in the church choir when he was a kid. A little town named Chagrin Falls and a church choir—it all sounded like something out of a storybook to me.

In the summer, Scott would visit his dad in California, and from

the way he smiled at the memories, I don't think there was much choir practice going on there. Scott credits Kent for being the one who passed on a love for music and singing.

When Scott was fifteen, his stepdad was transferred back to California, and the family moved to Huntington Beach. Scott had played football for his Chagrin Falls school, went west with a strong letter of recommendation from his coach, showed up on the first day of practice all ready to go, and the Huntington Beach coach kind of yawned. As he was talking, I could visualize his first day on that sunny field, suited up for practice, letter in hand, and shot down. Not the most promising beginning.

He played football anyway, kept his stepdad happy, and began to get into the same kind of trouble I did, pulling the "You tell your mom you're staying at my house and I'll tell my mom I'm staying at your house" trick. Weekends with his new friends were spent riding bicycles to parties, a fine old California tradition—roll up, the front lawn is covered in bikes, the lights are all on, and the grown-ups are mysteriously someplace else. The other tradition he discovered was beer pimping: break up into pairs and split up, each group hitting a different liquor store. The goal is simple: Get someone who's old enough to go in and buy you some booze. Scott wasn't new to drinking, but his new friends took it (and him) to another level. They were also very busy getting to first, second, and the occasional third base with girls. If this had been happening back in Chagrin Falls, Scott told me, nobody had let him in on the secret.

Regardless of how slick they are, teenagers get caught at some point. Scott woke up one morning to find that his friend's dad had come home early and busted the house full of hungover boys. He

made them each call their parents and confess what they'd done. Scott spent the first month of his freshman year, in his new town, on restriction. Not only was Scott naive, but so were his parents.

One of his friends, Corey, invited him to a barbecue one weekend, where the guys were playing in a backyard band. For reasons Scott's not quite sure of now (and he sends out a "no offense" to his friend Ross, who is Corey's brother and was the lead singer), he said to himself, I can do this better than he can. I can write it, I can sing it, and I can do it better.

There's an argument for being stubbornly unrealistic about your dreams. Otherwise they're not dreams—they're just ideas you had once and then left behind. Once Scott focused on music, he never changed his mind. He went to Orange Coast College for two years to please his stepdad, and still never changed his mind. When he asked to take the following year off to focus solely on music, Dave said yes, he'd support that—but only if the band was run "as a business, not a stoner side project." I don't know if anybody's ever actually done a statistical study, but I'd guess the Big Book of Rock History is filled with stories of artists who somehow (if messily) managed to do both.

Scott was actually the first person to give me advice about boys. I was pretty much a blank slate in that area. I'd never had a real conversation with my mother about boys and sex (and she never had one with her mother, either, which is how I came into the world when she was eighteen). Luis had explained girl mechanics to me, but nobody ever sat me down and said, "This is how boys work." In

simple language, without freaking me out, Scott did. He was noth-
ing at all like the man people see onstage now, caught up in the
music that takes him someplace else—to the casual observer, he was
simply my very kind friend. My very kind friend who had me talk-
ing to myself in my bathroom mirror.

One morning, Scott was taking me to an appointment, and I was
supposed to be a little cleaned up before I got there. There was Chap-
stick, lip liner, mascara, and blush buried at the bottom of my school
bag. I didn't have a compact or a mirror; even now, I'm clumsy about
putting this stuff on my own face and have always been grateful to
the professionals who know what they're doing. Scott pulled the car
into an alley just off Rodeo Drive and Wilshire Boulevard, parked it,
and waited for me to get out. "I can't," I said. "I don't know how to
make any of this work." I knew that his girlfriend was a professional
makeup artist; turning to him, I handed him the lip liner and said,
"Can you do it for me?"

Without a word, he took the pencil and spent the next couple of
minutes working on my crooked lips while perspiring like a member
of a bomb squad. I wanted him to kiss me. Kiss me, kiss me. I closed
my eyes while he worked on my face hoping, wishing, and begging
God that he would. He didn't.

Scott drove for other models, too, and one night, he came over
to the apartment to pick up one of them. His band was playing a gig
just a few blocks from the apartment; he invited her to come hear
them. When I heard this, my stomach sank. He was wearing that
green jacket. After they left, I flung myself on the couch and sobbed.
I wasn't old enough to get through that front door. That was the last
time I ever let my actual age be a barrier between where I was and
where I wanted to go.

The modeling agency began talking about sending me overseas—to Paris, London, Italy, Japan. This was a big deal, but because I was still a minor, the logistics were complicated. It was suggested that I go to court and become legally emancipated.

I wondered at first if Mom would be hurt, that she would think I was rejecting her. And she certainly asked a lot of questions. But when Candy Westbrook and I explained what was happening, she was, as in all things, practical: I was all the way across the country, I was supporting myself, and I needed to make decisions quickly about an industry she knew nothing about. "This is your chance," she said. "I never got mine, and I'm not going to deny you yours. Worst-case scenario, you can always come home."

My mother came west to go to court with me, and Candy came with us as well. The judge spoke with both of them, wanting to be certain this was a business decision, not a family rift or some kind of fight that would harm me in some way. He asked me a lot of questions, too. When the three of us walked back outside, I was a full-fledged legal adult.

Right around the same period of time, newspapers and tabloids flashed headlines about Drew Barrymore going to court to become legally emancipated. Her reasons were entirely different from mine—a bank account some very tricky people were going after, and a much bigger fight about it in a New York court. When I read the story, I thought, Good for her. (Because my emancipation didn't get the publicity hers did, few people ever knew I could sign my own contracts. "I'll make sure my lawyer sees this," I'd say, and rarely, if ever, signed a thing for the rest of my career.)

One day a few months later, I was sitting in the lobby of the Hotel Shangri-La in Santa Monica, waiting to be called for a casting for *YM* magazine, when I noticed Drew Barrymore sitting right next to me. I'd never met anyone else who'd been emancipated and neither had she. We talked for a while, and she invited me to her upcoming birthday party, at the Opium Den, a club I would soon know well. There's not much I remember about that party except that I drank too much. The next morning, even Scott's arrival to pick me up barely got my death's-door head off the pillow. As he drove me to and from my castings, I had to lie down in the backseat, hoping that would help. But the smell of his lunch sent my head out the open window.

Scott was my driver for three months, and then one day he said, "Mary, I'm not coming back—I got a record deal." The band had signed with Atlantic Records. They weren't Mighty Joe Young anymore; they were Stone Temple Pilots. There would be an actual album—*Core*—and he would be busy working on it and then touring with it. They'd be gone for a long time. No more driving Miss Mary. It's temporary, I thought. Don't panic.

After Scott left, his friend James started as my new driver. Miserable and mopey, I looked for excuses to bring up his name, fishing for anything Scott-related. Scott told me later that he'd taken some of my pictures from the agency and hidden them in his dresser; his girlfriend found them and made him rip them up and flush them down the toilet.

We actually had a weird near miss in the months that followed. Bordeaux hosted a party on the rooftop of West Hollywood's fabled Chateau Marmont (it had a long history before John Belushi OD'd there in 1982, but that was its primary claim to fame the first time

I saw it). I had worked all day and went straight to the party wearing full makeup and hair teased out to there, looking somewhere between barely legal and drag-queen-in-training. It was noisy and crowded, and the bar was wide open. One of the first people I met was comic Pauly Shore, who asked if I'd like to go to the Roxbury, then the hottest club in L.A. "Of course," I said in my best "Who, me? Underage? Don't be absurd!" voice, and we headed for the elevator. As we walked out, Scott and his girlfriend Jannina walked in. "Oh, hi," I said. "How are you?" He half-smiled, and I guessed immediately he had no idea who I was. "Well, good to see you," I stammered, and fled with Pauly to the Roxbury, where I proceeded to drink. A lot.

When Scott and Jannina got to the party, he ran into someone from the agency and asked if I was there. "She just left with Pauly Shore," he was told.

I managed to get so drunk at the Roxbury that when Pauly suggested it was time to call it a night, I couldn't tell him where I lived. Could not remember the address. Did not have a purse; did not have any money. I was pretty certain, though, that I had a major shoot early the next morning, for Italian *Vogue* for men—*L'uomo Vogue.* Everyone at the agency had been very excited about it. "I think it's a big deal," I slurred. Mr. Shore then proved himself to be a complete gentleman (I think this may come as a shock to some people). He took me to his house, settled me into a room by myself, set the clock, and made me take an aspirin and drink a lot of water. I remember stumbling into the bathroom, seeing my first bidet, and thinking, Well, I know there's a choice here, but I'm not sure exactly how one makes it. . . .

I was out the door on time the next morning with sufficient cab

fare from Pauly to go to the shoot, still wearing my clubbing outfit and a pair of false eyelashes I couldn't remove with a crowbar. When I got there, I discovered that the theme was Amish. Why *L'uomo Vogue* had decided this was the direction they wanted to go was beyond me. I was supposed to be the scrubbed-faced, healthy-looking maiden at the center of it all. Which is why there was no hair and makeup on site. I have seen birds' nests that would've been easier to comb out than my morning-after hair. Nevertheless, I pulled it together, cleaned myself up, masked my hangover as best as possible, and got back to my apartment late that afternoon with the sole intention of falling into a coma.

The little light on the answering machine was blinking like the landing field at LAX, and every message was from Scott. "I didn't know that was you. I'm sorry. No, really, I'm sorry. Are you okay? This is the third/fourth/fifth time I've called. Where are you? Is everything all right? Pick up, Mary. Are you there?" I played the messages over and over and over.

A week or so later, Scott called and asked if I wanted to come down to the Palace, where his band was opening for Ice-T's Body Count. He had this idea, he said, if I wanted to go along with it, that my girlfriend Reggie, one of the bookers from the agency, and I would dress up and toss condoms with the band's name on them into the crowd while the band played the Beastie Boys' "Fight for Your Right (to Party)" onstage. We both agreed to do it.

This will be fun, I thought, as Reggie and I went inside that night. And then reality suddenly loomed in the person of the girl-friend—Jannina was there. Scott explained that she was going to put stage makeup on us. I'd thought my leggings, platform boots, and bustier were trashy enough, but evidently not. The whole time she

was working on my face, I was thinking how unfortunate it was that she was with my future husband. Lucky for me, she gave no indication that she was psychic.

Moments before Scott and his band came out, I started feeling afraid—what if the love of my life turned out to be awful? And then it started. The man who stepped to the front of the stage with the mic in his hand was not the one who'd been sharing fried rice with me. This man was someone else. But oh my God, he was amazing. Standing on the side of the stage watching Scott, listening to him, I knew he was going to make it. Of *course* he didn't want to stick around and be a part-time driver for some twit girl model; he was a professional musician, a real one. What a fool I am, I thought. Even now, after all these years, after all the live performers I've been privileged to see, I still think he's one of the best front men there is. He doesn't just sing a song, he disappears into it—he simply takes off and goes someplace else.

It would be another couple of months before I'd see Scott again. James was driving me to and from my jobs, and coming home from a shoot one day, he said, "We're going right past Scott's—you wanna swing by?" I was still wearing my model hair and makeup, so I took a deep breath and said yes.

Scott and I spent most of that visit looking at each other sideways. I don't remember much about that house except that it had hardwood floors, which is where I kept aiming my eyes—the hardwood floors and the top of my motorcycle boots. When he asked if I wanted to hear something from the album, of course I did. I sat on the pool table while he fiddled with the tape, winding it forward and back until he found the song he wanted. The music started, and suddenly I heard my name. Something like, "Where did Mary

go? Where did Mary go?" It was a song he'd written—"Wet My Bed"—and I was in it. Or somebody named Mary was in it, and it was about her. Or about me. I didn't know for sure, but my face was on fire. "Did you check the bathroom, the bathtub? / She sleeps there sometimes. / Water cleanses, you know." He turned around from the tape player and looked at me, and there it was: Oh God. I'm gonna marry him.

And neither one of us moved. Days later, he was gone.

Soon after Scott left, I left, too—to Japan, for my first international travel experience. Contracts with Japanese agencies were very strict: be available for work all day, every day, and do not gain one single ounce. This weight challenge was always my personal demon, of course, but in Japan, it finally made sense to me—the sample sizes there are so tiny that the humans in them should probably be the circumference of a clothes hanger. In fact, a clothes hanger might've worked out better than I did.

Modeling in Japan didn't offer a single ounce of glamour. Once you arrived at Narita Airport in Tokyo, you were taken directly to your first casting; after that, it never stopped. I got up at five, went to one job until noon, to another until four, to another at eight, got home after midnight, and started all over again the next morning. And the food just confused me. I'd go to a job, they'd hand me a pretty little lacquered bento box containing strange items (and no one could ever tell me what, exactly, each one was) and a pair of chopsticks. The Japanese clients laughed at my pitiful attempt to use chopsticks. "Oh, Mary-san, you no can use?" I had no clue. I wanted a donut. I wanted

some pizza. I wanted some of my mother's homemade Mexican food. At night, I had just enough energy for one of two options: wash off the clown makeup, or eat dinner. Not both. Sometimes I just put a towel on my pillow and fell over, asleep before I landed.

Modeling in New York and Los Angeles, I was always a couple of inches too short; in Japan, unless there was another American model there, I was always the tallest person in the room. People stared. Walking up the stairs from the train, I'd sense someone right behind me, turn around, and sure enough, some guy was trying to get a look under my skirt. And then there was rush hour. There are guys employed by the Japanese train system called "pushers"—their job is to literally push, jam, shove, and cram every last person into every last available inch of space on the train. It was far worse than anything I'd ever experienced on the New York City subways, where, yes, people are packed in tight yet have this weird way of being distant from one another. Like, "Yes, I'm pressed right against your butt, and you're glued to my hip, but I don't see you, you don't see me, we don't acknowledge it, and we'll just forget this unfortunate moment ever happened." That was not my experience in Tokyo. Along with the pushers, there were grabbers—middle-aged businessmen trying to cop a feel and not being subtle about it. The first time it happened, I couldn't quite believe it; after the second time, I started dealing out swats on their hands, a firm "Hey, quit that shit!" and then I'd carry on with my day.

The contract was for three months; after six weeks, I was so desperately sad and lonely that I knew I had to find a way to get out. I'll eat my way out, I decided. Since it was clear that wasn't going to happen with bento boxes for lunch, I looked for an alternative and

found a great one—an Italian restaurant! I started piling on the pasta and within days, every piece of clothing I wore was too tight. By the end of month two, I was back on a plane for L.A.

It wasn't the Japanese culture I didn't like; I never had five minutes to experience that. It was the grind, pure and simple, and a sense that my body was not my own. But to be fair, the payoff was, well, the payoff—I left with thousands of dollars, which certainly helped equalize that first experience and lured me back to Japan again. I brought back home so much money that I duct-taped cash under my clothes. It took going back to Japan on tour with Scott, and a little leisure time to actually look around, before I truly understood the beauty of the culture, its traditions, and its people—and the nutritional wisdom of the bento box.

Soon after I got back—in June 1993—I was involved in a huge Calvin Klein event at the Hollywood Bowl, a charity gala to benefit AIDS Project Los Angeles. Nearly five thousand people attended. Some of them (the big-ticket donors who sat in the box seats) were treated to special "picnic" dinners complete with white linen tablecloths and rosemary chicken. Tina Turner was the featured entertainment, but first came the fashion show, with a long runway that stretched nearly 150 feet into the middle of the audience. All together there were more than three hundred models in the show—among them Kate Moss, the famously tattooed Asian model Jenny Shimizu, and Mark "Marky Mark" Wahlberg. Rehearsals went on much of the afternoon, during which a lot of champagne was poured and more than a little pot smoke rose into the air. As the audience began to settle in their seats, everybody backstage was pretty happy.

Some of the models would be wearing Mr. Klein's fashions for women, some would be wearing fashion for men. I was one of the few girls who had two looks, which was a great honor for me. For the first walk down the runway, I wore a long dress and tried to hold my own next to Cameron Diaz, who's taller, blonder, and stops traffic whether she's on a catwalk or a sidewalk.

For my next walk, I'd be wearing men's boxer shorts. Only boxer shorts. I had very long hair—that, and my arms crossed demurely over my barely-theres, comprised the entire top of my ensemble. I don't know if it was the champagne, the pot, the moon rising into the Hollywood Hills, the flashbulbs, the audience full of famous faces, or the short Brooke Shields video they ran just before the opener, where she once again uttered that famous line about nothing coming between her and her Calvins—but I had a case of galloping bravado, fueled by liquid courage. I was ready to rock my walk.

Mr. Klein stood just near the runway adjusting each model before we hit the runway. But there wasn't much adjusting to do when I stepped up—the only thing between me and Calvin were my Calvins. "I'm not sure I need to keep my arms wrapped around myself like this. Are you?" I asked. He smiled, said nothing, then sent me on my way.

I got maybe twenty-five feet down the runway, took a deep breath, and dropped my arms. Lightning didn't strike; instead, a slow roll of scattered applause. As I neared the end of the runway, I realized that on either side of the catwalk were two giant video screens focusing closely on each model in the show. Two topless Marys, four naked barely-theres.

A few moments later, Mark Wahlberg famously dropped his Calvin Klein jeans and grabbed his white-underwear'd crotch (which

had been famously displayed on the Times Square Calvin Klein bill-board). The *Los Angeles Times* later called it "the skivvies segment" of the event. People hooted and hollered and applauded. By the time Tina Turner took the stage, they were dancing in the aisles, dancing on the stage, and dancing in the wings.

The event made all the newspapers and raised a lot of money for AIDS research. Initially, some accounts got me confused with the far more well-known Kate Moss—we were similarly built and had long hair—which then earned me more modeling work. One magazine editor that I still run into tells the story to anyone who'll listen.

FIVE

trouble

When I first moved to L.A., I spent a lot of time alone in the models' apartment. Most of the girls were there only for a few days or were looking for a place of their own. Few were my age, and since I wasn't going to high school, I didn't do the hanging-out-with-girlfriends thing; mostly, I slept when I didn't have a job to go to or watched MTV all day and night. In fact, I watched anything that was on, far into the night.

Living in front of the television set changed

soon after I turned seventeen, and Kristen Zang and Ivana Milicevic came into my life.

Kristen, a model and aspiring actress from Lake Orion, Michigan, came to the models' apartment the day after my seventeenth birthday—a happy anniversary we still celebrate, seventeen years and counting. I met Ivana (born in Sarajevo but also raised in Michigan) at around the same time, at a callback for a music video, one that required appearing in a swimsuit.

I didn't mind wearing a swimsuit or lingerie for an actual job, but I was never comfortable walking around less than half-dressed at a cattle call or an audition, so I'd concocted a strategy for any casting that required it. "Gosh, the agency didn't tell me about that," I'd say, wearing my hopeful smile instead. "Should I go home and get one?"—knowing full well that nobody was actually going to tell me to do that. Ivana, I learned, felt the same way—she hadn't brought a swimsuit, either.

This time, the casting director was adamant. "No swimsuit, no audition. Sorry."

Quickly agreeing that neither one of us could afford to walk away from a potential job, Ivana and I both stripped down to bra and panties (simultaneously). We didn't get the job, but we walked away laughing, with the beginning of a strong friendship.

We both pulled that "I forgot my homework" trick for years—in fact, I still do. Recently, I was asked if I was interested in going on a call for a nurses' uniform catalog (in which "show up in a bathing suit" was never mentioned). Work's work, so in spite of having a two-baby body now, I gamely went off to the audition and walked into a room full of leggy teenagers in tiny bikinis, standing in a long

line hoping for the opportunity to show their books and their assets. I mean, seriously—have you ever met a nurse in a bikini? If you have, you were on the set of a porn flick.

Ivana, Kristen, and I were soon going to the same castings together and quickly earned a reputation not only for cracking ourselves up, but for turning sessions into comedy routines. "We sort of knew none of you was right for this," the casting directors often said, "but it's always fun to see you."

Any pretense to being glamorous artistes or disciplined professionals went out the window. We were kids, and we acted like it—stayed out late, got up late, ate junk, had no fitness routine, and one of us (that would be me) sometimes smoked enough pot to give contact highs to the people who handed us our burgers and fries at the drive-thru windows.

Our first meal of the day was usually at the Sunset Grill on Sunset Boulevard near the Guitar Center. If there was anything on that menu that wasn't a negative for cardiac health, I don't know what it was. Even worse, we had to sneak past the modeling agency to get there, whistling the theme song to *Mission: Impossible* and hoping we wouldn't run into anyone from the office. We'd put away egg-and-cheese sandwiches, race back home, clean ourselves up, then jump into Kristen's little white convertible VW Rabbit for our various appointments. In a business full of rejection, we managed to laugh it off when it happened, as though we had nothing better to do that day than hit Burger King. Once back home, we'd watch MTV until it was time to go out for the evening, then begin the nightly ritual of getting ready. We changed outfits at least three times apiece before deciding on the final result, put makeup on, wiped it off, then put it

on again, all the while cranking up the volume on the radio or Luis's boom box—hip-hop was generally the pick: Gang Starr, Nice & Smooth, and 2 Live Crew got plenty of play.

One night, in an effort to assist me with my ongoing quest not to look like a child, the girls came up with a genius idea for giving me boobs—they balled together a mountain of cotton balls and taped them to my chest; over that, I put on one of Kristen's bras, and we stuffed it some more. Then we added bronzer down the middle of my chest, basically drawing on cleavage. One look in the mirror and we laughed so hard the tears rolled down our cheeks. That was one look that never left the apartment.

Once we were ready, we headed for the Roxbury, Saturday Night Fever, or the Formosa. A friend of ours, Brent Bolthouse, then an up-and-coming promoter (and now a major club owner) held a dinner every Thursday night in the restaurant section of the Roxbury, charging us only ten dollars. If you didn't have the cash, you could go to Brent's house during the day and stuff promotional material into envelopes to earn it. Dancing was our main exercise (of course, drinking canceled out any health benefits). Odds were good that we might find ourselves dancing next to Prince, or across the floor from Madonna. This was pre-paparazzi, pre-TMZ, pre-tabloid reporters going through your trash. Sometimes a photographer you knew would ask to take a picture and would give you a copy if you asked. It was fun and relaxed—nobody was going to speed down the street when you left, trying to take a picture of your crotch with his cell phone. Big names rarely go out for the fun of it anymore (photographs are either taken at staged events or by playing "gotcha!" at the grocery store), and I feel a lot of compassion for the kids who do. The paparazzi ruined L.A. nightlife.

One night Kristen was sitting by the open window of the models' apartment when Nicolas Cage (whose assistant lived across the street) walked by and started a conversation. Nic's career was already in high gear; *Moonstruck* had come out five years earlier, and he was working constantly. That chance meeting turned into a long-term relationship for Nic, then twenty-eight, and Kristen, nineteen, and it took the Girlfriend Shenanigans Show bicoastal.

Since all three of us had modeling agents in New York, when Nic would go there to shoot a film, we would go along ostensibly for our work as well, staying in whatever five-star hotel suite the film project was paying for, sleeping late, ordering room service, and coming up with trouble to get into at night. In L.A., the house that Nic and Kristen lived in together, up near Beachwood Canyon not far from the Hollywood sign, looked like a castle. In the bedroom there were remote control curtains that turned the room pitch black when closed, no matter how much the sun was shining outside. If Nic was out of town working, the three of us went out all night, came back to the castle, piled into the giant bed, hit the blackout shades, and slept half the next day away. "If there was a sleeping event in the Olympics," Nic said to Kristen once, "I don't know which one of you would win the gold." When we finally woke up, we'd intercom downstairs for someone to bring us breakfast—because the house looked like a castle, we'd order Count Chocula cereal (it had a certain logic at the time).

Nic had a lot of guests at the castle, and one night Jim Carrey was among them. He glanced at a glass-doored cabinet, the top shelf of which held an ornate teapot and next to it a candlestick. "Oh, look!" he exclaimed after less than a second's thought. "It's the cast of *Beauty and the Beast*!"

Nic was a generous guy, but different from a lot of the other men we knew—intense, edgy, and not much interested in partying all night. He'd grown up inside the business—his grandfather was a famous movie music composer, his uncle was director Francis Ford Coppola, and Nic's dad was a literature professor. I admired him for dropping Coppola as a last name when he first started and not using it to open doors.

About my friends' private lives: L.A. was full of models, musicians, actors, directors, and writers. That's always been true, and most of the people giving it a shot are kids. From a distance, it can look glamorous (although reality shows are quickly doing what they can to change that perception), but in many ways, it was and is no different from any other workplace or even college campus—young people find one another. You make lifelong friendships with people who have the same goals and the same stresses that you have. You socialize and date and maybe fall in love with the people you meet. Relationships begin, they matter, and then, for all the usual reasons, they come to an end.

I loved going out with my friends, but I wasn't interested in having a boyfriend—a boyfriend was not part of my Future Mrs. Scott Weiland plan. Sometimes I went on a few dates hoping that something would happen, something to erase my feelings for Scott and the certainty that we'd be together. But I never had much success overriding my own emotions. It wasn't fair to waste anyone else's time, and I didn't want to waste my own. I knew I'd marry him, even when that knowledge had no basis in reality. I simply believed it.

But that didn't rule out guy friends, and as time passed, I made

some wonderful ones. Eric Dane and Balthazar Getty, for example, came to me as a pair. I was introduced to both of them when we were all out one night, and that was it. Eric and Balt were both getting TV and film work, and Ivana, Kristen, and I were all taking home nice paychecks. I think we found some form of comfort in not needing to put up an adult front. Four or five nights a week, we drank, danced, stayed at clubs until they closed, then we'd wake up the next day, do whatever we had to do for work, meet afterward, and start all over again.

I first met Guy Oseary (who now manages Madonna) when he was dating Kristen, just before she met Nic. I was going back and forth between California and New York for work, and sometimes stayed with Guy in L.A. He called me "Little Mary," and used to give me self-help books all the time. One of them was called *How to Be an Adult*. If he'd ever given me a pop quiz to see if I'd actually read it, I'm not sure I would've passed.

Sometimes, Guy and I had silly phone conversations in the middle of the night, our own version of "Name That Tune," where one of us would say the name of a band or a song, and the other one had to guess who it was, what it was, and what the label was. I was pretty good, but Guy had an encyclopedic rock brain—no surprise that he later ran Maverick Records. One night, we were on the phone well after midnight when suddenly he said, "Oh my God, Mary, your boy's on TV!"

"What are you talking about?" I asked.

"Scott. Turn on MTV, quick." And there he was. It was the video for "Sex Type Thing," Scott's first single. His hair was short, bleached blond, and the images in the video were violent and scary. He didn't

look like anybody I'd seen before. That didn't stop me from wanting to jump right through the TV screen.

There are people you meet who enrich your life; there are people you meet who steal parts of your life. And there are people you meet who, in one way or another, save you. Or, maybe more important, help you save yourself.

One night at Brent Bolthouse's birthday party, I was introduced to Anthony Kiedis, the front man for the Red Hot Chili Peppers, and we had a sweet, funny chat in the kitchen. I knew the band's music, and we spent nearly two hours talking about movies, too.

The next day, Anthony called Guy and told him he'd met a girl and was trying to find her. "She was staying here with me," Guy said, laughing, "but she left today to go back to New York."

The key to a long-lasting and deep friendship with a rock star is . . . never ever kiss them. Musicians are used to getting what they want. If you don't give it to them, they'll stay around till you do. What can happen during this time is that, as God is my witness, you can become friends.

The first time Anthony called, I thought it was Guy tricking me. We spoke on the phone quite a bit and then he flew to New York, where I was staying in a models' apartment near the Empire State Building. When Anthony arrived, I answered the door wearing a white T-shirt on which I'd painted the word *trouble* with red nail polish. Attention, men: This is a girl's way of advertising the kind of girl she is. (Just for the record, the white T-shirt I was wearing when I met Scott was blank.) The plan for the evening was to meet Rick Rubin, the Chili Peppers' producer, for dinner.

When we got down to the sidewalk, Anthony had a slight look of horror on his face. Our chariot was a block-long stretch limo. He apologized for the ridiculousness of the car and for being the opposite of rock. That was the beginning of our friendship.

And no, I never kissed Anthony. We became close, loving friends. A few years later, he would be a major part of my addiction recovery. Had we never met, I don't know how or if I could've eventually found my way. Anthony often drove me to twelve-step meetings, and we stayed in touch through my various attempts at sobriety. Just hearing his voice over the phone gave me enormous hope on the darkest days—I knew that he'd been where I was and that he'd found a way out. What I didn't know was that during the times that I thought he was working or on tour, he was still struggling with his demons. It wasn't until I read *Scar Tissue,* his autobiography, that I understood that all the while Anthony was being my true friend, his own soul was being badly shaken.

I met Steve Jones backstage at a Sex Pistols concert in 1996, just before I was heading to Japan again. The Pistols were about to start the international leg of the Filthy Lucre reunion tour, and Steve and I kept in touch by phone.

If Steve had not been a musician, I believe his career calling would've been comedian. While I was in Japan, his calls often pulled me up out of weariness and the blues and into helpless laughter. When the tour came to Tokyo, I was right there waiting. I saw every show from the side of the stage. And I'm somewhat sorry to report this, but as far as I knew at the time, there were no crazy Sex Pistol antics that took place on- or offstage—I guess that will happen with age.

The Japanese kids were a sweet audience. I'd never seen calm and gratitude at a punk show. When the bus got back to the hotel each night, there were always fans waiting for autographs and pictures. One night, Steve was nearly finished signing and taking pictures when he suddenly told everyone to be quiet. The crowd hushed, at which point he let out what I'm guessing was the biggest, longest fart in Japanese history. For a moment, there was silence. Then Steve laughed, I laughed, and everyone else laughed. There have been many reenactments since that day.

The most exciting activity you can do with Steve is eat. We are a perfect match in this department. It should be televised. We've been in deep middle-of-the-night conversations and suddenly decided that Thanksgiving dinner would be delicious. At four in the morning, we're at Jerry's Deli asking for extra gravy.

As much as I love how funny he is, the best part of Steve Jones is his honesty and openness. There is no man behind his curtain— he has no curtain. Listening to him talk about addiction was the first time I understood that it was a disease. Not one that I had, of course—it took a long time for me to acknowledge that, and Steve's not a finger-wagging, lecture-giving person. But he doesn't bullshit, either. He's walked the recovery walk for many years and quietly helped countless others along the way. When I was in and out of treatment centers, he was a rock. Steve will always be there for you if you really want it—you just have to know that you're not going to get the soft and sweet version of him.

I jumped to Wilhelmina Models, a bigger agency that represented many of the most visible and popular models of the time—icons

like Lauren Hutton, Beverly Johnson, and Janice Dickinson, and beginners like me and Rebecca Gayheart, who would later marry Eric Dane.

Much to the distress of some casting agents, I was not growing into the size of my feet—I was stuck at five foot seven at a time when nobody wanted to look at anybody under five foot nine (thank God for platform shoes). Nevertheless, I was getting work in print and in so many music videos that I lost count—a country artist, a French singer, a rock band, Belinda Carlisle, k.d. lang. I was making two to five thousand dollars a day on a regular basis, and when I booked jobs for Estée Lauder and Max Factor, the fees went to twenty thousand or more. Paris, Milan, more trips to Japan—my passport was getting a workout.

I was smart enough to know the odds against my success. Supposedly, the industry average was something like sixty auditions to get a callback (and that wasn't even the guarantee of a paid job). For every job I booked, hundreds of other girls were rejected. Only three years after my stint at the Burger King in Lakehurst, New Jersey, I was making more money than either of my parents would ever make combined.

My booker at Wilhelmina, also new to the business, was Jeff Kolsrud. Although the entire agency worked on my behalf, Jeff became my point person, the one I checked in with every day—which got easier once I moved out of the models' apartment and Jeff and I became roommates. He also became my mentor, my other brother, and as dear to me as Kristen and Ivana. It was as though I had reconstituted my family. The little house Jeff and I shared was not a crash pad, it was a home, and my need for order was something he shared as well. When my statements came from the agency, he sat with

me as my mother had done when I was a little girl, helping me go through every item, every charge. He understood every aspect of the business that up until then I hadn't paid much attention to—as long as the money came in, I spent it. If I ever wanted my own place, he said, that had to stop. Jeff had a sense of the future that I didn't have, and he wanted me to start planning for it. His own future would be a big one: he is the creator and owner of Q Model Management in New York, founded in 1998 and now one of the hottest agencies in the country. He developed *Models NYC* for MSNBC; he became an activist on behalf of the homeless, Gay Men's Health Crisis, and the Central Park Conservancy—and a couple of years ago, he and his partner, Franco, welcomed their baby daughter into the world. That little girl has the best outlook on life of anyone I've ever met. When she wakes up in the morning, the first thing out of her little mouth is "I happy."

Jeff teased me mercilessly about oversleeping, about staying out until dawn, and especially about my model-challenged diet, inform- ing me that putting potato chips *on* a bologna-and-cheese sand- wich rather than simply next to it was not exactly creative gourmet. "You're getting a little roundy," he said in the gentlest way. "I'm not sure how much longer you can use the 'growing girl' excuse."

Jeff even taught me how to drive—on weekends, he went with me to the empty CBS Studios parking lot on Fairfax and Beverly, and took a lot of deep Zen breaths while I struggled to master the intricacies of "drive" and "reverse."

I knew I had Jeff's affection, but I valued his judgment and wanted his respect. I tried to keep the worst of my increasing wild- girl behavior far away from our friendship, but when the cycles of depression would roll in and I couldn't manage to get myself out of

bed, it was hard to hide. When I finally got my own place and spent more than the rent on a great big soft bed with linens as beautiful as the ones I'd first slept in at the St. Regis, he teased me about that, too. "I'm not sure it's a good idea for you to have a bed that's even tougher to get out of, Mary," he said.

The Holy Grail of print for a model is *Vogue* magazine, and in particular, *Vogue Italia,* the Milan-based magazine that every advertiser, fashion editor, and modeling agent thumbs through religiously. Appearing in *Vogue,* I knew I was where a lot of girls wanted to be— certainly where I could never have imagined being. Nevertheless, in the middle of a shoot in Paris, surrounded by makeup artists and special lighting, wearing beautiful clothes, having my makeup done by artists who were as important on one side of the camera as the photographers were on the other side, I felt hollow and frightened. The feeling intensified when night came and I was alone in a foreign country, going back to an apartment with shutters on the windows that kept out the light. I slept through my castings, fell asleep in the makeup chair, barely spoke with anyone during my shoots, and in spite of being invited out, I huddled in bed all day Saturday and Sunday. Finally, I called the agency and begged them to get me out of there. Where? they asked. I didn't care. A change of scenery, a different hotel. They shipped me to London.

I went to work right after I arrived; a few days later, I got a message from my booker at the London agency. "There's a phone call from someone on his way to London. He wants to know if you'll have time to see him?" It was Scott.

I may have been lonely and depressed, but I had one thought

and one thought only: Finally, *that man and I are going to kiss each other.*

I was working a fashion show the day we were scheduled to meet at his hotel. I stuttered through that first phone call. "I need some time to get back to my place and clean up," I told him.

"No, no, it's not a problem. Come straight here," he said. I walked into the hotel lobby in platform boots, a purple fur coat, and garish purple eye makeup, and was greeted by the somewhat alarmed stares from a bunch of men in Savile Row pinstripes. Moments later, Scott arrived in a leather jacket and pink hair. We went into the bar to catch up. It had been more than a year since we'd seen each other. I wasn't a little girl anymore; he wasn't my driver. We weren't best friends or old drinking buddies. For a while, I didn't know what we were. And I wasn't sure what to order, either. Scott suggested a Fuzzy Navel—peach schnapps and orange juice. Probably thought the girl could use something nutritious.

He told me all about the Stone Temple Pilots tour for *Core;* they'd been opening for Rage Against the Machine and Megadeth, playing to huge crowds and increased notice (some of it mixed) from the critics. They were getting more video play on MTV; VH-1 was beginning to be important as well. The rest of the tour in Europe would be about smaller clubs, connecting with fans the way they'd done in California, continuing to make the case that they weren't just "another grunge band," said Scott.

I tried to keep up my end of the conversation. *Vogue, Seventeen, Glamour* magazine, blah blah blah. Long awkward pauses in between. "I want to ask you something," he'd say, and then stop.

"Okay," I said. "What?"

"Wait a minute, I have to go to the bathroom. Be right back."

Then he'd leave. Then he'd come back. Then we went through the whole routine again. He wanted to ask me a question, I wanted to hear it, but wait, he had to get up and leave for a minute. I drank more Fuzzy Navels. There's such a thing as too much orange juice. Finally, I'd had it with his getting-up-leaving-coming-back routine; I couldn't stand not knowing for one more minute. "*What* did you want to ask me?"

"I want to ask you if I can kiss you."

We sat on a couch in the hotel lobby and kissed each other until five o'clock in the morning. I think the next hotel shift was coming in to work when I finally decided that he was being too much of a gentleman. "Do you want me to walk you to your room?" I asked.

We stepped into the elevator, and when the doors closed, we held hands until we got into his room. It was a tiny room—two twin beds, with only a small space between them.

San Diego girl that I was, and London being what it is, I'd been freezing all day and had many layers of clothing to remove. After waiting for each other as long as we had, we now had to wait through Mary Undresses Item by Item. First, the massive purple jacket; then the platform boots and the super-warm socks. Black leggings. Black tights under them. A black sweater, then a tank top. Finally, I was sitting on the bed in panties and a bra. It was almost dawn. I look back on those two exhausted, drunk people and I'm amazed that the man hadn't gone to sleep already. But no, there he was. He took off his T-shirt and handed it to me. It seemed a funny gesture at that moment. Looking back now, I think the T-shirt may have represented something more. Even though I knew that he loved me and that it was right that we were in that room, I don't think he was

prepared for half-naked Mary—I'd led him up to his room, I'd taken off all my clothes, and I found that I wasn't quite sure what to do next. We figured it out. Two grown people in a tiny twin bed. It's a good thing our intention was to be on top of each other, since that was the only choice. The only camera that matters is the one that is in my mind, and there is nothing about that night (or what was left of it) that I will ever forget.

I had a call for an English magazine the following morning, and in spite of no sleep at all, I made it on time, made it through the shoot, and love those pictures to this day. I was glowing and I knew it. I canceled work for the following week to be with him. We went out, we saw the sights, we clung to each other like ivy on old London houses. He had a couple of publicity interviews to do for the tour. I went with him, and gossip soon had rock star Scott Weiland spending time with some American child. "It was Europe, she was seventeen, and she was emancipated," he said. And, she admits now, she was completely delirious.

I didn't ask about Jannina. I assumed they weren't together. Naive is an understatement. I didn't want to know. I didn't want to hear about anything in the real world. And I really didn't want to hear Scott telling me he had to leave London to head back to Miami to appear on MTV's *Spring Break*. "Germany," he said.

"What?"

"After Miami, the rest of the tour is in Germany. Meet me in Germany. Then the tour goes to Italy after. You can be with me then, too." And then he was gone.

The MTV appearance took it all to another level for STP, and meanwhile, I had crashed again, back to having only two speeds:

Scott and off. I crawled into a hole. I surfaced only long enough each day for weepy transatlantic phone calls.

I showed up in Germany the same day that the guys did, and what happened next was a little reminiscent of the Beatles' film *A Hard Day's Night*—not in terms of the impact of the tour, but the comedy that took place around the romance. The two DeLeo brothers, Robert (bass) and Dean, were sharing a tiny hotel room; Scott was supposed to share one with percussionist Eric Kretz. But Kretz had to pile in with the DeLeos to make room for me (he'd had to do the same in the London hotel, poor guy—he was always having to move out for me). The guys were all riding on the adrenaline that their success and the publicity had earned them; I was riding on the adrenaline of big love. They could've been angry or resentful at my presence, but instead they were warm and welcoming and incredibly kind.

Scott and I hit all the pubs, we saw all the sights, and we held hands everywhere we went. This was boyfriend/girlfriend stuff, and sometimes I thought my heart was going to fly out of my chest with joy.

The rest of the trip was on a double-decker tour bus, with bunks up top and a couple of seats up there as well, where we sat and watched the country go by. There was no such thing as privacy—if Scott and I wanted to be together, we simply squeezed into one of the bunks and I hoped, in my girl naïvety, that none of the guys would know what we were doing. It made no sense, of course—rock stars on a tour bus, and me praying nobody noticed the girl giggling in the top bunk. At one point, we were all watching a Led Zeppelin documentary together, and the unreality of where I was and the people I was with just washed over me. But the feeling wasn't "This

is just the most bizarre thing ever"—it was "This feels right. This is where I'm supposed to be."

I've come to understand that there are egos and resentments in every band (because what family doesn't have egos and resentments?). But these guys were funny. They could read one another and they loved one another, even on days when maybe they didn't like one another much. Meeting them when the band was just taking off was so much fun because they took nothing for granted and got excited about everything that was happening. My first impressions, formed on that tour, haven't changed much over the years. They're now older, wiser versions of themselves.

Watching Dean and Robert trade wiseass banter is the equivalent of seeing a Venus and Serena Williams match. Even now, I'm sometimes taken aback that they were raised in New Jersey. I'm not saying there aren't laid-back people in New Jersey, but Dean's whole vibe is San Diego beach town—he's always smiling and laughing, and really doesn't seem to give a fuck. That's my kind of people. In the words of his former wife, Juliana, "he's a charismatic guitar god to his enigmatic lead singer. And he's a nice guy."

The word that comes to mind when I think of Robert, who plays bass, is *vintage,* and not just because of his love for vintage things— amazing old shoes and clothes, and beautiful pieces in his home. But Robert looks as if you got into a time machine and landed in the fifties, and he was on a set, ready to shoot his scene in an old black-and-white movie.

Eric Kretz doesn't take center stage, but with impeccable timing (a very good thing for a drummer), he chimes in with something funny just when you're about to make the mistake of forgetting he's there. Scott and I think he's Owen Wilson's doppelgänger.

From Hamburg, the tour went to Frankfurt, then Munich, and after that, Scott and I were supposed to go on to Milan together—not only was it a stop on the STP tour, I had work scheduled there, and it's where my ticket home was waiting for me. But the STP show had been canceled due to weather. And Scott wasn't going back to Milan with me. I had to return by myself, he said, and I had to do it right now.

It turned out that Eric's wife, Shari, was on her way to meet up with the guys. And she was a friend of Jannina's. With whom, I finally realized, Scott was still very much involved. And now I was (literally) being tossed off the bus. It makes me shudder today to remember, but I begged. I wept and sobbed and shouted and begged him; I went to my knees, crying, "Don't leave me! Don't leave me." But Scott was adamant. It was as though something had hit a switch in him. I had to go.

The tour manager drove me to the train station in Munich; I sobbed all the way through the Alps, whose beauty was wasted on me. Once back in Milan, I crashed completely. I couldn't meet any of my obligations, I didn't show up at any bookings, and finally I rearranged my flight schedule and flew home without telling anybody. I landed in Los Angeles totally broke, leaving behind me in Milan and London angry modeling professionals. I wanted the big romance, I got the big romance, and now the big romance was a big mess. And so, as usual, was I.

SIX

black again

Scott's phone calls followed me home. She had been with him since the beginning, he said; often, she had financially supported them both. She never lost faith in him. He loved her; he loved me differently. How could he leave her now, just as what they'd both worked for was about to come to fruition? Couldn't I please be patient and wait to see how it played out?

Every one of these phone calls just made me feel more foolish. More stupid. I'd traipsed all over Europe after him, and during our last hours

together, I was on my knees begging him not to leave. I would've done anything to erase those memories from my brain; they were so painful, even shameful. I didn't know why I was expected to be understanding. I had a life, damn it. I had my own tiny cottage in Hollywood, just off Melrose, an even tinier studio in Manhattan's Murray Hill neighborhood, a good career, and family and friends who loved me. It should've been enough to sustain me until I either got over this damn man or figured out what was going on inside me that kept me feeling overwhelmed and stupid. So I went back to work. When I wasn't working, Ivana and Kristen kept me busy, and we'd added a fourth Musketeer to our shenanigans, Charlize Theron.

Charlize had been at Bordeaux at the same time I was. She was from South Africa (she and Ivana were a constant reminder to me that there was a big world out there that didn't necessarily revolve around Los Angeles), and from the beginning, she had a grown-up work ethic. Even in a crowd of crazy young people who were as competitive about having a good time as they were about getting work, Charlize never lost her way—she'd trained to be a dancer when she was a girl, and that fierce discipline stuck. She had serious goals back when I was still figuring out how to get across town, and she always booked more modeling work than any of the rest of us did.

It was my eighteenth birthday, and my friend Tony Hickox's brother James was directing a movie called *Children of the Corn 3: Urban Harvest.* I had been on a few of James's sets with Tony when he asked me to come visit this one. I gathered up Ivana and Charlize, and off we all went.

Tony and James were shooting a couple of scenes that had a

handful of people our age in them, and they asked us if we'd like to be in them. While the others sprinted to hair and makeup, I looked for some scenery to hide behind. Watching my friends so excited and focused, it was obvious that this was what they were born to do. I was a complete wreck just being part of a crowd (or, as I recently discovered on the credits list, "Young Woman 3").

Some time later, Tony tried to convince me to give acting another try. "It gets easier with practice," he promised. "How bad could it be?" He was shooting a cable movie called *Full Eclipse* and asked if I would play a young bride in a wedding scene with actor Mario Van Peebles (who with very good reason had been chosen as one of *People* magazine's fifty most beautiful people a couple of years before—nothing intimidating there . . .).

I was picked up from the makeup trailer in a golf cart, and on the way to the set I began to feel the familiar light-headedness; I was actually going to have to speak. The scene was supposed to be our exchange of vows in front of a crowd of guests. I only had a few lines, and most of them were short and easy to remember. Nevertheless, they were nowhere inside my head. I started, stopped, broke into a sweat, and began to sway a little. I could not get the words out of my mouth. Finally, Tony gave up. "Okay, Mary, how about this— no lines at all, you just stand there and look like a nervous bride." Now that I could do. Clearly, videos and commercials were more my speed—anything where I didn't have to talk.

I was flying back and forth between Los Angeles and New York for work on a regular basis, living out of a suitcase and sometimes not sure where I was when I woke up. One weekend in L.A., Charlize

and Ivana planned to go off to Magic Mountain for the day, but I had a bad case of the blues and didn't go with them. I didn't want to be cheerful or go play; it was all I could do to get dressed. I'd spend the afternoon at Charlize's and wait for the girls to come back.

Someone had given me two communion-wafer-sized ecstasy tablets—MDMA, a special kind of amphetamine. I'd heard this drug made you feel better than perfect. I wasn't looking for perfect, I'd have settled for all right. I turned on the TV, smoked some pot, then washed the first X down with a beer. Then I got up and walked to the fridge. Just as I got to it, I realized the floor under my feet was moving. When I turned around, hanging on to the fridge door for dear life, the entire living room broke into a million little squares. This was far from perfect, and it didn't come even close to all right.

Holding on to the walls, I worked my way back to the couch. I tried focusing on my breathing to relax, but with the room in checkerboard fragments all around me, it didn't work. Then a music video came on TV—Soundgarden's "Black Hole Sun" video. All of the actors in it were moving in slow motion, with demented gum-showing smiles—it looked as though their faces were dissolving. A man carried one of those doomsday THE END IS NIGH signs. One woman's smile haunts me to this day—her lips were ringed with a heavy layer of red lipstick, and the wider she smiled, the more her head was distorted. I doubt I'm the only one freaked out by this video, but even now, if I see it, I get a mean case of the heebie-jeebies.

Even odder, the Soundgarden video was followed by a Stone Temple Pilots video, "Big Bang Baby." In my hallucinating craziness, I thought this was perfect—Scott will save me! I sat in front of the TV and begged for his help. Not surprisingly, I got no response. Bastard self-important rock star. And then the room started to tilt. With

the last flicker of common sense remaining, I called Ivana's then boy-friend (whose name was also Scott, which seemed oddly promising), hoping I wouldn't get an answering machine. He actually answered the phone, I muttered some barely decipherable garbage, and then he heard the phone on my end hit the floor.

When he got to the house minutes later, thankfully bringing a friend with him, I was on the floor rolling around in bong water, having what looked like a seizure. All I can remember is that I couldn't stop moving my right hand; it was flopping around next to my head like a fish out of water. The two guys picked me up and put me on the couch, and for some reason started petting me like a dog. The seizure stopped, the arm flopping stopped. I calmed down. In fact, I felt just fine.

"You know what would feel really good right now?" I burbled. "A bath." As alarmed as Ivana's guy had been ten minutes before, he was even more alarmed at the idea of his girlfriend coming home and finding me wet and naked in the middle of an X trip. Appar-ently, there are still nice boys in the world. We compromised: fully clothed, I happily sat in the bathtub for two hours, letting the water run until finally the guys dragged me out. (It's sort of comical that the drug's previous marketing name was Empathy.)

When Charlize and Ivana got home, they heard the whole story. They were pissed off—my using drugs while alone scared them both. Nevertheless, they made me a sweet bed on the couch, soothed me into sleep, and that was, we thought, the end of that adventure.

I was half dead the next morning when I got a call from my agency—I'd booked a one-day cosmetic shoot for twenty-five thou-sand dollars. This was an amazing opportunity, the most one-day money anyone had ever offered me. My mind started racing, my

hands started to shake. I could barely get a cup of coffee down. Later that day, in the parking lot at the Santa Monica Mall, I realized I was having trouble swallowing and couldn't catch my breath. Convinced I was dying, I drove myself to the hospital, fervently praying the Oh-God-if-you-get-me-out-of-this-I'll-never-do-it-again prayer.

I suspect I'm not the only girl in L.A. to stumble into Cedars with breathing difficulties; the reaction in the ER was as ho-hum as if I'd come in with a bee sting. At first, I wouldn't admit to the ecstasy (high or straight, I always felt like a fool for using), but finally I confessed. The explanation: the muscles in my throat were constricting because of the drug, an allergic reaction that could've thrown me into anaphylactic shock. I left with a prescription for a muscle relaxer and sprinted for the hospital pharmacy.

The next day Kristen and I went to Cabo San Lucas. Sitting by the ocean in Mexico is always a nice way to pass the time. Add some Coronas and a few muscle relaxers, and you have a girl who's considering brushing up on her Spanish and never going north again. In every picture of me that Kristen took on that trip, I look like Gumby.

God got me out of it, but I didn't keep that promise.

Whenever I was in New York, I spent long, wonderful hours with Anthony Kiedis. We'd head for Tower Records, where he piled me up with music I didn't know and bands I'd never heard of. We walked through the flea markets in Chelsea on weekends and bought silly stuff, and we were always engaged in Anthony's endless search for the perfect French toast.

One September night in 1993 we went to *Saturday Night Live*,

where the host was the massive basketball star Charles Barkley and the musical guest was Nirvana, who performed "Rape Me" and "Heart-Shaped Box." After the show, we went backstage, where I met Courtney Love and Kurt Cobain for the first time. I'd never seen eyes like Kurt's—they were electric blue. After watching the live performance, it was hard to believe this reserved, sweet man had been the man onstage.

As Anthony and I walked through the city that autumn, somehow the subject of football cropped up and Anthony learned that I had never been to a football game. This gaping hole in my cultural history astonished him. "How can you never have been to a football game?" he said. "How can that happen in America? We have to fix that." We would go to a Giants game, he said.

Early on the morning he was supposed to pick me up, the phone rang. Anthony's voice, quiet and incredibly sad, was on the other end.

"We can't go to the game today, Mary," he said.

I admit it, I was disappointed. "What's wrong?" I asked.

"My friend died last night," he told me, his voice getting even smaller.

The night before, River Phoenix had died of an overdose, on the sidewalk just outside the Viper Room in Los Angeles. Reportedly, a mix of speed and heroin—a combination known as a speedball— sent him into convulsions and stopped his heart. As brilliant an acting career as River was predicted to have, he was also considered to be a gifted musician and composer. Anthony's heart was broken, and he wasn't alone.

Every time a community suffers a loss like that (no matter if it's a public figure or someone known and loved in private life only), we

all take the vow to learn the lesson and do better. It won't be in vain, everybody whispers. But everybody's usually wrong. Six months later, Kurt Cobain was dead, too.

Not long after that, Scott came to New York; STP was making an appearance on David Letterman's show (to support *Core,* which had already sold more than two million copies). They were also playing at the Roseland Ballroom the following night. He and Jannina had ended it, he told me over the phone. Could we please meet?

I would like to report that I was outraged, or that I told him in no uncertain terms that I never wanted to see him again, or that I said, "After that debacle in Germany, where I crawled on the floor? Are you serious?" Sadly—or happily—that's not what happened. My heart lifted at the sound of his voice and the idea of being with him. Once again, I thought, This is it. It's finally happening.

I didn't go to see the band perform; *Letterman* tapes in the late afternoon, and I was still working. Instead, we met at the Royalton on West Forty-fourth Street, where Scott was staying.

The Royalton was one of the first designer/boutique hotels, and everything in it, from the doormen's elegant black Armani suits to the pointy Philippe Starck chairs in the lobby, was unique. It was the strangest, space-age-iest hotel I'd ever seen. No flowered polyester bedspreads here, no lamps with plastic shades or towels so thin you could see through them. The beautiful bed went on forever, but the bathroom was barely larger than an airplane's—everything in it was brushed stainless steel, there didn't seem to be any spigots on the sink, and yet in the middle of it was a big soaking tub, room enough for two. And that's where Scott and I found ourselves later that

night, watching *Letterman* on TV when he introduced STP to perform "Wicked Garden." "Ladies and gentlemen, brace yourselves!" he said, and he rolled his eyes. It was fun to watch the band while the man I loved was right beside me in the tub.

We decided we were hungry and went downstairs to ask if we could have something like chicken. "We don't have any chicken," the woman said. "But we have duck." Oh, okay, we'll have some duck. And out came the teeniest little duck I'd ever seen. I had a moment of sympathy for that duck, and then I had a bite of it. Then Scott had a bite of it. It was one of the most decadently perfect things either of us had ever eaten. "We'll take more of these ducks, please."

We went shopping the next day, and Scott bought me a necklace with a tiny flower on it and a vintage red velvet dress. It was like a little girl's dress, and I felt beloved in it. I had a photo shoot that day (again, one of those sessions where thanks to the night before, I was glowing), and afterward, I went downtown to get a tattoo. I showed the necklace to the ink artist, who put the little flower on my right foot. Not long after I got the tattoo, the necklace broke.

The Roseland Ballroom performance that night was one for the Stone Temple Pilots history book—the guys came out dressed and made up like KISS, complete with white geometric face paint and long wigs of flying black hair. The room holds more than three thousand people, and from where I was standing, it seemed like most of them went crazy. Nobody could've predicted that YouTube would end up being the cybermuseum for these performances, but it's all right there.

I had a backstage pass to meet Scott afterward, but it took me a few minutes to work my way through the crowd. "He said you should

call him at the hotel," Dean DeLeo told me. What—he'd gone already? I must've misunderstood Dean. Or maybe Scott had misunderstood me? Confused, I went back to my own apartment—no Scott. I called the hotel, where he was registered as Clyde Clydesdale (the list of his pseudonyms included Mr. Pink, Steve Austin, and, for the two of us together, Phyllis and Willis McGillis). It seemed like it took forever for him to pick up the phone.

"I don't feel good," he said. "I think I've got the flu. You don't want to see me, I'm pretty sick."

"I can come over and take care of you."

"No, no, it's okay," he said. "I'm . . . really sick. I'll call you tomorrow."

But he didn't. Years later, he told me that was the first night he used heroin.

It would be another two years before I saw him again. Oh, but I heard the news: MTV Awards, a Best Hard Rock Performance Grammy for "Plush," a second bestselling album (*Purple*), an expanded tour, more appearances, general rowdiness and mayhem. And in September 1994 he and Jannina were married.

I learned of their wedding while standing in a parking lot, from a friend I hadn't seen in a while. Right in the middle of our catching up, she got a sudden look of concern on her face. "How are you doing, now that Scott's married?"

I asked her to repeat the question. This had to be wrong—how could it be that I didn't know until that moment? I'm thinking now that anyone who knew deliberately kept me in the dark. An act of kindness, I think. I hope. All I knew was, I had to get home. I ended the conversation with words I can't remember, excused myself, and began an aerobic speed-walk to my car, hoping not to throw up on

my shoes or scream so loud the parking garage attendant would be forced to call the cops.

I don't know how I actually drove home; when I got there, I ran through the front door and threw myself on the bed sobbing so hard I got dizzy. I cried for hours, I cried for months, I cried for nearly a year.

Longtime Stone Temple Pilots fans, Velvet Revolver fans, Scott fans—there is an infinite Internet world out there that knows the date of every appearance, every performance, every song the bands performed, every date they were late for, how big the crowds were or were not. They know when and where Scott and Dean and Robert DeLeo met; they know when it seemed as though smoke billowed out of Eric Kretz's drums, or what Axl Rose and Slash said, and what Scott said, and the song list of every CD. They're pretty sure they know what each song and every lyric mean. There are online links to every interview, every press release, every fragment of gossip or truth (and who's to decide which is which?). I know that even as I write, those fans are turning out to support the STP reunion tour.

I respect this kind of loyalty and knowledge (and I'm grateful for the kind of life it ultimately gave my family), but this was never the way I cataloged what went on between Scott and me. I didn't monitor the *Billboard* charts, I tried not to listen to the phone calls from management people or to worry when the guys were fighting or making up or creating something new. I simply fell in love when I was sixteen and stayed there for a very long time, while Scott pursued his dreams and I tried to pursue mine. I knew when we were happy, I knew when we weren't. I know now when we were healthy,

when we were in trouble, or when we were doing the best we could, together or separately. And I understood, once he'd married Jannina, that I had to stop rating my life in terms of where he was or how we were. There was no *we*. People coped with bigger hells than that every day. I had to get myself out of dream world and find a way to keep on moving.

I was determined to bury my sadness in work. Send me anyplace, dress me in anything, rearrange my body and hair anyway you like, put me in clown makeup, hang me upside down off the side of a building. It didn't matter, as long as I was moving and didn't have to think. With every assignment, I started out strong: get to a new city, meet a new photographer or clients, have great ambitions to show up on time, light up the room, and in general change my attitude—act as though I actually liked what I was doing. And then, three or four days, or maybe a week later, it would all slide out from under me. The black cloud moved in, the windows needed to be shuttered, I needed silence and darkness.

No, what I needed was some kind of help. I started asking my girlfriends—what do you guys think about this? Someone suggested a Chinese herbalist, who gave me a bunch of berries. Berries don't seem to work well for mood disorders. Mental illness plus berries just equals a snack.

The first real prescription I ever got for how crushingly sad I felt was for Zoloft. A girlfriend was going through a rough time, too—we both went to the same psychiatrist, who diagnosed depression and prescribed Zoloft. I'd been on it for a couple of days when I booked a bridal shoot. That wasn't my favorite kind of job to do—bridal shoots are all about the dress, and you stand for hours while they take the ripples out of the satin or move a fold so that the

light hits it and the shadow doesn't, and all the while, you're frozen from the waist down. But I knew the photographer, and the money was good.

Just before I left for the shoot, I got a phone call from my Zoloft-taking friend. "Dude, you have to stop taking that medicine," she said. "I was in the living room having a conversation with a friend and all of a sudden, I sharted in my leather pants!" Well, that's disturbing, I thought.

An hour into the shoot, I started feeling dizzy. And I suddenly knew I was going to be sick. "Get me out of this dress!" I pleaded, which was no easy task, since there were maybe fifty buttons up the back, with hooks and snaps and pins to make it fit. "Hurry, hurry, get me out of this dress!"

They did it with seconds to spare. I ran to the bathroom in my panties and bra and vomited. I splashed cold water on my face and tottered back to the shoot. "Are you sure you're okay to finish this today?" the photographer asked. They were on a deadline, it was all set up—I really didn't want to leave any more people stuck. So I stayed, nauseated, and did my best to not move, worried about what my tortured digestive system might potentially do to the white satin dress.

Had the doctor told us to expect these side effects? I'm not sure I asked. Nobody was Googling side effects (or much of anything else) back then; you just went to a doctor and got medicine for whatever was wrong. As it turns out, yes, vomiting and diarrhea were just two of the side effects; so were dizziness, confusion, vision problems, and a whole list of others. "I don't think you've been taking it long enough," the doctor told me when I protested. "Take it a little longer to get your body used to it. You may even be able to tolerate a bigger

dose." I could probably tolerate being shot in the foot, too, but I was damned sure I wasn't going to volunteer for it. No more Zoloft.

The next step in finding a solution was a sleep clinic. Maybe the reason I couldn't get out of bed was some kind of sleep disorder. That was an odder experience than adventures in Zoloft, and almost as uncomfortable. I went in, they took me into a little room, and they put electrodes all over my body—my head, on the ends of my fingers. There were wires everywhere; it was like watching the cable guy hook up a new television. "Now go to sleep," I was told, "and we'll monitor your brain waves."

Sleeping was the one thing I knew for sure how to do, but in that environment, sleeping was not happening. I was awake the entire night, I didn't close my eyes or even doze for one single minute. How can anybody figure out a sleep disorder if the subject attached to the electrodes can't actually go to sleep?

Finally, a doctor prescribed Prozac. This time, I stayed with it for a while, and it actually began to work. I felt stable, I felt somewhat relaxed. But I didn't want to do much. I didn't want to go out, I didn't want to dance, I didn't want to drink, and I had trouble being interested in anybody's conversation. On a scale of one to ten, I'd hit five, and I stayed at five. I didn't feel sick, I didn't feel sad—I didn't feel much of anything. In the middle of my own twenty-first birthday party, I found myself looking around the room and thinking, Well, this is pretty damn boring. So I stopped taking the drug.

It came as a nasty surprise to me a few years later, when I learned that antidepressants, when mistakenly prescribed for someone with bipolar disorder (which no one had yet mentioned to me

as a possibility), not only do not help with the depression half of the problem, they can often trigger mania.

Bipolar disorder is a cyclical mental condition produced by chemical imbalances in the brain that alter the function or structure of neurotransmitters—which are, for lack of a better description, the little guys that carry the cognitive messages back and forth. And when, for whatever reason, those alterations happen, the message doesn't come through, or it comes through wildly wrong. Think of a landline with static; think of a cell tower that gets hit by lightning and can't pick up a satellite signal. Think of the way the picture on your TV breaks into fragments when something goes haywire with the cable.

Bipolar disorder's mood swings can happen in different patterns and at various rates of frequency for different people—some rapid-cycle in and out many times a week, or even in a twenty-four-hour period. Some may only have one or two episodes a year. Some may not even remember the mania or qualify what they did as manic. Cut off your hair, drive 90 mph across the desert one night, stay up through the entire weekend cleaning your closet—how is any of that crazy versus just being really energetic? You dance on a table and get mad when everybody else wants to go home; you buy a house you didn't know you were shopping for. Hey, maybe it was a great party, or it was just a great house and/or a good deal—how do we judge the behavior, and who does the judging? In any case, there's an inexplicable mess there and sometimes you don't remember making it. All you know is you've crashed down the other side. There's shame attached to that; maybe people have been hurt by you, maybe something or someone is beyond repair. That's why, when life goes out of control and it is time to figure out a diagnosis, it's the depression that registers; the wild highs or erratic behavior often don't. So the

depression is what gets treated.

There are hundreds, if not thousands, of textbooks that explain bipolar disorder in all its various complexities, but put simply, it comes in two distinct types: Bipolar I and Bipolar II. Bipolar I is what most people think of when they envision manic-depressive illness: big, obvious mood swings, from manic peaks to depression valleys and back again. Bipolar II involves what's called "hypomanic" episodes—heightened creativity, lack of sleep, bursts of energy. That's not what people go to doctors for, of course, since it feels good to be that person who's working into the night, who makes beautiful things or thinks beautiful thoughts—that's not, in most circumstances, identifiable as "crazy" behavior. But serious, even crippling depression follows hypomania, and that's what happened to me. It's a complicated business, and everything can affect it—weight, stress, drugs, booze, hormone fluctuations, erratic sleep. Treatment varies and usually includes a combination of prescription meds and talk therapy. But first there's got to be a correct diagnosis (and there's no sure-thing diagnostic test for bipolar disorder as there is for cancer, diabetes, or high blood pressure).

And then, in addition to meds and therapy, a primary ingredient in treatment is consistency, something that had always been in very short supply in my life. Of course, I didn't know any of this then, but when the day finally came to figure it all out, it was obvious that both Scott and I had been walking a tightrope for a very long time.

When I left high school in the tenth grade in exchange for a life that seemed like more fun than Intro to Chemistry or British Writers of the Nineteenth Century, I didn't give it much thought—I just

jumped. Now I was making amazing money and leading what I'm sure looked like a glamorous life, but the question nagged at me: How long can you look at pictures of yourself? How much of your real life can you justify looking in the mirror and worrying about the size of your pores? Plus, no matter the size of the paycheck, I battled sadness as much as I ever had, and my constant criticism and nitpicking at my physical person just made that worse.

I thought I was smart enough to do something else, and Jeff Kolsrud had been on me for a long time to think about a Plan B in which the size of my pores might not matter so much. "There's a time stamp on modeling, Mary," he warned me. I knew I didn't want to be an actress, so I started looking around at what other people did for work and asking them questions. How did they get there, what was their job about, what did they like about it? Often, the question was turned back on me: What did I like?

I liked books. Ever since I first mastered Dick and Jane and their dog, Spot, I always had a stack of books on my bedside table; hiding in one saved me many times when I was traveling. *A Farewell to Arms, The Basketball Diaries, A Room of One's Own, The Great Gatsby,* Danielle Steel paperbacks grabbed while running through an airport. Once I borrowed a Dean Koontz book from my dad and ended up reading at least a dozen of them. Books—what could I do that was about books?

I enrolled in courses at Santa Monica College. I didn't have a high school diploma yet, of course—I hadn't ever really settled into my correspondence courses (ultimately, that wouldn't happen until I was pregnant with my first child and panicked about not being a high school graduate). But nobody asked me for a diploma. It was

just sign up and show up. I started light: Freshman English. Pre-algebra. Because I'd left school early, I was conscious of not knowing much, so I was always asking questions. To me, there is no stupid question, and in a classroom, that's actually an advantage. I didn't make a fool of myself with my course work—I showed up, I got the work done. I drank coffee all night long when term papers were due or when an exam was scheduled the next day. I actually did well, I got good grades, and it felt good. I remembered the notes from my teachers when I was a kid, all a variation on the same theme: "Mary is a delight to have in class, but she would do so much better if she could pay attention and stop fooling around."

The only plodding I ever had to do with a book was with *Moby-Dick*. God, I hated that book. When I neared the end, it occurred to me that the only reason I was reading it was because it's a "classic." I could not care less about what people think, I'm fairly certain I'll never be on *Jeopardy!*, and I just didn't care about Ahab and his damn white whale. So I put it down for good. (And for the record, *War and Peace* should be called *War and You've Got to Be Kidding Me*.)

I liked school; I liked being responsible. Maybe this was what normal life was like. Maybe modeling itself had somehow contributed to my depression. I decided it might be a good idea to just quit modeling entirely and find something else to do.

Charlize had moved from modeling to acting, and her career almost immediately took off. She was represented by United Talent Agency (UTA), one of the three big agencies at the time. I knew a couple of her agents, and I'd heard about UTA's training program. I thought, I'm a fan of wheeling and dealing—I've been doing it since I was a child. I know how to talk people into and out of things, I know how to read a contract, and I'd been managing myself since

I'd been emancipated; maybe I could learn how to actually negotiate one for somebody else.

Charlize arranged an interview for me, and I quickly began work on my "résumé." This was a tricky business, since my previous experience and education were somewhat lacking. So far, I'd taken only eight college credits—I had to pad that out a little. And then there was actual work history. Flipping burgers and scrubbing toilets seemed to qualify me only for more of the same, and I wasn't sure what modeling qualified me for. Moreover, my wardrobe of slips and baby doll dresses was inappropriate interview wear. I wanted this job. I thought it would bring me purpose and happiness. So I borrowed an Armani suit from Charlize and tried not to look nervous as I took the elevator up to the UTA offices. My generous friend was taller than me, and her grayish blue suit was too long in the sleeves and too long in the legs. I didn't look like a grown-up, I looked like I was dressing up as one.

While I sat in the lobby waiting for my interview, I picked up a copy of *Marie Claire* magazine that opened to a photo of me in a series of bathing suits, which I'd shot a few months before. I remembered the day I shot those pictures; I'd taken a handful of Vicodin beforehand. Vicodin gives you a feeling of comfort and warmth, it was just what I needed to get through a day when I was supposed to be basking on a beach. I put the magazine back on the table as though it were on fire. How would anyone take me seriously?

When I was called into the office for my interview, I thought fondly of that Vicodin. I had no doubt that the majority of people working there had walked through the same door with experience and education I couldn't hope to match. I was stunned when I was hired on the spot for UTA's training program—aka the dreaded

mail room. It was a Friday; they wanted me back on Monday. Maybe all that moving around as a kid gave me social skills I didn't know I had. Maybe the years of auditions and photo shoots, pretending to be someone I wasn't, added something to the picture. Or maybe it was because Charlize was their client, and they were doing her a favor. I'm going with the latter. Whatever, my cosmic bluff had been called: I had an actual job.

When I left the UTA offices, I sat in my car for at least ten minutes. What had I just done? Okay, maybe I could fake my way through "Mr. So-and-So's office, may I help you?" or calling the Ivy to make someone's dinner reservation, but real office skills? I didn't have any. I drove off, making a shopping list of everything I needed to learn in the next two days.

My first stop was Circuit City to buy a computer. I had never used one and couldn't type at all, let alone at the speed required. I called my friend Jody Britt and begged her to help me. She arrived on a mission of mercy. It turns out I'm computer-disabled—just figuring out how to turn the damn thing on was a challenge. Reading the manual was no help, and every time a program window popped up on the screen and said, "Are you sure this is what you want to do?" the only thing I really wanted to do was punch it.

I'd like to thank the creators of *Mavis Beacon Teaches Typing*, a CD-ROM typing tutorial. I typed until I couldn't feel my fingers, then I took a flying trip to the mall to buy a wardrobe that screamed, "I know what I'm doing and I belong here!" Then I went back and typed some more, cursing like a trucker at Mavis Beacon. It probably wasn't Mavis's intention that her students learn the whole damn thing in forty-eight hours.

On Monday, I started in the UTA mail room. The list of power-

ful people who've started in a Hollywood agency's mail room reads like a menu of Who's in Charge Around Here: Michael Ovitz, Bryan Lourd, Barry Diller, Jeffrey Katzenberg. People with master's degrees in business start in the mail room; people with advanced creative writing degrees start in the mail room. Lawyers start in the mail room. And it literally was a mail room (although e-mail and Black-Berry messaging have probably changed things since I was there). You sorted the mail, you delivered it, you learned who everybody was and how an agency works. You might even be asked to read a script and write a breakdown or summary of scenes and characters.

I was all fired up the first day I walked in there; within a few weeks, the black cloud was accompanying me to work. I had a close friend at CAA, another agency, and we were seen together at lunch. Someone told me there was a little buzz of gossip circulating: Was I spying inside one agency for another? I had a friend who was a film producer—he took me out, too, and half of UTA was at that restaurant. It was awkward, sitting a table away from my bosses. Someone asked about my friendship with Charlize, someone else asked why I wasn't modeling anymore. They were long days, every one like the day before, and at minimum wage. How did people actually live on this money? I wondered. Within three months, it was Japan all over again—I couldn't get out of bed in the morning, and I couldn't wait to get out of that job.

Oh, and somewhere in there I discovered cocaine.

SEVEN

not dark yet (but it's getting there)

Cocaine in Hollywood in the nineties was like a secret everybody was in on but nobody talked about. Somebody always had some, or knew someone who did, and I rarely paid for my share. Quickly, my share grew. It lifted me out of the depression and the stuck-at-five Prozac position, and into a more comfortable eight or nine. Or twelve. Or, what the hell, sometimes twenty. It helped me wake up; it helped me pay attention. When I was doing it, I wrote poetry and poured words into my journals. I lost weight. I went to

modeling jobs and everybody said I looked great. I wasn't flying, exactly—mostly, I was feeling for the first time in a long while that I wasn't living with one foot in a ditch.

I hadn't spoken to Scott in nearly a year. We led totally separate lives, we didn't know many of the same people, and no part of our routines overlapped. But I never stopped missing him or hoping that someday, in some way, our relationship would be different. The Scott stories were beginning to accumulate, though, and some of them were unnerving. Scott was unpredictable; he was melting down onstage. The second CD did well; the third was in some kind of trouble and parts of the tour were being canceled. Scott and Courtney Love were at the Chateau Marmont. The rumors were that they were together. I knew in my heart that they weren't. Vast amounts of heroin were supposedly being consumed. Driving in the car one day, I heard Courtney's voice on KROQ—106.7 on your L.A. FM dial—talking about Scott's arrest for possession of crack. He'd gotten a year of probation. I shook my head, took a deep breath, tried to bury my emotional response, and muttered, "That woman needs a day job."

And then he called me out of the blue. He was on the road with STP and wanted me to fly out and meet him in Dallas. "You're married," I said.

"We're not together anymore," he answered. "I need to see you. I'm going to send you a ticket." I resisted for five minutes, and then I folded like a beach chair.

I packed and repacked the same suitcase three times in as many days. The day before I left, I had most of my hair cut off. I know that in normal life, women get haircuts every day, but when your job depends on having long hair, it defies common sense to run out and

have it all hacked off. Looking back, I don't think my behavior was a result of anxiety; I think it was mania.

Scott sent an embarrassingly long white limo (the kind that usually hauls a dozen kids to a prom) to take me to LAX; another long white limo was waiting for me in Dallas when I arrived. The band was flying in from someplace else, and Scott would be arriving at the hotel after I did.

I went to the room, sat on the edge of the bed, and waited. I wondered why I thought this was a good idea. I wondered who was going to come through the door. I kept putting my hands up to my cropped hair. We were not the same people anymore.

When he finally arrived and wrapped his arms around me, all the familiar feelings came rushing back. But there was something different about him. He told me he was taking some kind of medication to block drug cravings, and he seemed just off somehow—tentative, careful. He'd always been somewhat quiet offstage, but the volume now was definitely turned down. Scott's blue eyes can turn to green, and they have a beautiful pattern, almost like Mexican tiles. I kept looking into them, trying to understand what was going on inside.

That night, we went out with the guys from STP to a strip club just outside Dallas owned by someone in the metal band Pantera. Strip clubs were never my idea of fun, but I thought I could stand it for a little while if that's what Scott wanted to do. What I didn't realize was that he had a minder at the club, a sober companion (as part of his court-ordered probation from his drug arrest), and that he wasn't even supposed to be drinking. I never saw the guy. I didn't know he was there, and Scott did his best to pretend that he wasn't.

I learned later that a sober companion is someone who's had a

healthy block of sober time—five, even ten years. Ideally, they're calm in a crisis, they've worked in a treatment center, they've had education in addiction treatment, and they're working with a supervising addiction specialist or therapist. They know, or should know, every trick an addict will try—it's a little like the underground computer hacker taking what he's learned and going legit. Or at least that's the way it's supposed to go. A movie studio or record company can insist on a sober companion as a condition of a contract. It's liability protection, and it's supposed to build a protective layer between the addict and temptation. It can strengthen sobriety, like a cast on a broken leg. But I've seen it backfire. Sober companions can get caught up in a celebrity's lifestyle and lose track of what the actual job description is. Suddenly, they're assistants and yes men, part of the entourage that gets inside the velvet rope. And sometimes, even when sober companions are seasoned professionals, it turns out celebrities have hired them just for show, with no real intention of working a program for recovery—the simple truth is, they're just not there yet.

When Scott kept asking me to go to the bar and order a Jack Daniel's and Coke and a plain Coke, I did it. They both came in the same kind of glass. When I got back to our table, he'd switch the glasses and drink the one with the whiskey in it. I didn't know that booze wasn't okay. Nobody said, "Here are the new rules of the road, and this is why we have to stick to them"—I'd have to learn that the hard way.

When the lap-dancing started, my skin began to crawl; as one girl lathered up for a shower scene, I looked at Scott and was relieved to see he didn't like it, either. We left and went back to the hotel. The following day, we went ice-skating at a local mall, which was a

comedy show all on its own—Scott skates like Scott Hamilton, and I skate like a girl who spent her formative years in flip-flops. That night, we went to a Social Distortion concert. Afterward, it was the same Jack-Daniel's-and-Coke routine.

At some point, someone mentioned his wife. The word went up my spine as though someone had applied a cattle prod. I was supposed to stay for another couple of days, but decided that if the word *wife* was still in play, I couldn't be there. I had no intention of revisiting my on-hands-and-knees-begging scene from Germany. I packed up and prepared to leave, and just before I did, I announced my new rule. "I don't want to see you until you can show me an official piece of paper containing the words *legal separation* or *divorce*. When that happens, please call me."

A few weeks later, the call came. "I've got something I want to show you," Scott said. When he arrived, he was thin, almost gaunt, and there was something in his eyes I hadn't seen before. He was holding a piece of paper in his hands. "Legal separation," he said. I had tried to imagine this moment in my head many times, but it had never looked like this—sad, solemn, even broken.

We went to Chateau Marmont, where Michael, Scott's younger brother, and a couple of their buddies awaited us in a suite. I'd never met Michael before. He was taller than Scott, with dirty blond hair, and kind of scruffy. Here, however, it was clear from the drug paraphernalia on the coffee table that these guys had been getting into trouble long before we walked into the room. Oh God, I thought. Someone here is going to die.

Logic seemed to dictate that Scott and I go to a bar across the street and score some cocaine, which we did, in one of the most disgusting bathrooms I'd ever seen in my life. Do a line on the toilet?

Hell, yes. When we got back to the hotel, Scott joined the guys in the other room, and I climbed into bed, trying my best to focus on one *Scooby-Doo* cartoon after another. I'd convinced myself that staying awake and being ready to rescue someone was my mission; concentrating on the cartoon would help me with that. Fortunately, I'd inhaled so much coke that there was little danger I'd fall asleep on my watch. My right mind had definitely left the building. I was stuck in a tape loop of simultaneously being high and being Florence Nightingale—the boys were on a tear, and I had to stick with them just in case someone went down.

Then we all pulled up stakes and moved to the Mondrian Hotel.

If you're rereading the previous couple of paragraphs, looking for the rationale that brings us to this point, you can stop now— there is no rationale. Paranoia is not even a strong enough word for the way these guys reacted to everything, constantly looking under doors for shoe shadows or out the window for anything "suspicious"; every time they saw a white van, they were convinced it was the FBI. We had to stay ahead of "them"; we had to move—and I had to save them.

The next morning, when something like consciousness hit me, I found myself alone in the bed; Scott was in the bathroom. I walked out into the sitting room, where Michael sat on the couch, his eyes closed, his head thrown back at a weird angle. His face was white, his lips were blue, and there was a kind of foam at the edge of his mouth. I knew what sleep looked like. And I knew that what I was looking at was not sleep.

"Scott!" I shrieked. "You've got to come out of there! I think your brother's dead!" There was no response from the other side of the

bathroom door. I ran to it and banged on it with my fists. "Come out now!"

We dragged Michael (who was six foot three, bigger and beefier than Scott) into the shower and turned on the cold water. We yelled at him and slapped him until finally he came to. "Hey, guys, come on," he said mildly, putting up one soaked arm to ward off the blows. "I'm fine. Jesus." It wasn't the response you'd expect from someone just back from the dead (well, maybe the Jesus part). Mostly, he seemed irritated that we got him all wet.

It was like a bad version of *Adventures in Babysitting*. I know now that every step I took was wrong, for me, for them. But I always had to learn everything the hard way—this would prove to be no exception. Finally, exhausted and scared, I left and went to Ivana's. The guys kept using. I'm not sure anybody noticed my departure.

I didn't see or hear from Scott for nearly a week, until he showed up at Ivana's. He arrived just as I was melting down old lipsticks. When the tube is nearly empty, you scoop out what's left into a spoon, heat it up, then pour it into a little sectioned pill box. I opened the door holding the burnt spoon full of melted goo, and Scott nearly had a heart attack. "What the hell are you doing?!" he yelled, at which point I almost flung melted lipstick into the air. He'd thought I was prepping heroin. "But I wouldn't do that," I insisted.

Being together one day was no guarantee we'd see each other the next. He'd go to the studio to write or rehearse, he'd go out for a pack of cigarettes—and that would be the last I'd hear from him until he reappeared. One day when he did (missing a tooth, wearing an ugly hat, and sporting a scraggly beard), he couldn't remember when he'd last eaten or slept. I gave him something so he'd calm down and sleep, and when his head hit the pillow, he was out for twenty-four

hours. He tossed, he turned, he muttered, and he sweat, soaking the linens right through. I didn't know that was not a safe way to go through detox. When he woke up, he woke up in withdrawal. And it was New Year's Eve.

"I'm supposed to be at my house," he said. "My brother-in-law is throwing a party there."

My brother-in-law were not words I wanted to hear. "Jannina's brother?" I asked.

"Yes," he said.

"Will she be there?"

"Yes," he said.

I was too pathetic to ask him to leave. I just wanted him home with me. I wanted a "happy" happy New Year's, but Scott was on his way home to his wife. Legal papers changed nothing, and I was right back where I started. Happy New Year's.

Early one morning, I was driving on the freeway, realized that I was driving high, and couldn't remember for sure when this particular coke binge had started or how long I'd been at it. I saw a black-and-white cop car behind me in the rearview mirror and braced myself for what was going to happen next. Nothing did. He pulled around me, passed, drove on down the road. This can't be good, I thought.

Charlize had purchased a big house in L.A., and it was scheduled to be totally remodeled while she was away shooting a movie. Because I was traveling so much, I'd given up my apartment and basically camped at this house whenever I had jobs in town. Except for a bed and my computer in the master bedroom, the house was

empty. Everyone who came over thought it was spooky, but in the beginning, the darkness, the stillness, the emptiness didn't bother me. It had a very Old Hollywood vibe; interesting people led interesting lives here, I thought. Sometimes at night I'd turn on the pool lights and go for a swim by myself—it was warm, like bathwater. *Someday I'm going to live in a big house all by myself and do what I want—stay up all night, sleep all day—and nobody will bug me or tell me what to do.* That had been the dream of that long-ago seventh-grade girl, riding her blue bike all over Coronado Island. Well, so, here I was, dream come true. Alone in an empty house, coked-up, driving stoned. Not exactly what I'd had in mind. Suddenly I was deeply afraid.

Anthony had been sober for a long time, and I felt closer to him than I did to my dearest girlfriends, who I'd so far managed to keep in the dark about what I was doing. And so I called, looking for him, asking for help. But he was out of the country. His tour manager, Louie Matthieu, was my friend, too, and well along in his own recovery. When I told him what was going on, he said he was on his way.

When Louie got there, I was huddled on the floor in one of the many empty bedrooms. He drove me to his own home, where I sat in his living room with his wife and new baby while he made some calls. "This is how it works," he explained. He would take me to a place where I could detox; from there, we'd find some kind of rehab setup. He drove me to the Exodus Recovery Center in the Daniel Freeman Marina Hospital in Marina del Rey.

Because I'd checked in at night, no one from the counseling staff was on duty. Sitting at the nurses' station, I went through the first step in the process, what they call "intake"—answering questions

about my general health, my family history, a list of whatever drugs I'd been taking. I didn't think the list was all that bad until I actually started to recite it. Xanax, for anxiety (from more than one doctor); Vicodin, thanks to the dentist (and my own trickiness with the written prescription, circling five refills); muscle relaxers, on a renewable prescription after the bad ecstasy trip that had closed my throat. And cocaine. A lot of cocaine. Oh, and I'd been drinking steadily, too. I was deep in chemical soup.

The detox meds they gave me (to reduce cravings and keep me from convulsing) threw me into reverse. I could barely move. And I still can't understand why anyone ever believed that overhead fluorescent lighting was a health-enhancing design decision.

Hospital decor—can there actually be a professional job description with these words in it? I've never met anyone who was thrilled about their time in a hospital or rehab experience, so why not do something about the dreary vibe? Beige and mud almost everywhere you look. No music, no color. No, wait, there is color: a pink hospital-issue blanket. Or a faded blue one. At the rates these places charge, you'd think they'd cozy it up a little to encourage you to stay longer.

Detox lasted a week; a few days in, I met with a drug counselor, but I didn't go to any twelve-step meetings. I can get better on my own, I thought—all I need is a place to rest. I was told that my next move would be to Impact, a rehab center in Pasadena. While I was waiting to be scheduled on the "druggy buggy"—the van that would take me there—a girlfriend, someone who was doing well in her sobriety, came to visit. "This is a good place to start, Mary," she said. "I know a lot of people who came through here. They know what

they're doing. Oh, and by the way, there's news about Scott. He's back at rehab, too—at Impact."

My brain lit up like the Fourth of July. I hadn't seen him in months, and now he was going to be in the same place I was going? Great. I'm there. I couldn't wait for her to leave so I could start packing.

Before she left, my girlfriend (wisely) told one of the counselors about me and Scott. Exodus called Impact (it occurs to me that this sounds like a CIA operation), and Scott was questioned about his relationship with someone named Mary Forsberg, a potential candidate for transfer from Exodus. He didn't shrug it off with a casual, "Oh, yeah, we dated for a while" response—he told them that what had gone on between us was serious. That did it. Impact was out and Cri-Help, in North Hollywood, was in.

One of the first barriers I hit at Cri-Help (after another round of questions about drug consumption, family history, and a litany of all the terrible things I'd ever done) was an assignment of chores. Mine was to clean the bathrooms. No, no, there must be some mistake, I don't do bathrooms anymore. "Everyone here has a job to do," I was told. "Your commitment to doing yours is a symbol of your commitment to sobriety."

"Well, then, I guess I'm just not that committed," I said. Five days later, I walked out the door, heading back to Charlize's big, empty house. I can do this myself, I thought. Besides, I knew where Scott was now, and I knew what I was going to do about it. His birthday was coming up, and after hitting a dozen card stores, I couldn't find a single one that said what I was feeling. So I made one: plain white, with a little sticker of a birthday cake on it. Inside I wrote "Happy Birthday, Baby," signed it, sent it, and waited.

A few days later, I was climbing the walls, wanting to use. As if on cue, a letter came from Scott, followed by a phone call. He said that he was in a sober living facility, and that he was ready to get clean and stay clean. He loved me and was so glad I was getting help as well. "They give me passes to go to AA meetings away from here," he said. "I've been going, and I want you to come with me."

Yes, I thought, this will be good—for *him*. If I go, it will help *him*. I don't know why I believed that dates at a twelve-step meeting (dates that often involved his sponsor or a sober companion) were romantic or formed a good basis for some kind of actual relationship. Whatever happened to dinner and a movie? But I'll take it, I thought. I'll take anything.

Scott's short-term passes from sober living (for meetings) became three-day passes, and no need for the constant escort anymore. One sunny day, we decided to drive up to Santa Barbara, to a seafood restaurant he liked. When we walked in the door, it seemed as though there were icy bottles of Corona on every single table. Just as we sat down, one of the busboys trundled in some cases of Corona on a hand truck and stacked them behind the bar. Each case had the word on the side of it, in big block letters: CORONA CORONA CORONA. "I'd really love to have a cold beer," I said.

Scott's eyebrows went up. "I don't think it's a very good idea," he said.

"Oh, come on, how bad could it be?" I asked. "It's not heroin, it's not cocaine. It's just beer! You can't get into trouble with beer."

Two hours later, we'd moved on to double Jacks and Coke. Three hours later, we'd hit every bar in Santa Barbara and closed the last one. Then we drove around looking for the inevitable dark city park or parking lot in search of the inevitable dealer. Like something

out of a movie, a transvestite hooker magically appeared and sold us her coke stash. We grabbed it and checked into the first hotel we found.

When morning came, it was a contest as to which of us looked more repulsive. I buried my head under the pillows. "Jesus, I can't believe we did this," Scott said. "Come on, we've got to get out of here. I have to go back and check in and hope nobody finds out." I felt physically bad and only wanted to go back to sleep. Scott, who was becoming a rehab veteran, felt guilty and ashamed at having blown it again. His status with STP was increasingly uncertain—a lot of tour dates for their third album, *Tiny Music . . . Songs from the Vatican Gift Shop,* were canceled. He was going in and out of his little rented studio to work on a solo album, *12 Bar Blues,* but he was sick, and getting sicker.

When I reread my journal entries now—most of them powered by cocaine or guilt or grief—I am both humbled and horrified by the false starts and wipeouts, the short-term bursts of optimism, and the fractured ego that asserts, over and over again, that pure will and "self" is enough to get the job done. I had modeling jobs, but my best self was not the Mary who was showing up. That girl had disappeared. I didn't much like the one who'd taken her place.

LOS ANGELES, 1-13-98, 12:37 A.M.

Scott was missing for a while and then he showed up at my door two days before New Year's. His eyes were pinned, he was missing a tooth, he had a beard and weighed 148 lbs. The sick part about it was he still looked good to me.

We talked all night and at about five or six in the morning after he told me about all the things he was going to do to change and how much he loved me, he said he couldn't sleep and that he was going to take a shower. After about two minutes, I knew what he was doing. I asked him to come out of the bathroom (I was going to ask him to leave). He stood in the bedroom doorway with blood running down his arm. I wish he'd said that he loved me, but instead he just stood in shame.

I told him that both he and drugs were not allowed in my life in 1998. He asked me for help and we flushed everything down the toilet. I took him to get help. He was using again within eight hours. Someone called me last week to say that they were taking care of him and that he wanted me to know that he was okay.

LOS ANGELES, 2-4-98, 12:50 A.M.

I'm writing in pencil so that when I get better I can erase this crap life.

SYDNEY, AUSTRALIA, 2-22-98, 12:30 A.M.

I was eating lunch at a cafe in Bondi Beach and Anthony [Kiedis] walked by. Can you believe what a tiny world this is? Just three weeks ago he stopped by my house in L.A. to borrow a suitcase from me. I never even asked where he was going. These past couple of days I've had a horrible depression. I can't make it go away. There are things that are making me sad, but nothing should make me this sad.

SYDNEY, 3-28-98, 11:32 P.M.

If misery loves company, why don't I have any friends? I want to go home so bad. I'm trying to stick it out and get over this

*depression. I'm eating like a pig. I'm going to try and be anorexic.
I'm sure it won't work, I can't even miss breakfast without freaking
out. I hope to get out of this slump soon.*

SYDNEY, 4-6-98, 10:40 P.M.

*I'm having trouble keeping my weight down. The anorexia
didn't work for me. I couldn't even miss a meal. I read an article
on Scott today; it was really sad. He's so out of his mind. I'm happy
not to be with him for once in my life. I hope he doesn't die.*

SYDNEY, 5-5-98, 11:34 P.M.

*I'm going home in three days. I did not work well here at all.
I couldn't figure out why the girl next door was working so much
and then I found out she's sleeping with photographers. If that's the
way it goes, I'm happy not to work. I've been a little sad this week
and I've tried to make myself feel better with food. It was working
until today when I realized all of my clothes are too tight.*

LOS ANGELES, 7-7-98, 1:20 A.M.

*This world is trying to suffocate me. I'm sure of it. My teeth are
moving. I feel they are trying to escape. Even my body parts want
nothing to do with me.*

LOS ANGELES, 12-6-98, 10:18 P.M.

*I hate to say this, but, God—what have you sent me to love?
This man is insane. A bunch of us went to the Chateau Marmont
last night but it was boring so we got in the limo to go home, and
Scott told me that he took some codeine and drank a small bottle
of vodka. Then I told him that I took some Vicodin. Then he*

confessed that the last time we fucked up he took ten Vicodin and not three. So I told him that I've drank and had some Vicodins, too. So there you have it. We both suck. We convinced ourselves that since we already fucked up we could finish a bottle of Jack that was in the car. We drank it and then had amazing sex. When we got home he decided that since he fucked up this much that we should go downtown, come home, light candles, and have an "experience." I cried and begged him not to, but then we were in the car. For twenty minutes we drove around looking. Finally, some guy came over and took Scott's $100 and gave him shit. Then these gang- bangers threw a bottle in the car and it hit me in the arm. I told Scott to drive fast, but he still wanted to score. More bottles started hitting the car. He finally got the idea, but he still didn't want to go home. I freaked out. I was scared, and my arm hurt.

eight

EIGHT

the chaos tour

Scott and I flew into New York for Fashion Week in the spring of 1999 to see the fall shows and shoot for a few random magazines. It would be good publicity for both of us, his managers and my agency agreed. As usual, the road to hell began with the best intentions.

It was the first time either of us had ever experienced that mass of photographers in our faces, blinding us with flashing cameras. After the first show, on the way to the next one, we exchanged The Look and detoured back to the hotel, where

for the first time we enacted a little road show that would replay itself many times before we finally closed it down.

Looking as adult as we could, while also trying to give the appearance of two people in need of medical attention, we went to the front desk and asked if they could call us a mobile doctor. Then we went back to our room and waited. It was too much, that waiting; we literally started jumping up and down with excitement. You'd have thought we were five years old and it was Christmas morning. Quickly, we put together the plan, because working doctors is not easy. You need to have a script for how you're going to squeeze drugs out of them, and it helps to have a wingman in on it with you; it's the you-lie-and-I'll-swear-to-it school of scoring.

After what seemed like the longest hour, the knock at the door finally came. As is usually the case, an older gentleman carrying an old-fashioned black doctor's bag walked in and introduced himself. "So, which one of you will be my patient today?" he asked. In a ridiculously hoarse voice, Scott introduced himself as the patient.

"Problems with your throat?" the doctor asked, and Scott began the script we'd worked out. He's a singer, he says; we've been on the road for a long time, he's nearly blown out his vocal cords.

Then I chimed in. "I also think he's coming down with something—everyone else in the band has been sick. We're the only two left that haven't gotten it."

Every time, the doctor does the same thing—opens up his Mary Poppins bag and pulls out the little flashlight and a thermometer, shines the little light down Scott's throat, comments about his glands, then scolds him about smoking.

Next scene: time to take the patient's temperature. During the exam, I always made myself busy, returning to the conversation just

as the thermometer's going in. Mary makes small talk, a naive and innocent girl in the big city. Where's the nice doctor from? How long has he lived in the city? Did he raise his family here as well? Oh, my goodness. "Can you believe this weather?" All during this charade, Scott was working to kick up his temperature. Sipping a hot beverage helps.

Eventually, the doctor broke out the long-awaited prescription pad. Every time, they'll write you something that's just not gonna do it. Knowing that, I usually said something like, "Scott, don't forget to tell him about your allergy." That's Scott's cue to sidestep generic cough syrup and request hydrocodone instead—a muscular cousin of my childhood codeine cough medicine, guaranteed to provide that warm, everything's-gonna-be-fine glow. Watching the doctor write out the prescription always fueled the manic feelings we were trying so hard to keep a lid on. It's going to happen, it's going to happen.

You'd think one bottle of liquid codeine would be enough for us, but no, here comes the second act: Scott directing the doctor's attention toward me. "My girlfriend hasn't been feeling well either," he said, concern oozing from his voice. "Would you mind taking a look at her since you're already here?"

Just like that, our roles are reversed: Scott's making pleasant small talk, I'm warming the thermometer in my hands.

Once the prescriptions were written, we couldn't get the doc out of the room fast enough. Humming like high-voltage wires, we sat through a ten-minute wait until we were certain he'd left the building. A quick call to the front desk locates the nearest pharmacy—we have been known to run there and walk in circles while they're filling the scrip. "No, no, we'll wait right here for it, thanks."

Rushing back to the hotel, I was always close to vomiting, knowing the fix was that close. I remember sitting on the edge of our bed, each of us with a bottle in hand—a quick "cheers!" and half a bottle goes down the hatch. Lying on the bed holding hands, we'd spend the next few minutes dreamily staring at the ceiling. You always want to save a bit for later, for when you can feel your limbs coming back to life and you don't want that to happen.

When you think you can get up without throwing up, it's time to move in the direction of more trouble. We were staying within walking distance of Bowery Bar. A designer had invited us to a party there after his show, and the place was crowded with models and celebrities. But we did not come to mingle or exchange air kisses with famous people we didn't know; we came to see who might be holding. It was a good crowd for shenanigan hunting. I'd spent a large chunk of my modeling career in New York, and although I'd never used drugs there when I was working (except for the occasional joint), I'd always kept company with the shady crowd. I had a pretty good idea of any number of people who would steer me in the right direction. In minutes, I bumped into an old friend whose career was very hot at that time; in fact, he was the main attraction of this particular party. Scott was never shy about asking around for a drug connection, but we were both surprised when this guy turned out not just to be the information source, but also the supplier.

We took off for the men's room and hid in a stall. They gave me a small bump of coke, which combined with the codeine cough medicine put me into an immediate state of happiness. Paying no attention to what the guys were saying or doing, I was very busy having my own conversation in the fast lane of my head. When the guy broke

out another bag of white powder, I waited for my turn—but then he put it away. "Hellooo?" I protested. "I didn't get a second go!"

"It's okay," said Scott. "I'll find you something else, Mary."

"I don't think so," I said. Getting shut out, waiting for another connect, was not acceptable. I lost my temper—spectacularly.

Taking my arm, Scott steered me and the disagreement out to the street, explaining that the white powder was a mixture of coke and China white heroin. "That's too much for you. It's too dangerous," he said. Under most circumstances, a reasonable person would've been grateful to the lifeguard. Me, I felt cheated. I threw a right cross at Scott's jaw. "You're a fucking drug hog!" I shouted.

I think this may have been the first time I really scared the shit out of him. This sweet little girl, whom he'd shared a front seat with in his beat-up old Chrysler boat for so many months who barely ever spoke a word the entire time, had just punched him in the face. We were both learning that mania and drug use was not a smart combination for me. I look back on that moment with horror—what had made me so angry? The thought of coming down? Deep outrage that my soul mate was putting himself between me and another round?

Moments later, we were back inside Bowery Bar. We found our friend again and we all decided to leave together; he brought a young Slavic model with him, very tall and beautiful. I have no clue what they're feeding those girls in the Eastern Bloc, but they are astonishing freaks of nature. Poor thing, she had no clue what was about to go down. Outracing the sober companion, we bolted into a cab, headed for the Four Seasons, and the four of us checked in. Then we raced to the room.

To this day, I believe those two guys shorted me on my share. I

felt another wave of being high, but nothing like I'd expected, nothing like I'd wanted. The four of us stayed up all night, talking and talking until the evil sun came up. In an instant, it was clear that the day before us was going to be ruined and torturous. We knew Scott's people were frantically looking for him, and he was going to be in a shitload of trouble for ditching his sober guy. The cell phones were ringing like crazy; turns out that the minder had already headed back to L.A. on our original flight (the one that we'd already missed). Time for Bonnie and Clyde to head home.

I tried to take the blame by having Scott tell everyone that I'd gotten really sick that night; reluctantly, they bought it—or they didn't want to deal with the truth. Nobody wanted to admit what they knew. Nobody ever does. A car service came to get us, and we pulled away from the Four Seasons with shame and regret. Not quite enough shame and regret, however; after check-in at the airport, when we were told that our flight was to be delayed a few hours, we went straight to the American first-class bar and started in with Jack Daniel's. When the announcement for boarding finally came, we literally stumbled to the gate.

While getting settled, I recognized Patrick Demarchelier, one of the most celebrated photographers in the world, sitting a few seats in front of us. He was craggy and handsome, a legendary French master of bringing beautiful images to the printed page. I was standing (barely) a few feet away from a man who, under normal circumstances in my business, was almost impossible to meet—if you did, it meant you were at the top of your game. I may have been drunk, but I wasn't stupid. It wasn't likely that I was going to introduce myself to him that day. How did I get to be this girl?

My solution was to order champagne. Unfortunately, I promptly

spilled it all over Scott, soaking his pants. The flight attendant brought him a blanket, and he stood up, dropped his drawers, and wrapped the blanket around him like a skirt. A few moments later, the pilot announced that due to mechanical reasons, this flight was canceled. Everyone gathered their belongings and headed for the exit. I watched as Patrick Demarchelier walked off the plane and away. I knew that I would never find myself in front of his camera. It was the death of a dream—not the dream of becoming a famous model, but the dream of any success at all.

Even now, every time I fly American, I can't quite shake the images from that day—a half-naked, blanket-clad Scott and me getting off the plane, calling for our car, impatiently waiting for it to come. We drove into the city, back to the Four Seasons, and started all over again.

After we got back from the catastrophic trip to New York, I was tired and ashamed. I went to the gym, I went to AA meetings, Scott and I went to meetings together, we finally moved in together. It didn't matter—the roll had started.

I came back to the house one afternoon and there was Scott with Ashley Hamilton. They did a kind of slow-motion "uh-oh" move when I came through the door. I glanced at Scott's face, then moved close enough to actually look into his eyes—pinned pupils and a look of dim, enviable bliss. I was tired of being shut out of what he was feeling. Within hours, we were sharing the same belt, tightening up the veins in our arms, and slamming back against our chairs like kids in the first car on a roller coaster. The Chaos Tour was on.

It happened almost the same way every time. We would leave

the gym and go for coffee. On the drive home, without fail, one of us would comment on the weather. "Why does the sun feel so good today?" The sunroof was open and Guns N' Roses' *Appetite for Destruction* played over and over in the background, just loud enough to work its way into our subconscious and hit the switch that got us going. Especially "It's So Easy": "So come with me / Don't ask me where 'cause I don't know." But I did know, and so did he. One of us would break the silence and casually suggest El Coyote for lunch. It's not like we can get into that much trouble over lunch, right? An outdoor patio. Sunshine. Maybe a margarita. Or two. The music got louder, the car went faster, and somewhere along the way, we had magically changed direction—downtown, to score. After that came the race to get home. Every light on the way turned red, every street was a detour. It took forfuckingever. Once we got there, we ran as though the hammers of hell were behind us, when in fact they were straight ahead.

Flying through the door and diving onto the big green couch was step one of the ritual; the couch was velvet, the color of grass, and it was so big that two people could lie on it and there would still be plenty of room. Step two was dumping everything out of the brown paper bag onto the wooden coffee table. Step three: Scott would bring me a framed Neil Zlozower photograph of Keith Richards; I'd lay out the goods right on top of Keith. I have one vein on my left arm that was made to make love to a syringe. It almost never failed (and the few times it did, I was generally on my way to rehab anyway). Wrapping my skinny little black belt around my skinny little arm was the final step before countdown.

I've labeled myself a Type A addict: everything had to be perfect. I've used with other addicts, users I'd classify under Type D for disaster. They are messy in prep, plunge, and enjoyment. Next to get-

ting high, prep was my favorite part. After Scott taught me how to cook, it was my designated job, and I did it well. The apt pupil was now the obsessive-compulsive manager—how to use, what was a safe way to use, how to get into trouble without getting into trouble. I know now that OCD was involved in how exacting I was about the step-by-step, but looking back, I think I felt safer being the one in charge. At one point, I even wore a heart rate monitor when we were shooting speedballs, and I insisted that we stay hydrated with Gatorade and put down a Power Bar every day. Or every other day. Sometimes, a day would pass without my knowing it, and then I'd insist we try to eat two. As if that would've made any difference to whether we ultimately wound up dead or not.

The little house we lived in (near Melrose and La Brea) was filled with odd artifacts. Scott called them accessories; I called them crap. The minute the drugs hit, it all came to life. Lying together wrapped in green velvet, we watched the house and its contents morph into some kind of dream. There was a cow's skull—after the initial rush, when we were able to open our eyes again, we would both look at the skull. I don't know why we ever bothered to ask each other "Do you see them yet?" because they would appear at exactly the same time for each of us—beautiful white doves, flying out of the skull and into the living room. Lying there with my arms wrapped around Scott watching the doves dance brought me peace; until my children came, this was the calmest I had ever been.

Once the birds flew away, we walked around the house looking for other objects to fixate on. The wooden Buddha in the dining room floated; the candlesticks danced. Experiencing these moments, looking forward to them—that was enough to keep me hooked and coming back for more.

But for Scott, every beautiful experience was almost immediately followed by something dark and frightening. After the sense of calm passed, he'd get agitated—he knew what was coming. He often said he had a lonely, desolate place inside him, and that no matter what he did, he inevitably ended up there. I wish I knew why our experience split into two like that. He would travel down a dark path, then I would follow him and try to turn him around. Sometimes I succeeded, sometimes I failed.

Not long before we were married (in May 2000), we went to Maui for a prewedding honeymoon. One night we watched the Robin Williams movie *What Dreams May Come.* I apologize in advance for spoiling it for anyone who's never seen it, but it's overwhelmingly sad; first, a couple's two children are killed in an automobile accident, then the husband dies, then his grieving wife dies sometime afterward. The husband, safely in heaven, learns that his wife (who'd committed suicide after his death) is in hell. The love he has for her transcends time and the reality of their deaths; to save her, he leaves heaven and goes on a journey to hell. We cried through the whole thing, and like a glutton for punishment, I cried through it again just recently. This time I was overwhelmed by sadness from losing Scott and our marriage, but it wasn't the old, familiar I-could-never-live-without-you feeling. It was a realization: Following Scott through the darkness felt a lot like searching for someone in hell.

And then at some point, he started following me.

There's a point where being high is no longer about being high at all—it's about being really sick and the frantic need to get the drug into your system to stop the sickness from getting worse. Between

doing that, and doing that again, you spend hours being paranoid, looking out the window, having hallucinations. I know there are a lot of people who get high on a daily basis but still manage to get something productive done. That wasn't us; we were watching a TV that wasn't even on, convinced it was a program about insects.

Per court order (from a whole series of probation violations stemming from the crack possession in 1995 and another bust in 1998, with each judge warning "one more time"), Scott was again spending his nights at a sober living house, and his days holed up with me. He'd get up in the morning, do a group meditation and the house chores, then be the first man out the door. I'd be waiting around the corner. The drive back to Hollywood is fifteen, maybe twenty minutes, but it felt like an hour.

Once we got home, we'd immediately use anything we had left or wait for our dealer to come by and do a drop. At the end of each day, Scott would make it back in time for curfew with seconds remaining and do a monitored urine test with clean pee we got from God knows where. I spent most nights after he left sitting in front of the bathroom mirror staring at my pores until the sun came up. Sometimes my friend Stevie (a woman Scott had met through Maria, one of his dealers) would come and keep me company. She was a stripper, not usually the kind of girl I'd hang out with, but she was kind and funny—besides, everyone else seemed to have disappeared. I was grateful for the company. The thought of dying alone with a needle hanging out of my arm was too pitiful. Or maybe what I really wanted was the assurance that there'd be someone there to call 911 if I went blue. Probably not such a good idea to invest my rescue faith in Stevie, given the night she shot up in my shower and came very close to dying there. The water had been running forever and

after she stopped answering me, I broke into the bathroom to find her lying on the floor, naked and seizing. As we'd done with Michael, I pulled her into the cold shower until she finally came to. I was so unhinged that I spent the rest of the night picking at my face. By the time the sun came up, I looked like I'd been attacked by a swarm of mosquitoes.

The first time I ever met Scott's stepfather, Dave, came during the worst stretch of our Chaos Tour. I'm not certain how long we'd been getting loaded, but long enough so that the modeling jobs had dwindled away; I'd gone from pretty to pretty scary-looking. This particular day, Dave was in town from Colorado, and he and Scott had made a date to play golf with Michael that afternoon. It was crucial that Scott come directly back from golf to hook me up again. We were out of dope; he swore he'd take care of it and get back on time. When the doorbell rang, Scott was upstairs in the shower, and I was on the bedroom floor having a mad anxiety meltdown. I went downstairs, opened the door, and there stood a giant of a man: six foot three, a former football player for Notre Dame. I can't imagine what he saw. I hadn't slept or eaten in days. My arms were scabby with track marks and looked like they should've been attached to a corpse. My eyes were barely open. For all I know, most of our first conversation together was conducted with my eyes closed.

Meeting your boyfriend's parents for the first time carries a lot of stress. Add try-to-pretend-that-you-are-not-a-junkie pressure and you have a girl whose head might blow at any moment. Dave came in and sat down on the big green couch while I ran up to get Scott out of the shower. I never went back downstairs. Dave was sitting on the big green couch, we'd run out of drugs, and of all banal things, Scott was heading for the golf course.

The minute they left, I felt nauseated. I took a clock into the guest room and lay down. Every once in a while, I pried my eyes open and looked at that clock. As time went by, something was kicking me in the stomach. The kicking was soon accompanied by sweating and nausea. Hours passed and no Scott. The stomach-punching became so intense that I curled into the fetal position and held my breath as wave after wave went through me. I'd done my share of bargaining with God during bad trips and excruciating hangovers, but this time, I truly thought I was going to die. I went to my hands and knees on the floor, but not in prayer—instead, I went from one room to another, checking the wastebaskets, peering under the furniture, hoping to find a used needle, convinced that even a drop of dope would've helped. Unfortunately, Scott and I never left a drop behind.

I crawled back to the guest room to what I thought would be my final resting place and waited. I swear I heard the key turn when he finally got home. I screamed some version of bloody murder, begging him to help me. It was the fastest Scott had ever set up a rig for me, but it seemed like forever. Still lying on the guest bed, I could barely sit up while he fixed me. The reaction was immediate. Even before he finished, I felt new again.

I have so many vividly ugly memories like this, sometimes they all run together in my head like a Worst Nightmares Film Festival: showing up for a Disney catalog shoot and becoming convinced halfway through that my face was melting off, leaving in a panic and waking up behind the steering wheel about twenty minutes later, going west on the 134 freeway at 55 mph; attending a Fourth of July party with Scott at Leo DiCaprio's in Malibu, both of us pale and sick, wearing long sleeves to hide the track marks and barely able to

talk. I'd been to the dermatologist's the day before, and my face was such a mess from picking and scratching. I got a shot of cortisone and a bandage over the worst spots. Scott told him I'd been bitten by spiders. If we'd been less wrecked, we'd have noticed that most of Leo's guests were going out of their way to stay out of ours.

The first red carpet we stepped on as a couple was in mid-1999, for the premiere of the second Austin Powers movie, *The Spy Who Shagged Me*. Scott sang the lead on Big Blue Missile's remake of the Zombies' "Time of the Season" for the soundtrack, so we came out of our drug-induced hiding. I was so out of it, I wasn't sure what I was supposed to do with myself while the photographers clicked away, so I stared at the carpet. It wasn't even red—more like seventies' orange shag. Something else did catch my attention: Verne Troyer—Mini-Me—being interviewed just to my left. Moments later, the crowd began to roar. Approaching the carpet to Scott's right was, drum roll, please: Mr. Bigglesworth, the hairless cat! I could feel my eyelids blink and blink again. Mini-Me, hairless cat. Mini-Me, hairless cat. I looked at Scott helplessly, telegraphing, "We've got to get out of here."

And then there was a modeling trip when I got cripplingly drunk at an airport bar in Atlanta and surfaced at a coke party in New York City, in a scary scene out of *Scarface*. There was a mountain of cocaine there, what I call movie-producer-quality cocaine. As soon as no one was paying any attention to it, I stole it and split. Then I went off on a street-by-street search through the city for a needle I could use to put it into my arm. Once I found one, I took my treasure into a diner, ordered a sandwich I knew I'd never eat, went into the bathroom, used the water from the tap, and shot up. For the rest of the night, I walked a few blocks, found another diner, ordered a

grilled cheese, headed for the bathroom, and shot up again. Repeat.
Repeat. By dawn, I was back in the models' apartment, sitting in the
bathtub and trying to scrub the stink off myself. I was also intensely
exploring my legs, looking for another usable vein. I showed up at
my *Redbook* photo shoot two days later, but I don't know how, and I
don't remember anything about it.

The days run together; the drugs run together. And the rehabs
run together, too. We each had a few more to go before we hit "sur-
render."

We'd made reservations to go into Exodus, for time number, oh,
who knows. We planned for an afternoon check-in, but when noon
showed up, we still had a lot of heroin and coke left. It's obvious
where I'm going with this—we needed to ride it out. Scott was cer-
tain it would be our last run and I played along. It's rare to volun-
tarily admit yourself into rehab without first running as fast as you
can into a wall, and that was our plan.

In spite of our compromised state, we at least had the courtesy
to call and let the nurse know that we were running late. We also let
the limo driver know that he, too, would not be needed until a later
time and could go until further notice. A limo to get to rehab? We
were such douche bags. Every few hours, Scott would ring Barbara
the nurse and let her know that we were still coming. He didn't want
our beds to be given up. We were upstairs in our own bedroom, sit-
ting on the floor. When the imaginary ants had all marched away,
it was time to go again. It was the end (or so we kept saying), and I
wanted every ounce I could inject.

Before I could pull out the syringe, a strange ringing filled my
head. I touched the palms of my hands to my ears and the room
swayed like the floor was going to collapse underneath us—for a

split second, I thought it was an earthquake. I tried to focus my eyes on the heart rate monitor, but the numbers looked wavy. "Scott, something's wrong." He answered, I could hear him, but I couldn't hear what he was saying, the ringing was so intense. It grew louder, like a plane flying right overhead, and then everything went black.

Before I was completely gone, Scott was on the phone with nurse Barbara. He called her because he was too scared to call 911. She asked him a series of questions. "Is she still breathing? Is she responding at all?" I was breathing, but I wasn't surfacing. He lay down beside me and spooned me the entire night, never releasing me from his arms. I thought I was dying; neither one of us knows now why I didn't.

When morning came, he woke me up—it was time to make the trip to Exodus. He called for the douchemobile, we started to pack, and then we got high again. You'd think a near-death experience would make an impact, but it barely slowed our roll. We packed our rehab necessities as though we were going to Paris—feather boas and heels for me, one pair of checkered Vans for him, plus a three-piece suit and an assortment of hats. Except I only threw in *one* of my shoes, and Scott only threw in *one* of his. Packing for rehab when you're still wrecked is an exercise in nonsense: if it's July, you'll probably throw in a fur coat. We always had to send someone back to our house to pick up practical items like slippers, pajamas, toothbrushes, and something comfy to sweat in.

When the limo came, we still had drugs that needed finishing, so we stopped at a dive bar on the way to Marina del Ray, shot up the last of it in the car, then went looking for somewhere to dump the evidence. We found a huge Dumpster in back of the bar and tossed it all in. Then we ran into the bar for one last drink, and

crawled back into the limo. Just more than twenty-four hours late, we finally walked into Exodus hand in hand, our driver carrying our bags behind us.

Just before the Chaos Tour took off, Scott had begun seeing an addiction therapist at Promises Malibu. Her name was Bernadine Fried; Scott called her Bernie. He wanted me to come in with him. Well, if it will help *you*, I thought.

I don't know what I expected when I met her, but the petite brunette who greeted us was a surprise. My first assumption was that she most likely wouldn't like me or want me around Scott. I sensed that about a lot of people, and often I was right. Had Scott not liked her and needed to see her, I may have never gone. I had a wall of protection that I'd spent years building and not much energy for letting other people in.

Up until I met Bernie, every therapy session or twelve-step meeting that Scott and I attended together was based on my being the girlfriend or the appendage or, worse, the self-appointed watchdog. But this was different—the energy in the room was different. She looked at me, she asked what I thought and what I felt. She had a cool vibe; to some degree, I knew she knew me. She could see the road I was on, she knew how far I still had to go. She understood, as I did not, that Scott and I had more than our own demons to wrestle with—there was the business he was in as well. I was so lost in the fog that I didn't completely understand what Scott's fame was doing. He had toured across the country and around the world with STP; they'd made four multimillion-selling CDs, and his solo *12 Bar Blues* included collaborations with people like Sheryl Crow and Dylan's

producer Daniel Lanois. He'd accumulated MTV Awards, American Music Awards, and a Grammy, and a host of magazine interviews (positive and negative), all of them detailing his drug struggles, his arrest record, and on-again, off-again relationships among the guys in the band. And yet, stoned or sober, I continued to see him as the sweet guy with a beat-up car. Seeing through the eyes of love is one thing; getting it consistently wrong is something else.

After a few sessions on Bernie's couch, I started to feel okay there. She's pretty, and she has a soothing voice. Unlike other therapists and doctors who often had something negative or quirky I could obsess over (which then allowed me to dismiss whatever they were saying), I began to actually hear Bernie. She became a necessary part of our lives.

Bernie told Scott that in all the years she'd been doing addiction counseling, she'd never seen anyone go from zero to a hundred as fast as I'd done. "It's as though you started at Intermediate Addiction," she told me. "You've met your match," she told Scott. The two of us were stones dropped into water, she said, falling fast, drowning together. Slowly and carefully, she began to unravel our complicated family dynamics and the history of our addictions, both separately and together. We were genetically loaded for the hell we were going through, she explained. That didn't absolve us of responsibility—if anything, understanding it might possibly give us the beginnings of a road map out of hell. In time, she told us that she was in recovery from heroin addiction herself—nearly twenty years at that point. Uh-oh, I thought—no way to fool her. Sooner or later, she's going to call us on everything.

For a while, the three of us met together; as time passed, Bernie and I began to meet alone. When it was just the two of us, she didn't want to talk about Scott or his issues, no matter how I tried to turn

the conversation around to "What should I do about him? How can I help him?"

"That is for Scott and me to talk about," she said. "When you and I meet, we are going to talk about you. What you think and feel, and what needs to happen next for you in order to find sobriety and health." Scott and I were enmeshed, she said, as though we'd become one organism. In order to go forward, we had to become two separate people. That didn't automatically translate to breaking up or going in two different directions—it meant that I had to figure out who I was with or without him.

I wasn't sure about looking too closely at me. For so long, the only emotions I'd had revolved around Scott—wanting to be with him, happy when I was, grieving when I wasn't, worried when we weren't together, scared when he was away. Without this primary connection to define my days, what would I have? With no drugs to blunt or bury those emotions, who would I be?

Bernie referred us to a psychiatrist, whom we'll call Dr. Langford. His L.A. office sat many floors above the street. God forbid anybody comes in here with a height phobia, I thought the first time we went to see him. A long wall of floor-to-ceiling windows looked down onto the sidewalk; it felt like an enormous space.

In every doctor's office, I am fascinated by the books on the shelves. The titles are usually frightening or pitiful. *Women and Crime. Eye Movement Desensitization and Reprocessing.* After I've committed the titles to memory, I move my gaze to the wall art. Well, not art exactly; more like framed things on the wall. You know that TV commercial for weekend art expos at some chain hotel? I'm convinced that's where doctors buy their art. When your world is out of control, a framed print of a man and woman holding a para-

sol in a rowboat does not help. And no cartoons, please. I can find humor in nearly everything, but framed cartoons about sick people and their doctors are not funny.

The only things that lift my spirits in a doctor's office are the framed university degrees on display. I've even figured out some of the Latin. *Medicinæ. Chirurgiae. Summa Cum Laude.* I like visualizing my doctors during their college years. Younger, optimistic, working so hard, getting smarter every day, preparing to save my life. Dr. Langford looked a little like Ed Grimley, Martin Short's *Saturday Night Live* character.

Earnest and focused, leaning forward in his chair in a way that made me want to lean back, Dr. Langford said we had a stack of paperwork to process first—our medical history, our "current problem." What brings you here today? Everything. Everything brings me here. I sat on the couch as close to Scott as I could possibly get without actually sitting on his lap. We began with a series of questions, most of them specific to our past medications. These two lists were impressive for a relatively young couple; a casual observer might've guessed that we'd spent a large portion of our lives in pharmaceutical trials.

I don't remember how or when I first learned that Scott was bipolar—somewhere along the line, he'd told me. I didn't know exactly what it meant—it was simply part of who he was. A little bit crazy. Okay, a lot crazy. But I loved him, and if crazy came in that package, I'd deal. But when Dr. Langford suggested that I, too, was bipolar, I couldn't resist laughing. It was as though Scott had rubbed off on me—a simple case of love addiction! Bipolar? Ridiculous. Bipolar disorder made Scott creative and interesting and wildly unpredictable. Applied to me, it meant only that I was mentally ill. Depression I might've bought, and there was certainly plenty of evidence

for being a junkie—but I was not crazy. Besides, wasn't there something to be said for how we were young and brave enough to live on the edge? I saw this as an asset, not a weakness or a deficiency. Not everyone had the balls to live that life.

The degrees on the wall said this doctor was an educated man, so how could he make such a colossal mistake? Even I could see that my only real issue was my inability to separate myself from Scott. All right, I'd do what I could to kick the other drugs (maybe, sorta, kinda), but Scott was my main one, he worked fine, and I wasn't giving him up. And I wasn't copping to being mentally ill without a fight.

Carefully, the doctor tried again to explain what he believed was going on with me.

Bipolar disorder is no place for amateurs or self-diagnosis, and it's no place for denial, either. Scott was farther down this road than I was; he was exhausted, and he was scared—for both of us. "You went through thirty thousand dollars in one month, Mary," he said. "We're sick. We need to do whatever he says to get well."

Oh, well, that was different. If Scott was in, then so was I. We discussed the few medications that were available and with each of them came a long list of side effects. Awesome side effects. If a medicine has only one possible side effect, I'd bet money that I would experience it.

The first consideration with bipolar disorder is always lithium. At first, I reacted to that as though the doctor suggested that I go to a gardening store and consume rat poison. Like everyone else in the nineties, I'd read *Prozac Nation* and knew for sure that I was not the same variety of crazy as Elizabeth Wurtzel. Of course, I could relate to her depression and mood swings, but I was not mentally ill. I was

not insane. (Yes, an original poster of the movie *Frances* had graced my bedroom wall, but this was only because I had a love of genius filmmaking, not because I especially related to anything in Jessica Lange's amazing portrayal of Frances Farmer.) The list of lithium's potential side effects was a long one: tremors, dry mouth, diarrhea, sleepiness. Feeling tired. Not being able to get out of bed. Nothing new there. Tellingly, the one that scared me most was weight gain. A complete deal breaker. I'd rather be nuts. I'd spent my whole modeling career trying to lose that last five pounds; I was not interested in volunteering for an additional five. Or more likely ten. Plus, I'd need to report for blood tests regularly—something to do with checking my liver. This seemed too much like work. Nevertheless, I gave it a shot for a few weeks. The minute the weight piled on, the lithium went into the trash.

Okay, how about Depakote? It was an antiseizure med, the side effects didn't look so daunting, it might help. Yes, I told the doc, let's try this one. It occurs to me now that I probably shouldn't have been allowed to have a vote.

I'll never know if Depakote might've worked. I took it for a few days, and we relapsed again not long afterward.

The kicker for Scott was the night he took a pill he found at the bottom of his bag that he thought was Xanax, and it turned out to be naltrexone, an anti-opioid-craving med that (given the speed-balls he'd injected beforehand) plummeted him into withdrawal. He became violently ill and we sprinted for the hospital, where the ER docs gave him morphine to "calm down"; instead, it almost killed him. Where was I? Out in the parking lot, with a needle in my foot. When I came back into the hospital, I climbed onto the gurney with him, where we both passed out.

The next morning, both in wheelchairs, we were on our way to rehab again. For maybe the third time, our admissions counselor was Laurie, someone I'd come to think of as the Wicked Witch of the West. "Well, well, look who's back to visit," she said, her voice loaded with sarcasm, her hands on her hips like the parent who's just about to kick your ass. "It's our Scott and Mary."

Scott's behavior got him tossed out of his sober living residence, and since it was yet another violation of probation, put him in jail and on the court docket to deal with the long-pending criminal charges and a judge who was out of patience.

The night before court, I couldn't sleep, and my fear was as much about my own fate as it was about his. If he was sentenced to anything other than house arrest, I didn't know what I was going to do. There was no way I could make it on my own without using. When Scott was with me, I was a wild girl using drugs with her boyfriend. If he was gone, I was just a junkie.

I can't remember what I wore to court. I'm sure it was my best attempt at looking modest and demure, but the "what's wrong with this picture?" was the big coat I wore to cover my road-map arms. And then there was my hair, a very bad shade of blond, with pink tips. I have, and had, no explanation for this choice.

I don't remember the drive to the courthouse, how I got there, who drove. For a few moments outside, it was a dream; walking in the doors and through security made it real. As I exited the elevator, I was greeted by Scott's friends and family. His parents had flown in from Colorado, and countless sober people from the program had shown up to lend Scott support. I knew that most of Team Scott believed I shouldn't have been allowed in the building at all, that I was to blame for the probation violation, that if we hadn't been

using, he wouldn't be in a holding cell, handcuffed, waiting to hear his sentence.

I was blessed to have my own team—Balthazar Getty and Eric Dane. When Judge Larry Paul Fidler walked in, my stomach rolled. Scott had appeared before him previously, and it was clear by the expression on the judge's face that he was not happy to see Scott on this occasion. Balt and Eric stood on either side of me, each with a hand on my arm. They knew that if the day ended with Scott on his way to jail, the odds were good I'd fall to my knees.

A few people spoke on Scott's behalf. He had stayed sober since the day after his naltrexone incident, he had been attending meetings and working with a sponsor. Even the DA's office suggested that any sentence imposed could be served half in jail, half in a lockdown rehab. Judge Fidler listened carefully to everyone who spoke, but the air in the room felt like doom. There would be no easy way out; if there'd ever been a time celebrities got a free pass, it was over. Not long after this, Robert Downey Jr. was sentenced to a jail term as well. "Rules are rules," the judge told Scott. "If you break my rules, you go to jail." The sentence was a year, reduced by the thirty-five days he had already served. Eleven months. This leg of the Chaos Tour was over.

I'd never heard of a person leaving jail a "new person"—who would Scott be when he got out? He would be changed forever. And why was it that we were constantly torn apart? I was shaking like a leaf, so scared I couldn't cry. Eric and Balt stayed with me the rest of the day, but the little voice in my head grew louder. The voice that makes the plan for you and waits for you to follow. Toward the end of the day I told the guys I was fine and that I wanted to go home and sleep. I was loaded within hours; I'm not sure when I surfaced after that.

I was alone. I'd been ducking my friends, lying for months to Kristen and Ivana (and Charlize had long since decided to keep her distance); everyone I hadn't run from was running from me. So I called Ashley Hamilton, and we decided to run together.

That first day, we tried to get through just on methadone. We felt nothing. I called my dealer Martine and had him meet us near Ashley's new place, in the parking lot at the Yum Yum Donuts on the corner of Vine and Melrose. After that, I started heading to Ashley's every day. He lived in an Old Hollywood building near the Paramount lot, with renovated, old-school elevators. I'd like to point out how very slow an elevator can move when you need to get high and your pockets are loaded with heroin and coke. Ashley became my temporary partner in crime. He had a steady supply, and I knew how to make crack. This made for a great partnership.

After his sentencing, Scott was in the Los Angeles County men's jail for not quite a week, in a small cell apart from the general population. Then he was transferred to Biscailuz Recovery Center—jail and rehab, all in one. Ultimately, he'd do six months there. I visited as often as I could. The cleaner he got, the sicker I got, and the more clearly he saw me. I was so out of my head, I assumed that when Scott was released, everything would go back to "normal" and we would continue our Bonnie and Clyde run. But I was (finally) about to hit the wall, and Scott would never be my running partner again.

NINE

nine

swimming through cotton

Addiction is not a weakness of character (although if you're bipolar, it's statistically almost baby-and-a-cookie easy to fall down the rabbit hole); it's a recurring chemical disorder of the brain that creates both physical and psychological dependence. When researchers run a brain scan of a living addict's brain, the physical difference between how it reacts to the words *cocaine* or *heroin,* versus how a nonaddict's brain reacts, is remarkable. Long after he's clean and determined to stay that way, an addict's brain still reacts as

though he's traveling with the Weather Channel's storm trackers during tornado season.

Addiction is a liar and a cheat. There's no safe room in the addict's mind—ultimately, there's no place to hide. It's a lot like that movie stereotype of the gambler at the table who takes all your money and all your dreams, then shuffles the cards again. Even though you're naked and penniless and everybody you love has long since taken the train back to Normalville, you sit right back down and wait for the deal, dignity be damned. And then comes the point when there's no high to be found anymore. You run and run until finally, you run out. Ideally, you don't die before that happens, or lose, discard, or somehow misplace everything that ever mattered.

The first time you walk into a twelve-step meeting or a rehabilitation facility, nobody tells you how many times you're going to have to do it before you get it right. Nobody tells you that it will likely be two steps forward and one step back for the rest of your life. Nobody tells you that odds are, you will circle around endlessly and keep coming up against that First Step—admit that you are powerless over your addiction and that your life is out of control—until the day you finally stop selling yourself the same old bullshit story about your life. How it's a mess, but it's manageable, and anyway, you can fix it yourself. And even then, after you think you get it, you can still stumble and fall.

Full disclosure re: number of rehabs (mine): seven. Exodus; Cri-Help; Hazelden Springbrook in Newberg, Oregon; Vista Pacifica; Promises Mar Vista; return trips to a couple of them. The list is disturbingly reminiscent of all the schools I went to before the seventh grade. Over and over and over, I dragged my ass in and dragged it right back out again, until somewhere between six and seven, Scott

issued an anguished ultimatum—get clean or we couldn't be together. At that, what little light remained in my soul began to flicker back to life. Nevertheless, I went kicking and screaming.

Whenever I have a bad day, a sad day, a day in which I doubt how far I've come, or the memories get foggy around the edges about how hard I had to fight (or the memories have such gaping holes in them that I'm amazed a breeze doesn't blow through), I look into my two children's faces. And then, after I've tucked them into bed, I reread my journals.

HOLLYWOOD, 10-11-98, 11:22 P.M.

Today I escaped rehab. Some crazy institute called Cri-Help. Let me tell you, I cried help all the way out the door. I can't believe I lasted five days. I'm not paying a fortune to clean toilets. My janitor days are over. I promised myself many years ago that I would never clean a floor or toilet again. Therapy it is not. Previously, I was at Exodus to detox. Now, that was good times. They force so many meds down your throat and get you so high. You detox without getting sick. It was heaven for six days. I couldn't even lift a cigarette to my lips. They medicate you until you're nearly blind. One of my roommates at Cri-Help was a stripper from San Diego. It wasn't a total loss. At least I learned some moves.

10-12-98

I managed to get myself to two meetings today. I want to fight this so bad. We flushed my pills down the toilet. That was so depressing. This is so sad. There are so many drugs that I haven't tried. I'm ashamed to feel this helpless. I'm hoping someone will take over because I am exhausted from the ride.

10-16-98, 10:32 P.M.

I'm tired of writing, but they insist that I do it every day.

10-24-98, 10:37 P.M.

I'm still okay. Three days ago, I was ready to give up. I was going to hold out until after I saw my caseworker. Of course I was late, so I called to let them know. They told me that she quit. In my sick mind, this was a free pass, God's way of saying that it was okay for me to get loaded. So, with my pajamas still on, I was out the door, but God made me stop at the mailbox, and there was a letter from Scott. He wrote how happy he was that I was getting help and that he loved me very much.

EXODUS RECOVERY CENTER, 5-16-99, MIDNIGHT

It looks good for me here, but it had to get bad for me first. One drink turns into a drug. Only problem is, this time it turned into shooting heroin and coke and smoking crack. Things I never hoped to do and ended up loving. It makes me crazy, my mind is telling me to split, leave, and ruin my life. In the back of my mind I'm thinking, I'm not an alcoholic or addict. I do know that I am a fool. I'm in love with that high. I think about it all day. God, please don't let it ruin my life. Please don't let it ruin my life with Scott.

BACK HOME, 6-14-99, 4:24 A.M.

So I'm really needing some help this time. I'm sitting on the bathroom floor with my heart rate monitor on because I've been doing drugs all night and my heart feels out of control. I wish I

could stop this. This does not feel good. I'm scared. I keep talking to myself and I've thrown up so many times. Making matters worse I keep nodding off and falling asleep.

SPRINGBROOK, NEWBERG, OREGON,
6-19-99, 11:14 P.M.

New rehab. I'm feeling better about recovery this time. I'm doing everything I'm told. I'm scared that I'll go home when I know I should stay here. The cravings are so hard to get over. I hope God removes them from me. I couldn't sleep last night. I was sweating, cold, and crying because I hate to be here again. I hope I get it this time. I miss Scott.

BACK HOME, 7-18-99, 11:23 P.M.

Once again, I did not get it. I went back to Exodus with Scott, then I was sent to rehab in San Diego. My family knows all about this shit now. I wish they never knew. It's just one more thing for me to worry about. Scott got kicked out of his sober living house and now he has a babysitter. He signed a contract saying that he wouldn't see me until September 10. I think that he is probably going to jail. I hate him so much right now. I still love him, but I wish I didn't because he is killing me. Nothing in my life is working, not even this pen. I don't feel like making it through this. The noise in my head will never end. I will always be lonely even with the one I love. I am held prisoner at my own house in my own head. I really don't know what to do with myself. There is always the sadness of killing yourself. I couldn't handle the hurt I would cause my family. I almost can't be bothered

to relapse. I'm not the best chemist and I have no more places to run to. Besides, I'd have to take my head with me. If only there was a way to cut my head off and rip my heart out. Anything to keep that senseless organ from beating. Scott and I had one minute of chaperoned time together and a kiss. Time is playing a joke on me, creeping the way it does. Someone upstairs forgot to make me complete. Lately, I have been crying so much that I vomit. I don't recommend spending a summer this way. During the past summers, I have felt my best. Now this is my best. I FUCKING WANT TO DIE.

HOME, 8-16-99, 2:20 A.M.

Scott was taken into custody Friday. Friday the 13th. He has a hearing on September 3 and will be sentenced then. I think he may have to go away for a year. It's hard to stay strong and positive for him when I feel so sad and scared. I feel horrible for him. He is so sad and calls me every day crying. I wish I could help him. We have gone through so much. I wonder if we'll ever be a normal couple. My doctor has me taking lithium now. I feel kind of like a zombie, and I've gained weight. This drama is killing me. My baby is in jail and I'm an overweight zombie. I'm going to New York this week for a job. I'm scared to leave the house because I don't want to miss Scott's call. I'm torn between work and being there for him.

HOME, 9-3-99, 5:30 P.M.

I'm waiting for the dealer. He's coming to ruin my twenty-one days clean. I'm so angry and sad now. God—please don't let me die. I just want to get over this pain. Scott was sentenced to one

year in jail. I can't take it. I don't want to feel this pain. Eight years I have been waiting to be with him and now it will be nine. I don't understand.

PROMISES TREATMENT CENTER, MAR VISTA, 10-5-99, 9:46 P.M.

I've landed myself back in another fucking treatment center. I put myself in such a miserable place. Shooting speedballs by myself. Knowing damn well that I could kill myself. I was lying to Scott. I hate that so much. I had to put myself here. As I read through this journal, I wonder how I could put myself through so many of these places. Then I realized that I hadn't even written about them all. This is number seven. Lucky number seven, I hope. I have stayed here longer than any other place, so that's a good sign. I'm trying to pull myself together, but I miss Scott so much. God, please help me get it this time.

PROMISES, 10-18-99, 5:34 P.M.

I hate this shit. Three more days. I don't think I can take another group or share one more damn feeling. I wish Scott could come home. Why is our life this way? It's miserable. I don't even have anything to write about because I've been stuck in here. I'm starting to get scared that I might relapse when I go home. I hope I'm able to surrender and treat myself good this time.

My least favorite room in a hospital was the bathroom, almost always shared with the very ill roommate renting the space on the other side of the curtain or the other side of the room. Sometimes there was a bench in the shower; I usually planted myself on it, threw

myself a weepy pity party, and kept the warm water running until somebody noticed I was threatening the local water supply. I liked the feeling of isolation (frankly, you don't get much alone time in rehab). An institutional shower stall would be a very good place to conduct therapy sessions. Even now, it's not unusual for me to break down about something in the shower. I sit down directly beneath the shower head and adjust the water pressure so that it comes down hard. I've never been able to decide whether that's about getting clean or being punished.

Often, especially after the Chaos Tour finally came to an end, I sat on the bench in the shower examining the damage I'd done to my body. I'd avoided looking at my arms all day long and now, here they were. There's no way this is me, I didn't do this to myself. Mary, you have no visible veins, and the arms you've dreamed about using someday to hold babies are both covered in scabs. You did do it to yourself.

The first visiting-hours session in rehab should be put off as long as possible. If you're on detox meds, you're too high and dizzy to make sense. If you're not, you're sick, shamed, and awkward in a social situation without the customary glass of whatever, a little shot of something before company comes. It's all you can do to keep your eyes at half mast. When your family and friends are announced, you shuffle (and I mean shuffle) down the hall. It's pitiful. Your slippers keep falling off (hence the term *slippers*), and you hope the wall holds you up until you get to where you're trying to go.

Once you sit down, you occasionally look sideways to see if your visitors have abandoned you yet. Direct eye contact is a bad idea— every time you begin to prop up your head, all your loving people force-grin back at you, a facial expression whose sole purpose seems

to be to reassure you that you're not a junkie. (Right. And the mo-
mentous occasion which brings us all here together is, oh, something
like walking up onstage to pick up your college degree.) Even after
the first visit, the conversation is always the same. To fill the silence
and sadness, it goes something like this: "We are so proud of you."
"You're looking much better." "I can see the color is coming back in
your face." "What are the other patients like?" "Have you made any
friends?" "I've been to a lot of hospitals, and this is the nicest one."

Please. You do not look good—you look like crap for weeks (if
you stay that long), and you know it. Your lips are dried and cracked;
it's almost certain that at some point, you will drool. The hospital
gown exposes track marks, bruises, and scabs on your arms. If you're
a picker like I was, God only knows what your face looks like. You
are too weak to shampoo your hair, let alone blow it dry, and brush-
ing and flossing your teeth requires more coordination than you're
capable of. I'm certain that neither Miss Manners nor Emily Post
ever considered giving advice on the proper etiquette for visiting a
crackhead, but in my opinion, a simple "You look like shit" would
be fine. At least it wouldn't be a lie. And the goal here is to stop
lying. Right?

Your visitors are almost always well-dressed. It's a little discon-
certing, this Sunday-best thing, since only days before, you were
most likely walking around with only one shoe yourself. If you're
lucky, they'll bring food. Chewing in slow motion is one way to
hold up your end of the conversation. Actually, everything you do is
in slow motion, because most rehabs have a no-caffeine policy. No
caffeine in the soft drinks, no caffeine in the coffee. Decaf coffee is
like smoking something that tastes and smells like crack, but doesn't
get you high. Pointless. But that's usually the only thing they restrict,

so bring on the calories and the carbs and the processed sugar! I'm the only person I know who actually likes hospital food. Sometimes there's a small lunchroom with decaf coffee and snacks; at Exodus, my favorite item was hard-boiled eggs. Scott would cut them up and add them to a Styrofoam bowl of mustard, mayo, salt, and pepper. Then he'd smash the mix between two pieces of cheap white bread and hand it over. I could never get enough of that.

After you've finished eating like a tranquilized horse, you stabilize yourself for the well-wishes and hugs that accompany the goodbyes, after which your sad family and friends watch and wave as you shuffle your way back down the hall. Generally, your posse can only handle this until you're halfway to your room, at which point they turn and run, stopping only for the hand sanitizer near the exit, in hopes of wiping away the last hour. I know my family and friends did this with me, and I did it with Scott. Once safely outside, everybody sits weeping in their cars. Or maybe they hold it together until they get home, and fall apart there.

I've gone back and asked everyone who came to see me what was running through their minds during all those visits, and every answer is the same: There was no way this happened to Mary. She's not an addict. The only explanation is that she's so attached to Scott that she would even follow him to rehab. I did my best to keep my bad behavior a secret and it worked. I thought I was pretty crafty at the time, but in retrospect, I'm baffled. How is it that I spent nearly a year on a never-ending heroin-and-whatever-else-you've-got run without setting off a single red flag? How could they deny the damage I'd done to my arms? One day, I was model pretty; the next, I resembled the undead. Didn't anybody notice?

As the medicated fog of detox lifts, it's replaced by guilt. Parents

Me and my dad in 1978. The decor looks like we're on the set of *Roseanne*.

My parents' remarriage, the one that was supposed to lock it in. It didn't.

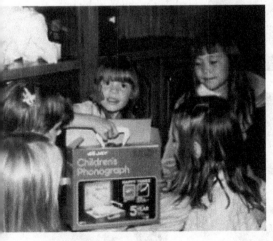

"I Love Rock 'n' Roll."

With Candy Westbrook at the "Model of the Year" competition in Washington, D.C.

First kiss with Scott and then some, London, 1993.

Ivana (*left*), Kristen (*right*), and me "throwin' it" for the camera at Kristen's twenty-third birthday at the Whisky in L.A.

With Steve Jones at my birthday party at the Little Door in L.A. This picture captures a rare moment—I'm in Steve's presence but not bent over with laughter.

Never too fucked up to shop: Scott and me during the Chaos Tour, hemorrhaging money on Rodeo Drive.

Scott always loved this rubber dress (I had to powder my body to get it on). We are at a Japanese restaurant in Hollywood before the start of our hotel run with his brother Michael. Little did I know that within days I'd be reviving the dead.

After Scott did a solo show in L.A., we hit the Chateau Marmont and, later, downtown. This photo was taken in the back of a limo moments after we confessed to each other that we'd both relapsed—and before we went looking for heroin.

Pajama party at the Playboy Mansion. I had no clue till much later that Scott's time in the bathroom was spent with a crack pipe in his mouth.

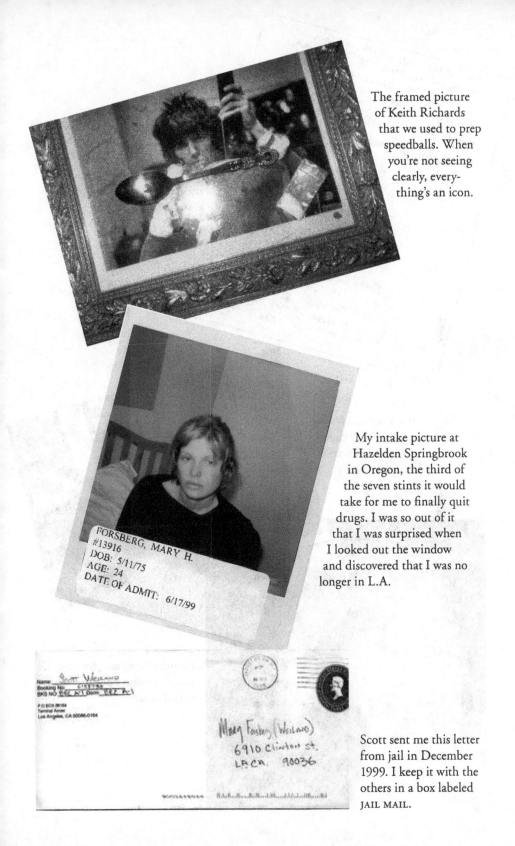

The framed picture of Keith Richards that we used to prep speedballs. When you're not seeing clearly, everything's an icon.

FORSBERG, MARY H.
#13916
DOB: 5/11/75
AGE: 24
DATE OF ADMIT: 6/17/99

My intake picture at Hazelden Springbrook in Oregon, the third of the seven stints it would take for me to finally quit drugs. I was so out of it that I was surprised when I looked out the window and discovered that I was no longer in L.A.

Scott sent me this letter from jail in December 1999. I keep it with the others in a box labeled JAIL MAIL.

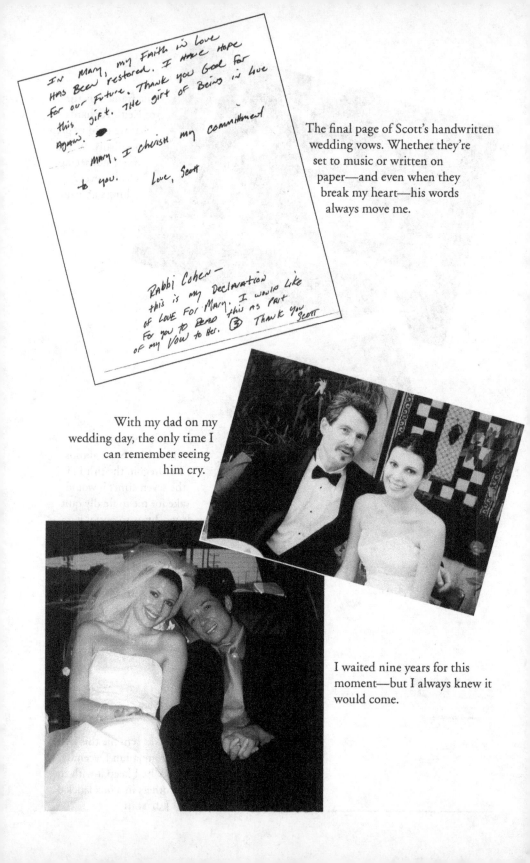

In Mary, my Faith in love Has Been restored. I have hope for our Future. Thank you God for this gift. The girt of Being in love Again.

Mary, I cherish my commitment to you. Love, Scott

Rabbi Cohen—
this is my Declaration of love For Mary. I would like For you to Read this as part of my Vow to Her. ③ Thank you
Scott

The final page of Scott's handwritten wedding vows. Whether they're set to music or written on paper—and even when they break my heart—his words always move me.

With my dad on my wedding day, the only time I can remember seeing him cry.

I waited nine years for this moment—but I always knew it would come.

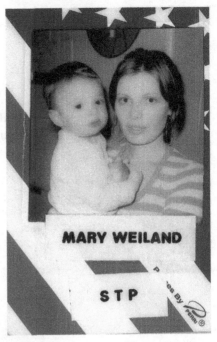

Red Hot Chili Peppers drummer Chad Smith won the guess-Mary's-belly-size contest at my baby shower for Noah. That's Robert DeLeo just over my right shoulder.

My STP tour laminate with Noah.

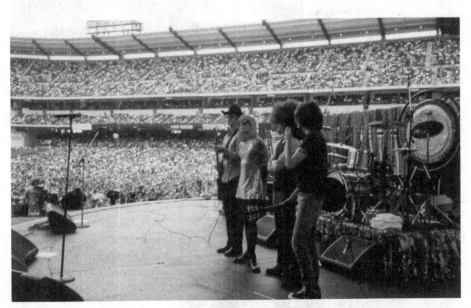

Stone Temple Pilots (*left to right:* Robert, Scott, Eric, and Dean) onstage at a KROQ show in L.A. The stage revolved them into the spotlight, prompting a tremendous response from the crowd.

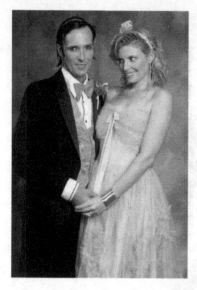

With Scott at my *Pretty in Pink* prom-themed thirtieth birthday party.

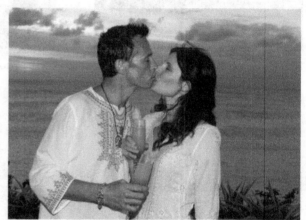

After renewing our vows in Bali, 2007. This moment was meant to stick. I will always cherish that time but lament that promises are so easily broken.

Lucy's seventh birthday, July 2009. No matter what the future holds for Scott and me, I will always love him, and we will always be a family.

have dreams for their children—this is not one of them. You've killed that dream, and they're sent home (or brought back in for family group sessions) to grieve it. Both my parents kept saying they'd failed me; my dad in particular, with his own history of addiction and hard recovery, always felt like this was something he'd done to me, something that he could've seen and somehow prevented. The saddest words I ever heard him say were, "I should've saved you." But I knew I'd done this to myself, and I'd done it to my family as well—how could I carry that shame? Many times, this guilt leads to relapse.

And let's be honest here: The other thing that leads to relapse is missing the high and wanting it back. You're drug-sick, you're lower than gum on a sidewalk, and you think if you can't get back out and score in five more damn minutes, you're going to rip out all the hair on your head and punch yourself in the face. Yes, I did punch myself in the face.

A lot of rehab experience, especially in the early days and weeks, is spent trying to outwit the very people who are trying to get you well. You make this so-called effort to pull it together, you do it for show, because it's harder for someone to be angry with you if it looks like you're trying. You get more sympathy when you appear to be struggling. Seasoned addicts even game the detox process—they clean up under medical supervision, then walk out the door knowing that the next high is going to be way better than the last one.

And then there's all this complicated, overwhelming science—biology, chemistry, psychology—that allegedly explains how you got into this mess and how, possibly, you might get out of it. Professionals in all these fields study the science of addiction for their entire careers and still don't have all the answers; an addict spends a month learning about it and—no surprise—flunks the take-home exam.

Limbic system? Opiate receptors? Serotonin? The dopamine effect? Genetic predisposition? Turns out that all those years I was worrying about my hips, I should've been worrying about my hippocampus, that tiny place in my brain that neurologists call the seat of memory and reason. I'd been pouring junk on it since I was thirteen. I couldn't remember what day it was—how could I possibly absorb all of that? For a long time, I didn't.

It's as though you've been raised in the woods by wolves; now you must become a functioning human being. It's not enough to be clean and sober—you need to rewire your brain. There are people who go through their daily lives getting to their jobs on time, raising their families, coping with kids or loneliness or creativity or the world situation, and they don't get high. They don't put a needle into their veins, they don't consort with scary people hovering near the edge of city parks or dark parking lots. How do they do that? For an addict, this is a much bigger question than What is the meaning of life? Twelve-step meetings can help you learn; therapy can help you learn; maybe faith, or grace, can help you stick with it. But for three out of every four addicts, it takes multiple trips to rehab, and stays longer than a couple of weeks, or a couple of months, or longer. It depends on the drug of choice, it depends on the support system, it depends on how good the counselors are, it depends on how much damage you've done, and ultimately it depends on whether or not you're really through with running. It depends on factors that no one can see or fix.

Staying in recovery was difficult for a very long time. I missed the ritual of using as much as I missed the drug itself. During one of my early attempts at sobriety, I missed it so much that I loaded a syringe with water and shot it into my arm. I knew I wouldn't get high,

but I wanted that specific feeling—the adrenaline of expectation just before you open birthday presents, just before you bungee-jump off the bridge.

I don't recommend kicking heroin cold turkey. The first time I did it was before Scott went to jail. The day began as a disaster, and I had to have two friends come over and help me get him into the UCLA psych ward. Dr. Langford made intake arrangements and was meeting us there. Scott and I were dropped off, and we made our way into the building. I don't remember much about that meeting; Scott, the doctor, and I sat at a round gray table that was made of either cement or metal. The discussion was about Scott's need for a seventy-two-hour hold.

Hours had passed since I last shot up. I'd gone from feeling like a little girl swimming through cotton candy to a death-row inmate whose stay of execution was just about up. I wanted to go home, I wanted to sleep. Dr. Langford called me a cab, and I hugged Scott good-bye. From the look in his eyes, I knew that his run through the fluffy pink cotton had come to an end, too.

I fell asleep in the cab and woke up in front of our house. I don't remember paying the driver, I just remember trying to steady my hand so that I could open the door. Getting upstairs to our bedroom was painful. I had to sit and rest every few steps. I was sweaty, hot, and cold all at the same time. I was wearing a black puffy North Face jacket, and by the time I reached the top of the stairs it was drenched. I lacked the energy to take it off. My skin was cold, my eyes wouldn't stay open, and I just wanted to sleep. I crawled into bed all alone and slept facedown for at least a day.

When I woke up, I knew something horrible was happening. Panicky, I called Ivana, controlling my voice (she still didn't know what was truly going on with me), and asked her please to bring me something to eat and some Gatorade. I knew it was going to be difficult getting back down the stairs and I started right after I hung up the phone. I sat at the top of the staircase still wearing my sweaty clothes and the puffy jacket, then went down the stairs on my butt, one step at a time. In between, I closed my eyes to stop the spinning. When I got to the front door, I unlocked it, then fell onto the green velvet couch. This time, it didn't enfold me in comfort. It felt more like a bed of nails.

I didn't hear Ivana come in. She brought so much food: sandwiches, ice cream, chips, Little Debbie snack cakes. I put away the first bottle of Gatorade in one gulp. Ivana wanted to stay for a while; we hadn't seen each other in so long. And now she was worried. I insisted that it was the flu. It wasn't hard to convince her—the Gatorade came right back up. I woke up the next morning and Ivana was gone. I had nodded off during our visit.

Then Scott called. I'd promised to come visit, but I wasn't there. When was I coming? "I'm really sick," I said. I didn't even have to tell him what was happening; he knew that along with nausea came deep, bone-wrenching pain. The body doesn't give up opiates easily. "Come here," he said. "The doctor will give you something for the pain."

I made my way there still dressed in the clothes I'd been wearing for two days. Scott was safe, on detox meds and being watched by a medical staff. Me, I was a do-it-yourself project. Dr. Langford didn't like it; my doing this alone, without medical assistance and detox,

wasn't a good idea. But I no longer had the kind of money it would take to check in for an extended stay. When I left, it was with two tiny manila envelopes containing meds for the next two days.

I vowed it would never happen again, but it did. Every time I relapsed, I tried to keep that first cold-turkey nightmare in my head, but it wasn't enough to stop the cravings. "I will only do it today. How much harm can one day do?" Two days turned into three, three into a week. Gone again. I was in love with getting loaded as much as I was in love with Scott. Before I knew it, I was always back in that puffy jacket sleeping and sweating, and staggering off to visit my true love in between.

He was getting better, I was getting worse, and there was nothing wrong with his powers of observation. When his ultimatum came (he'd pay for rehab, but I had to go and I had to stick this time, or else we wouldn't be able to be together), I thought about putting up a fight, and started to layer on the lies. But I was exhausted. The thought of losing him carried more weight than any desire to be well again. I'll go tomorrow, I thought. Or maybe the day after. Tuesday's good—how's Tuesday for you?

One night, I had dinner with Eric, Balt, their friend Josie, and her friend Rosetta (who would later become Balt's wife). They took me to Chateau Marmont, and I was so loaded I fell asleep in my soup. My entire face went into the bowl.

A couple of days later, after sweating through cold turkey again, I packed a bag and drove myself to Promises Mar Vista. My seventh and final trip to rehab. I spent my first few days there asleep in that disgusting puffy jacket. Heroin and I were finally done.

TEN

into your arms

No matter if you had happy Christmases or sad ones when you were a child, if you're feeling fragile, the season can really kick your ass. Short days, enforced cheer, and nonstop TV commercials reminding you how inadequate you are in the giving-sharing-jolly department. It's now my happy experience that the presence of excited children changes everything, but that year, with Scott behind bars and me in very early opiate recovery, it was an uphill slog. Scott's recovery had started months sooner than

mine, and he'd reached a stage of cautious optimism. I wasn't quite there yet.

Scott loves Christmas. He gets into it more than anyone I know. Even in jail, he made a celebration of it, coaching fellow inmates through the two- and three-part harmonies he'd learned in choir as a kid and rocking Christmas carols. I couldn't even give him a proper gift—books were about the only thing accepted, and I had very little money of my own. Unless you're six years old, buying someone a gift with his money isn't really a gift.

I spent a couple of blurry days in San Diego with my family, then came back to L.A. Scott's parents were in California to visit him, staying with his brother Michael and his wife. Scott had made it clear to everyone that we were going to be together when he was released, so I was invited over. I felt guilty that he was spending Christmas in jail while I was with his family. I recently found some snapshots from that day—all I can see is a scared, awkward, and very uncomfortable girl who couldn't have told you what day it was. Also in the picture were some other very uncomfortable people who were doing the best that they could, and weren't any happier about it than I was.

On New Year's Eve 1999, the turn of the new century, Scott got out of jail. With the exception of the long-ago first kiss in London in 1992, the hug we shared that day was probably the most important embrace of our lives. As a condition of his early release, he had another thirty-day rehab stint (at Impact), then he finally came home. We were sober, healthy, optimistic, and more in love than ever. Simple things—pizza, ice water, waking up together—took on the significance of treasure. We began to reconnect with our friends and

family, and Scott went back to work with STP, getting ready to take their fourth album—called, comically, *No. 4*—out on the road.

We went to twelve-step meetings together and to appointments with Bernie. One of us was always habitually late, of course, and I still dreaded getting out of bed in the morning (so coffee and break-fast actually happened at noon), but we were starting again. It wasn't a cakewalk, but it wasn't a constant jagged-edge dope run on the bad side of town, either.

One morning a couple of weeks after he got home, he suddenly got out of bed—stark naked—and went down on one knee. "I don't have a ring," he said, "but I want you to be my wife. I want to spend the rest of our lives together." I didn't cry, at least not at first—I'd always believed it would happen, but I also thought I'd be in my early hundreds when it did. For years, a normal life seemed like one of those paradise islands way off on the horizon—something to sail toward, but farther away the closer we got. Now the fantasy I'd created in my mind at sixteen was going to happen. That day, we held each other for a very long time.

Through all of our separations and setbacks, we had always talked about having children; within months of getting engaged, I discovered I was pregnant. We'd thought it might take longer, but as everyone joked, I held my own for the Mexican side of the family. When I called my mother to tell her about the engagement and the pregnancy, her voice contained nothing but love and excitement. Given the tumultuous relationship Scott and I had shared, no doubt there were a few people who raised their eyebrows when they heard the news—it was high time that Prince's "Party Like It's 1999" stopped being a Scott-and-Mary theme song.

We planned the wedding for May 21, 2000, in an L.A. restaurant called the Little Door, which had a beautiful patio and a hidden garden just beyond the doors, with red bougainvillea vines and ivy everywhere, and a tiled stone fountain. We hired a wedding planner named Randie Pellegrini, and I had only two requests: Keep it simple, and don't tell me if anything goes wrong.

Although we were both raised Catholic, we didn't have time to go through an annulment of Scott's first marriage or to take the prescribed classes in order to have a ceremony in a church. We had waited long enough to really commit to each other, and I felt like God backed us up on that decision. We didn't want an insta-preacher from the Church of What's Happening Now, so we were happy to find a rabbi who'd taught at a Catholic university, which seemed to cover all the bases. If there'd been someone with even more religious qualifications, we would've taken him, too. Better safe than sorry.

Shortly before our wedding, Scott's mother and I went shopping together for her dress. We were never close, and with everything that had happened, it wasn't likely that we ever would be. But this was the woman who had raised the man I loved. Her heartbreaks had been at least as frequent as mine—I hoped that our wedding-outfit shopping expedition would lighten the tension between us. We spent an entire day looking and finally found the perfect outfit at Neiman Marcus, a soft shell-pink dress. The price tag was outrageous. She opened her wallet and pulled out a contraband credit card. "Mary, sometimes a girl needs to buy something that her husband wouldn't agree with," she said. "I suggest now that you're getting married, you have a credit card that you pay on your own." It was advice that my mother had given me long ago, but I enjoyed the confirmation

coming from another woman. Luckily, when it comes to fashion, Scott has always agreed that most items are a necessity.

For the No. 4 tour, Stone Temple Pilots were hubbing out of New York, and Scott and I were staying at the Mercer Hotel. One night, we were going to meet Dean DeLeo and his then wife, Juliana, for dinner. Dean and Juliana were good friends with actor Patrick Dempsey, and we all met up at Nobu. I was still at the stage where morning sickness lasted all day long, and I had to work very hard to focus on the quality of the company I was with rather than on the fact that I was surrounded by the smell and visual of every kind of raw fish a fabled Japanese restaurant had to offer.

Right in the middle of dinner, Whitney Houston and Bobby Brown came crashing through the door—and "crashing" is not an exaggeration of the kind of entrance they made. Afterward, we all went to a club for a while, where we were escorted to the VIP section. I was offered a seat next to Courtney Love. It had been five years since she and Scott had their adventures at Chateau Marmont. She was healthy, so was he, and there wasn't a moment's uneasiness among us. I knew that Scott cared for her, but never was there any romantic involvement (the only girl Scott wants within a ten-mile radius of him while he's using is a drug dealer or someone making a delivery). That night, Courtney was very glamorous and gracious. Mostly, we spoke about Pilates and fitness. When Scott told her we were expecting a child in a few months, she lit up a cigarette and confided in me that she would mostly likely never have another baby (her daughter, Frances Bean Cobain, was about to turn eight), because she couldn't

stop smoking. She said this while exhaling smoke straight into my nostrils. A few minutes later, David Lee Roth arrived and took the seat across from us. He had long, bleached-white hair and skin the texture of Fire Marshal Bill's. I blinked through the smoke at Scott, giving him my "Really?" face; we got up in unison and ran for the hotel.

Courtney was also staying at the Mercer. She somehow squeezed Scott's room alias out of the front desk staff, and called us every day with a new plan, inviting me to work out with her, or asking if we'd like to go with her to dinner at Donatella Versace's. Eating, working out, or appearing in front of anyone having to do with high fashion weren't on my list of things to do, so we gently declined. Courtney lives in CourtneyLoveland, we couldn't get mad at her. Like us, she was doing her best. If you'd told teenage me, the one with the baby doll–clad Courtney poster hung in her room, that one day I would decline such an invitation, I'd have thought you were insane.

Jeff Kolsrud arranged for me to meet with a designer for my wedding dress, just down the street from the Mercer.

There are girls who plan their weddings their entire lives, with scrapbooks full of magazine clippings and fabric samples for the dress, the outfits for the bridesmaids, the colors, the cake, the flowers. I'd never been that girl. I'd worn many beautiful clothes as a model, but they were costumes I put on in exchange for a paycheck—in my deepest self, it was still all about naked Barbie and a roll of tape. Now that began to change. I wanted to be pretty for Scott; I wanted to wear something special. Mostly, I hoped I'd stop throwing up from morning sickness by the time I became Mrs. Scott Weiland.

When I walked in the door of the designer's studio and found myself surrounded by rows of beautiful gowns, I needed to sit down immediately. Nausea might've played some part in that, but a roomful of wedding dresses can really focus your attention: I'm here because I'm getting married. I wanted something beautiful—this would be my only wedding day. Finally, I chose a simple strapless gown, full length, with fine blue and silver beading.

As we started the fitting, I asked the seamstress to please leave a little room; I was pregnant and expected to be rounder on my wedding day. She smiled and nodded—I guessed she'd heard this many times before. We worked along in companionable silence until she asked when the wedding was scheduled. Very soon, I told her. The look of alarm on her face told me that my good news wasn't good for her. Maybe a girl should have that scrapbook and start planning more than a few weeks ahead of time: It can take months to hand-bead a gown. I was so grateful when it showed up on time. It was enough to make me believe in fairy godmothers and singing mice with needles and threads.

My wedding day was the first morning in three months that the bedroom floor didn't roll beneath my feet like the deck of a ship—the baby nausea was gone. Kristen, Ivana, and my little sister Julie, all gorgeous in dusty rose dresses, helped me get ready. When it came time to help me put on my dress, they handled it as carefully as butterfly wings. But when we buttoned the last button, we realized we had a serious problem. Not only was the extra room not necessary, the morning sickness had dropped me a bra size (not that there'd been all that much there to begin with). Frantically, we began stuff-

ing my bra with flesh-toned silicone inserts—"cutlets," everyone calls them. Wiggly little chicken cutlets—as many as we had, we didn't have enough to sufficiently stuff the top of that dress.

Scott's groomsmen were Sonny (a close friend from Impact), his brother Michael, and Ashley Hamilton, who was working on his sobriety as hard as we were. Our parents and stepparents were all there, our brothers and sisters, our grandmothers, as well as Jeff Kolsrud and Bernie Fried, Anthony Kiedis, and all of the guys in STP and their wives. Seventy-five people, all loving us and wanting only happiness for us.

The moment before I began my walk toward Scott, my dad took my hand, and then he started to cry. I'm not sure I had ever looked full-on into his face before, and what I saw there moved me profoundly. I knew in that moment that my days as a little girl were over. As we walked together, I had a conversation with God in my head. I thanked Him for finally fulfilling my dream; I was so ashamed that I'd lost faith early on. I promised never to lose faith again. There were rose petals on the floor, and I looked at them as hard as I could, clutching my dad's hand. And then he let me go.

I was crying, Scott was crying—suddenly, everybody was crying. Ivana, who was crying, too, handed Scott a tissue—between the heat and the tears, half the tissue stuck to his face. Ivana went from crying to desperately trying to hold in what she knew would be uncontrollable laughter. Scott and I laughed, then cried, started over again and cried some more, until finally the rabbi took pity and read the vows for us—we could not get the words out.

Once we stumbled through our vows and the roomful of weepy people began to shift into celebration (and a collective sigh of relief),

I put down my bouquet of deep red roses and spent the rest of the day hanging on to Scott with one hand and holding up the bust of my dress with the other. It was fine. I didn't care. We were surrounded by family and friends, we were signed on the dotted line, and I was a grown-up wife, married to the blue-eyed man in the black suit. To marry him, I would've happily shown up with just the chicken cutlets and nothing else. Our first dance was to the Lemonheads' "Into Your Arms"—"And if I should fall / I know I won't be alone anymore." Scott heard it when he was in jail; he was mopping the floors, and when the song came on the radio, he stopped mopping and began to weep. "That's when I knew I'd marry you when I got home," he told me.

Last year, my sister Julie wore my dress for her wedding. Now it's being saved for my daughter, Lucy. She wants me to save everything else in my closet for her as well. Every time I dress for an event, there's my little girl, with her mother's feel for clothes and her grandmother's eye for a bargain. "Mommy, will you save that for me?" I may end up in a one-room apartment someday, but there will always be closet space for everything I've saved for Lucy.

After a two-day escape to the San Ysidro Ranch in Santa Barbara's wine country, we went back on the road with STP for their U.S. tour. For a while, life on the tour bus was like being in a cocoon—no long airport lines, no security checks or delays, and a kitchen I could visit whenever I wanted. Which was often. Scott made me a special bed, with soft down comforters, cashmere throws, and pillows to cushion my rapidly expanding body. Everyone from the road crew to

my new husband spoiled me rotten. If I wanted a cheeseburger, one magically appeared. If I wanted my feet rubbed or couldn't reach my back to scratch it, shazam, a genie appeared.

Scott was sober and happy, the guys in the band were as affectionate and funny a band of brothers as they'd been since their earliest striving days, and the fans were consistently amazing. STP played small stadiums—called "sheds"—and venues all over the country. They headlined with groups like the Red Hot Chili Peppers, with crowds ranging from three thousand to eighty thousand. If there was anything but joy in the eyes of everyone around me, I didn't see it.

Throughout the years, I've been privileged to see some astonishing concerts—I've loved losing myself in the music, lights, and even the smell of an arena. But one downside of being at the side of the stage instead of in the audience is having to let go of the sense of fantasy that drew you into the music in the first place. When you travel with the band, you always see the man behind the curtain— the band behind the curtain. Turns out the Mighty Oz is just a group of guys, and sometimes watching grown men bicker about who's got the missing eyeliner sort of crushes the vibe.

Unlike the cliché, I never glowed when I was pregnant. My hair hung limp, my skin was impossible, and I gained far more weight than I should've. Toward the end, with both my babies, I looked more like the Kool-Aid pitcher than I did a radiant mother-to-be—I was a perfect circle. But, sadly, a bosomless one. All my life, my only nonsurgical hope of filling out the top of a bikini was motherhood. One day, midpregnancy, I ran into Victoria's Secret certain that I finally met the requirements for bikini cleavage. I stood in the dressing room with my arms above my head while the very nice woman wrapped a tape measure around me in two places that tickled. I

waited for the announcement that would graduate me from the 34A I'd been since I was thirteen.

"Thirty-six," she said.

"Thirty-six what?" I asked.

"Thirty-six," she said again, then sort of shrugged. Great. Evidently the pregnancy was doing nothing for my bosom; on the other hand, my back was expanding. Pouting, I bought some very large panties and left. I'll never know why I was booked for modeling jobs while I was pregnant. When I look at those pictures with friends now, we drop to the floor laughing. Damn chili cheese dogs!

I stayed with the tour for the rest of the summer, until I was too pregnant to be comfortable and not allowed to fly anymore. In September I realized it was time to do that nesting thing.

One afternoon when I was back in L.A., Scott somehow hit a button on his phone, and it speed-dialed me without his being aware of it. When I answered, then realized that he didn't know I was on the other end, I decided to listen and see what kind of tour shenanigans he was up to (I'm a girl—what did you think I was going to do?). It was riveting beyond belief. The guys were having a conversation about how difficult it is to eat enough vegetables on the road. Yes, this is the *Inside Edition* truth of it all—no sex or drugs, just concern over fiber intake, a lesson on the importance of one of the five food groups. My eavesdropping was a bust, and I was laughing so hard I thought I'd get caught.

Scott wrote "Sour Girl" (and almost everything else on STP's *No. 4* album) primarily about and during his divorce from Jannina. "A sour girl the day she met me . . . a happy girl the day she left me."

I understood what he was writing and why, but I never felt at ease with it. So many of the songs were about the end of that marriage. Did I feel guilty? Sure I did. And possessive, too. I didn't want to hear those words. Moreover, much of Scott's time working on it in the studio had been during our Chaos Tour. Objectively, I could admire the work; subjectively, I didn't want it as a touchstone for the beginning of our life together.

I was hugely pregnant with Noah when they were getting ready to shoot the "Sour Girl" video with Sarah Michelle Gellar. Scott had become a big *Buffy the Vampire Slayer* fan while he was locked up, and he liked her. A day or two before the shoot, I let him know that the idea of him shooting those scenes did not make me feel very cheerful. Not because it was Sarah Michelle—it could have been anybody. I was blimpy, she was gorgeous. Yes, I knew it would help promote the album—*Buffy* was at the top of the TV ratings. Yes, Sarah Michelle was beautiful. Yes, the director, David Slade, was terrific, and he had an interesting concept—oh, the hell with it, I'd just have to deal. So I waddled onto the set the next day and planted myself in the director's chair. Relief strolled into the room in the smiling, handsome form of Sarah Michelle's now-husband, Freddie Prinze Jr. We sat together during the shoot, him watching his wife, me watching my husband. It could've been worse.

Noah Mercer Weiland decided to make his entrance on November 19, 2000, at Cedars-Sinai Hospital in West Hollywood. Scott didn't have an assistant at the time, so I was managing his calendar; when my labor began, as we were getting ready to head

for the birthing suite at Cedars hospital, I found myself saying things like, "Well, you've got a dinner at the Ivy tonight, probably better cancel that. We've got a massage scheduled for later, probably better cancel that, too."

"Oh, the masseuse can come to Cedars," he said. "She can do your shoulders or something."

My response was less than enthusiastic. "No. I can't even feel most of my body and the thought of some strange lady touching me while I'm half-naked and in stirrups makes my skin crawl. Thanks, but no thanks."

We settled into what I called the Madonna Suite at Cedars, complete with living room, bedroom, bathroom, and kitchenette. Except for some mind-blowing sciatic pain and the fact that an actual baby was on the way, the scene resembled a party. At the time, Ivana was dating our friend Brent Bolthouse, who'd become a successful club owner and promoter. Everyone in L.A. wants to know Brent so they can get into his clubs—we joked that he was working the door at Noah's birth.

For me, the party atmosphere soon evaporated. I wasn't a pretty girl during pregnancy, but I'd had a lot of pretty thoughts, all of which ended in the effortless arrival of a pretty baby. Now I was in agony. Every time I had a contraction, the sciatic nerve screamed up my leg like a hot poker. I don't care how talented you are at breathing through labor contractions—you'd have to be some kind of Zen yoga Superwoman to manage both kinds of pain at the same time.

My new best friend the anesthesiologist kept increasing the IV dosage, but those meds were specific to the labor pain, not the sciatica. Ultimately, my legs, which felt roughly the size of an elephant's,

were dead weight. I couldn't feel or move them, and I couldn't feel the contractions, either. But I could feel that goddamn sciatic nerve.

And then the masseuse walked in and began setting up her table. What the fuck? Then Scott asked our friends to leave so he could get his massage. He turned the lights down, he began to remove his clothes, the masseuse lit the incense, and our friends slowly backed out of the room with looks of stunned disbelief on their faces.

I knew that new dads were stressed; I'd heard that sometimes they suffered sympathetic nausea or even real labor pains that were medically treated. But this was ridiculous. However, screaming "Are you fucking *kidding* me?" is probably not the kind of ambience a birthing suite requires. I was quite certain that if I gave full vent to what I was thinking, both my heart rate and the baby's would've blasted the heart rate monitor through the wall and into the next room. Breathe, Mary, just breathe. When the OB nurse came in to monitor my progress, the expression on her face was a perfect movie moment spit-take. "Excuse me, sir? Your wife's having a baby right now. You need to bring your relaxation time to an end. Get this woman and this equipment out of here. Now. I mean right now."

The doctor who had been treating me throughout my pregnancy was coming from Hawaii on a plane; someone I'd never met before arrived to take his place. In moments, I had little oxygen cannulas in my nose, I was being encouraged to push, and the sciatic pain was so harsh I thought I was going to pass out. Come on, little baby. Finally, we had to go for assisted delivery, where the doc used the grotesquely named vacuum extractor/suction cup to bring Noah into the world. He arrived with a little cone head—not the most glam entrance a rock star ever made, but hands down, the most miraculous one we

had ever seen. When they lifted him away from me, I suddenly had an irrational fear that they were going to switch him with somebody else. "You need to follow that baby!" I told Scott. "Don't let him out of your sight!"

Noah had a bumpy beginning—jaundice and some breathing difficulties. Nursing didn't start off well for either the mother or the amazingly hungry child. We left Cedars in time for Thanksgiving, which we'd arranged beforehand to be at our house, since all of our family members had come to town for the blessed event. In what alternate reality had I ever thought this would be a good idea?

Learning to nurse a child sucks. There, I said it. You're exhausted when you start, your boobs hurt, everything else hurts, sleep is something in the dim past, privacy has evaporated as well. There's joy in the arrival of a new healthy baby, but why didn't anybody tell me about the embarrassing, painful, and frustrating part?

And trying to learn to nurse a child (let alone find a comfortable way to sit in a chair) in a room full of extended family joining hands and endlessly sharing what they were grateful for was agony. My mom stayed, Scott's parents stayed, the phone rang off the hook, company kept coming in and out. I couldn't decide whether to eat or shower or nap—I was so out of sorts that one of my cousins stopped by and I had no idea who he was.

I thought I'd read all the right baby books, but I must've missed the one that told me how to actually do this. All I could do was cry. My breasts were huge—finally!—but I couldn't produce enough milk to satisfy Noah. When he finally fell asleep, I put him into his little carrier, took him into my walk-in closet, shut off the light, and sat in the dark and cried.

The hormones that had been protecting me since my first months in sobriety seemed to have turned on me. Was this normal? In those first days, I was so in love with my colicky, cranky baby, and so exhausted by what he needed from me, that in the middle of the night I'd look out the window and think I'd hallucinated people in the street. Women had babies all over the world every day—I wondered if they just knew automatically how to do the right thing at the right time. Because I did not.

It wasn't just galloping postpartum depression and a houseful of noise that had me sobbing on the closet floor. The day we left the hospital, Scott's parents drove me and the baby home while my mother drove Scott to a dentist's appointment. Where he picked up a prescription for Vicodin. Mom waited in her car while Scott ran into the pharmacy. She assumed he was getting an antibiotic prescription filled. When they came home, I took one look at him and seriously considered kicking him in the nuts. As fuzzy as I was, I knew what he'd done. I went into our room and tore it apart looking for that bottle. When I found it—and it was missing the number of pills the label said it contained—I confronted him, freaked out, and ran to the closet to cry. More than eighteen months of recovery, up like cigarette smoke. I was angry, scared—and a tiny bit envious. On some level, I wouldn't have minded taking the edge off in the good old-fashioned way. Every twelve-step meeting and rehab we'd ever been to warned us that relapse was part of the disease; you fall down, you get up, you start all over again. Nevertheless, looking down into Noah's little face, I knew in my soul that that option was out the door for me forever, no matter what. I may not have yet been a fully competent mother, but I was damn determined to be a fierce one. I could not understand why Scott couldn't find that same determination in himself.

For the first three months of Noah's life, we all moved to a rented estate in Malibu, where STP was working on their fifth album, _Shangri-La Dee Da._

At first it seemed like a good plan—all the perks for a rock band in the throes of creation. A chef, a trainer, a swimming pool, a tennis court. Like the idea of a baby suite at Cedars, how could anyone complain about this setup? Scott and I lived in a guest house on the property, where I was either taking care of the baby or sleeping when Scott took a shift. I couldn't leave Noah alone—there was no baby monitor (because of our location, we couldn't get them to work) and no nanny, since I was determined that no one was going to raise our child except us. Scott was completely immersed in what he and the band were doing in the big house, where they were surrounded by staff, tech production people, an ever-changing guest list of visiting friends, and hour after hour of live rock 'n' roll. This was a far cry from lullaby territory.

He was also using—Vicodin and I didn't know what else.

I don't know what kept it going after the fateful trip to the dentist. I understood a slip—we'd both been warned. I was a mess myself, exhausted and messy and on edge when I wasn't in a coma an hour at a time. But at least I could put it down to hormones and sleep deprivation. What was up with him? Did he feel excluded by the bond that had formed between Noah and me? Was he overwhelmed by the responsibility of having a wife and a child, after so many years of freedom and wildness? Did it bring back the uncertainty of his own childhood, when his divorced parents each remarried and quickly had other sons, other babies, shiny

new little boys who took center stage and inadvertently pushed their big brother off to the side? Those were all new families, just like ours was now—maybe he'd somehow gotten lost in them and was afraid of getting lost in this one as well. Whatever the reason, I was as far away from Scott as I'd ever been, in spite of the fact that physically, he was usually only a few yards away.

It was winter. The holidays had somehow blown past in the haze of Everything Baby. We were at the beach in the cold and damp, with gray skies everywhere I looked, and I couldn't remember the last time I talked to a grown-up who wasn't actually a member of Stone Temple Pilots or the band's entourage. I missed people, but I wasn't sure I remembered how to talk with them. I missed my old body, which I deeply regretted taking for granted. How could I deliver an eight-pound baby and lose only three pounds? I was a sodden lump, usually with spit-up or baby drool rolling down the front of my shirt. When Noah snuggled into me, I told myself it was all going to be okay, but where had these headaches come from? Sharp-pointed migraines, worse than any hangover I could remember, with colored lights, purple flowers, and hot-pink cartoon animals hovering just outside my range of vision. Sound hurt. Light hurt. I was convinced that I was going crazy.

I could feel the old black cloud moving back in and went to see my gynecologist, hoping that he'd tell me everything I was feeling was normal, that it wasn't about me in particular but about new motherhood in general, that it would lift. He sent me to another doctor, who prescribed Ativan, an antianxiety drug, which in a matter of days had me feeling jumpy and irritable. I tossed the pills and went back to him to ask him for something else.

"Only if you return the other pills to me," he said. I'd been honest with him about my drug history, and now he thought I was trying to pull a fast one on him. Meanwhile, Scott was getting prescriptions from docs for a variety of alleged ailments, and popping pills like they were M&M's.

To promote the new album, the band went back on the road, both in the States and in Europe. In my recently reassumed role as watchdog, I packed up Noah and we went along. Scott said he needed us with him and I needed him to need us. Now I'm not sure it's where we needed to be.

The tour bus bliss from the year before was a blurry memory; in reality, the bus wasn't much bigger than a hotel bathroom (or maybe a jail cell), and now there were more of us along for the ride. Noah's sleep was still erratic, and Scott could never settle down after the show. The other guys might go out and get something to eat, and gradually wind down: Scott would walk in circles, or be flat on the dressing-room couch, staring at the ceiling. Couldn't eat, couldn't sleep, couldn't kick back and watch TV. I could see the electricity jumping off his skin.

My intention in bringing a child into the world was that his dad and I would raise him and not hand him over to others—this is what families were supposed to do. But being on the road and me being exhausted wasn't doing Noah any favors. We hired a nanny.

When the European tour came to an end, we took our first vacation as a family. We flew to Spain and checked into a stunning hotel in Marbella, a gorgeous resort town on the Mediterranean. Blue skies, blue ocean, sunshine. It was the first time I'd truly relaxed since Noah's birth, and it seemed to work in the same way for

Scott. The headaches disappeared, the intimacy returned. And then we came home.

Together and apart, Scott and I had moved around a lot, living in hotels, motels, apartments, and rented houses from one end of the country to the other, traveling in tour buses. Now, however flawed and vulnerable we were, we were a family. I wanted us to have an actual home base, and I wanted it to be far from Los Angeles. So we bought a house on Coronado Island.

This, of course, is the scene where the forensic psychologist on *Law & Order* says in a serious voice, "It appears the plaintiff was trying to return to the scene of her childhood and somehow rewrite history." Or, "As is often the case, the defendant wanted to return to the scene of the crime." Maybe the fact that the people selling the house we bought were in the process of getting a divorce should've been a sign. Maybe the fact that it had been built in 1929 (the year of the Great Depression), was in the process of renovation, and didn't have any windows should've been a sign. Whatever—we loved it. It was a beautiful, old, Spanish-style home, with three big bedrooms, a sprawling family room, a formal dining room, so many windows (well, once we actually had them installed), a great backyard, all within walking distance of the ocean. It seemed to contain every hope we'd both grown up with—family gatherings around the Christmas tree or Sunday mornings lazing around while the aroma of the second pot of coffee filled the kitchen. And so we bought it. We kept our apartment in West Hollywood. I worked on putting the house together, I went back to modeling when the right jobs came up, I stayed sober (knowing that Scott was not), and I made plans to celebrate Noah's first birthday.

STP was performing in Las Vegas, at the Hard Rock Hotel, and we decided to make a family weekend of it, flying in from San Diego and taking my mom and stepfather, Mark, along. When we got to the hotel, Scott wasn't in the room. We got everybody settled, and I called him on his cell to let him know we'd arrived. "I'll be there in just a minute," he said.

"Where are you?" I asked, thinking he'd say rehearsing, or getting something to eat, or out by the pool.

"Just give me a minute, Mary, I'll be right there." But he wasn't. Every fifteen minutes I'd call him and ask him where he was. His response was always the same. I'm almost there. See you soon. It didn't take long before my Scott-dar was flashing red. I found him in the hotel, in another room—with a doctor, who had his prescription pad out after hearing a tale of woe about Scott's recurring knee injury and why he couldn't perform that night without pain meds.

"He's addicted to painkillers," I told the doctor. "Don't give him narcotics. Please, don't give him narcotics."

There are good, caring doctors—I've had the benefit of being treated by many of them, and I'm grateful. But this one was straight off the assembly line of celebudocs, à la Michael Jackson's and Anna Nicole Smith's doctors—as predictable and generic as the standard-issue tissue boxes in hotel bathrooms. "I'm sorry," he answered. "He says he's in pain, and it's my duty to give him medication to relieve that." He knew Scott was full of shit, and rattled off a list of other rock stars he'd prescribed for. Doc Hollywood, having blown off that whole Hippocratic Oath/Do No Harm crap, just wanted to get paid. He signed the prescription, handed it to Scott, and left the room.

At which point Scott prepared to leave the room as well, in a hurry to get the scrip filled. "I'm not going to let you fucking do

this!" I yelled. "It's Noah's birthday! You've wrecked most of the whole damn year, you have to stop this now!" And I planted myself between him and the door. He tried to blow past me, and I frantically tried to hold his arms, swinging and shouting, determined to stop him from putting another damn pill in his mouth. He shoved, I shoved back. When I wouldn't quit, he grabbed both my arms, lifted me with a bit of force out of his way, and went out the door. Following right behind him, I grabbed his ankles and slid on my stomach as he marched toward the pharmacy. I finally let go and lay defeated on the Hard Rock floor in tears.

I want to make something as clear as I possibly can on this page: although there is no excuse for the events that took place that night, at no time did Scott *ever* hit me, or even threaten to, not that day or on any other. In fact, I'm not sure at that point he even realized I was there. I was simply a physical obstacle between him and what his brain was screaming for. I knew the hell he was in (after all, not that long ago I'd been the woman crawling on the bedroom floor looking for a used needle), and within seconds of his leaving that room, I decided that there was only one thing I could do to save him from himself: I called hotel security and told them he'd hurt me.

The bruises were already showing up on my arms and wrist. Security called the police, who tracked Scott down and arrested him on a charge of battering. I never would've testified against him, I didn't ask him to plead guilty, and I was stunned when he did. I didn't want my husband in jail—I wanted him in treatment, as soon as somebody could stick him there. But the wire-service photos of his booking pictures hit the Internet, and he was repeatedly characterized as the wild, drug-crazed rocker who punched

his wife and spent his son's first birthday in jail. A thirty-day rehab would follow.

The following day, I was driving back to Coronado with Noah and my mom. The tabloids were screaming, Scott's pictures were on television, and my phone had been ringing nonstop with calls from friends and family. Many were calling because they were concerned, but some of them were just plain nosey. I felt like total crap. I'd had my husband locked up for something I knew he didn't do.

I was merging onto the Coronado Bridge when my phone rang yet again. It was Robert Downey Jr. "You did the right thing to have him arrested," he said. "And don't let anyone tell you otherwise."

This was profound kindness—he'd walked through that same hell, he knew the demons Scott was fighting, and he understood my desperation. Robert's words were the first ones that helped restore my confidence in myself and in my decision.

A week later I was driving home after a girlfriend's wedding at the Beverly Hills Hotel. I'd gone with my friend Julie Kramer, and I was surprised to find myself having a good time. The groom was manager to some high-profile comics, and every toast had the room roaring. The highlight of the evening was Brad Pitt, dressed to kill and cutting it up on the dance floor with a little kid. That was fun, I thought to myself as I drove through the darkness. Scott's going to get well again, Noah's sleeping through the night, I'd dropped the baby weight, the house was coming along nicely . . . then it occurred to me that every month a certain biological event comes along, and so far this particular month it was a no-show. I was pregnant again.

I guess our timing could've been better—but is there any perfect time to have a child? Scott and I had siblings we loved, who loved

us in return. I liked knowing that my brother and sisters were in the world, that I could talk to them, that in spite of the difference in our ages, we had shared histories and memories. Now Noah would have that. I was excited for Noah. He would have a brother or sister. At the same time, I was yelling in the car: "Motherfucker! I'm going to be a cow again!"

And once again, Scott promised me that this time it would be different.

ELEVEN

i do . . . again

I realized early that the Lucy pregnancy wasn't going to be like the princess experience I had with Noah. Scott was in rehab, and although Noah and I visited with him, it was a long drive between Coronado and L.A. for visits that never lasted long enough. I never much liked the idea of little kids visiting rehabs. I was uncomfortable with it as a patient and nervous about it as a parent. Scott felt the same. Nevertheless, we tried our best to make each visit fun for Noah, and we spent most of our times together at a nearby park. I'm not

sure how genuine our laughter was at that point, but Noah's laughter was as pure as a child's can be.

When Scott got out of rehab, we kept a place in L.A. (on Blackburn Street, soon to be known as "Crackburn"), ostensibly so he could be close to his twelve-step group and his probation officer. I figured out pretty fast that he wasn't staying clean. I immediately went into rescue mode, putting a sleeping Noah in his car seat and driving around downtown L.A. in the middle of the night, muttering obscenities to myself while trying to spot Scott making a buy. Sometimes I left Noah with a girlfriend and searched by myself, finding him in all of our old ugly locations, begging him to get clean. During the day, I was chasing a toddler; into the night, I was chasing my husband.

Near the end of my pregnancy, Scott was again readmitted into rehab—into Brotman Medical Center, in Culver City. And then, a few days into detox, he slipped out again. I tracked him down—he'd made the break with a couple of drug-addled women who were, I say with no hesitation whatsoever, the two ugliest women I'd ever seen. I literally had to drag his dead-weight body out the door. He had just enough daylight in his head to resist my efforts, so I punched him in the jaw as hard as I could. He fell over into a bed of ivy and smashed his face on a metal sprinkler head. I then dragged him to the car and drove him back to the hospital. The whole time he was being flushed with naltrexone to cleanse him of the drugs, I sat next to him with ice on my hand. When I thought it was safe to leave, I went home to my baby. An hour or two later, he left, too, and resumed the run where he'd left off—and ended up back at Brotman within days.

———————

Not long ago, I had a long conversation with Dave Navarro from Jane's Addiction. Back in the day, when Scott was on a drug run, he'd make the occasional stop at Dave's house, and that was one of the first places I'd check, sucking up my tears and trying to sound like a wife retrieving her husband from a long football afternoon with a buddy, not a crack run through the seamier sides of town. "Hi, Dave, it's Mary. I was wondering if Scott was there or if you know where he could be?"

Everyone has a one-day-Scott-showed-up-at-my-house story, and Dave's is my favorite. Scott arrived at Dave's house totally out of his tree—in fact, from the way Dave explains his appearance, standing in the doorway with twigs and leaves in his hair and missing a tooth, he may well have fallen out of an actual tree. That man has an issue with teeth. Up until recently, he was missing one again. How or why this happens, I've never truly understood.

At the time, Dave reminds me, he himself was not in top form, either. At one point, he'd pulled a shotgun on a guy from the Los Angeles Department of Water and Power. I'm sure DWP prepares its employees for all kinds of contingencies, but a paranoid, gun-wielding customer is probably not in the job manual. As if nearly killing your utility guy isn't bad enough, Dave would also periodically call the fire department on himself for reasons he could not adequately explain. Faced with Scott minus a tooth and wearing a head full of vegetation, Dave told Scott he was out of control. You know you're out of control when a man who threatens civil employees with a shotgun and keeps a coffin as a coffee table tells you you're out of control.

Scott was shooting speedballs that day. When the inevitable paranoia set in, he tried to convince Dave that there were ghosts in his house. I'm aware this story doesn't fall under "funny, ha-ha," but it does have its own particular kind of comedy—Scott and Dave like an old married couple, bickering about the existence of ghosts. When Scott went to that place, he wouldn't back off until you swore you believed whatever it was he was trying to sell you. After hours of arguing, he finally wore Dave down: yes, okay, okay, there are ghosts in the house. The difference was, Dave's ghosts were always friendly, Scott's not so much.

I told Dave that I could only imagine what his home was like during that time, and his response was, "Come on, Mary, you were there. You came over with Scott." I was? I did? Not only could I not remember going to Dave's house, I still can't. Evidently, Scott and I went to Dave's together to play him some of Scott's new music. The music was great; even now, I think they would have been an amazing match. Dave agrees that yes, he thought the music was great and he would have loved to collaborate with Scott, but the idea of having to actually work with him was, in Dave's words, "scary." How scary do you have to be to scare Dave Navarro?

My other favorite Dave-and-Scott story was the time Scott, in an effort to convince Dave that he was totally in control of his faculties, announced that he was going out on the balcony to clear his head and write him a letter about their drug problems. Already beginning to nod off in a post-high buzz, Scott headed outside. Dave reports that hours went by; at some point, he wondered just what kind of long-ass letter Scott was writing. When he went out to check, he found Scott fast asleep. The letter said:

Dave—

My only real concern for you and I is that

That was it. Not even a period. It's fucking genius. Apparently Dave thinks it's genius as well, because he framed it and hung it on the wall.

As Scott and I got closer to my due date for Lucy, we began to panic at the idea of Scott's not being there. I negotiated a deal with Scott's team at Brotman that they would slowly lower Scott's detox meds but keep him there until I was induced, and then release him in a cogent state (ideally) for long enough to join me for our daughter's birth at Cedars. Daddy on call in a detox unit: this sounds like an odd scenario for a joyous birthing scene. But I never felt sad when Scott was in treatment—first, because it meant I knew where he was; and second, because it meant there were qualified professionals on the team again, dedicated to bringing him back from the dark side, and I could take myself off watchdog duty.

On Friday, July 19, I checked into the same birthing suite at Cedars where we'd had Noah. My mother was there to be my significant-other birthing coach, my girlfriends were there for moral support (we'd even had our hair and nails done beforehand and brought a supply of gossip and fashion magazines). I tried my best to focus only on Lucy's arrival—to bring her safe and strong into the world, surrounded by people who loved her and welcomed her with open arms. Nevertheless, after my doctor induced labor, the whole production began to look like something halfway between network news and a comedy show, as I called Scott's nurse at Brotman with

the up-to-the-minute report. For eight hours, every hour, until right up to the end, where it was every fifteen minutes, "Hello, it's Mary Weiland. I'm dilated five centimeters. Call you again soon!"

Lucy's birth was far easier and much faster than Noah's had been. I knew that Scott was on his way and did my best not to push. But there are some aspects of being a control freak that simply don't work in nature. Lucy arrived one minute before her father did. She looked, even in those first few seconds, exactly like him. He was allowed to stay with us for an hour—it was quiet and tender among us, and he looked at his little girl with so much love. But there was such an underlying sadness. And I was angry that it had to be like this. When he was taken back to Brotman, the baby endorphins kicked in and helped me get through watching his back as he walked through the door. I was so determined that Lucy's first day on the planet not begin with me shouting at her father, who was already in pain.

Lucy, Noah, and I stayed in Los Angeles for a few weeks to stay close to our doctors, and this time I had a nanny from the beginning. The migraines started again. I had two babies who needed me, and all I wanted to do was take a fistful of painkillers and sleep. Scott was released from Brotman, stayed in a hotel nearby, and came to visit me and the kids accompanied by a sober companion.

Two months after Lucy's birth—exhausted, lonely, and angry—I filed for divorce. I didn't think I could hold it together anymore, and it wasn't clear that Scott cared if I kept trying. Besides, it's not as though a threatened divorce worked any miracles. He was in the grip of something else that was taking all his energy and focus.

Not long after that, on what remained of the tattered *Shangri-La Dee Da* tour, after years of friendship and tolerance, Dean DeLeo

finally hit the I-want-a-divorce wall as well—he and Scott got into a near-fistfight, and that was the end of Stone Temple Pilots.

I didn't pursue the paperwork for the divorce—that time around. After my initial show of defiance, I ran out of emotional steam. Sad and lost, Scott stayed primarily in L.A. while the kids and I stayed in Coronado. I'd had a fantasy since the day we bought that house that I could find a normal life there, maybe even reconnect with my old girlfriends from high school, walk the kids in the sunshine, and stay out of the circus for a while. That didn't happen. I was spending too much time alone on my couch, especially after the kids went to bed and it was wine-thirty. I'd have a glass or two or three, eat crap snacks by the pound, and watch TV until I couldn't keep my eyes open any longer. Scott would come and visit sometimes, but that's what he was—a visitor. This was not the way it was supposed to go.

One night, Scott and I went to an event for the designers Dolce & Gabbana, and ran into an old friend, Susan Holmes. Susan was married to Duff McKagan, who'd been a guitarist with Guns N' Roses. Duff and two of his former GNR bandmates (Slash and Matt Sorum), plus guitarist Dave Kushner, had been working together on a new project. We exchanged phone numbers and promised to get back in touch.

A few days later, Susan called and asked us to meet her and Duff at the Little Door restaurant—our wedding restaurant—for dinner. Duff wanted Scott to hear some of the new music. "Do you think Scott would be interested in working with them?" she asked.

I didn't know if *he'd* be interested—I didn't know what, if anything, could hold his interest these days. But what *I* was interested in

was a crucial piece of information that Susan (and later, Dave's wife, Christine) passed along to me: All these guys were recovering addicts. Clean, healthy, sober, years-long recovery. I figured that if Scott was around them, he would see that guys "just like him" had families and health and creativity and rock 'n' roll. It could be done.

When we all met, I made my best sales pitch. "Just listen to the music," I said.

"It's a little hard for me, I think," Scott said.

I dug in. "Please. Just listen."

It took him forever to listen to the CD that Duff gave us, so long that we lost it, and Slash brought a new one by. Scott was reluctant. It wasn't a band that he could picture himself fronting. It wasn't STP, and it wasn't his experimental solo work.

I got so many calls from the guys wanting to set up dates, but Scott could never give me a solid answer. I finally suggested that they find a one-off just to get Scott in the studio, because I knew that once he went back to work, he wouldn't leave the studio. The one-off turned out to be "Set Me Free," on producer Danny Elfman's soundtrack for *Hulk* (the 2003 Ang Lee version).

In May 2003 Scott was again arrested for felony drug possession—he had heroin in his car. In August, Duff went with him to court, where he was fined and put on probation again, on the condition he stay sober. Early in October 2003 we finally got rid of the damn Crackburn apartment, and Scott moved into another, smaller place nearby. The kids and I stayed in the house in Coronado.

The drive between L.A. and San Diego, which in my teens had been about an hour and a half long, now stretched to three and sometimes four hours, depending on the traffic, which was usually bumper-to-bumper in all lanes. My traveling companions were two

tiny people; we had to stop along the way for changing or feeding, and then at the end of the road, there was Daddy, still fragile, but gaining five minutes at a time. It wasn't fast enough for me. I was buckling under the care of the kids, the constant worry about Scott's health (which never seemed to get any better), and the feeling that even though he was really beginning to do some good work with VR, the two of us were stuck in an old familiar tunnel with no light at the end. It was as though every morning, I woke up in the Bill Murray movie *Groundhog Day*.

One afternoon in early October 2003, the kids and I were visiting Scott at the rental in L.A. The living room was as plain a room as you can imagine. We never really stayed in that place as a family—it wasn't a home—so there was no reason to decorate beyond a basic motel motif: big white couch, matching chair, a dark wooden coffee table, and a TV. Before we put Noah and Lucy down for their naps that day, Lucy entertained us by running around with a Pull-Ups training diaper on her head. Ivana taught her to do it and she did it often, knowing that it was a predictable way to make us all laugh.

Once the kids were sleeping, the room grew very quiet. It was hard to believe that laughter had been in it only minutes before. Scott and I sat on the couch, trying to make conversation. Then I said, "I cannot do this anymore." The defeated look on his face told me that he knew what I meant. There was too much in us that seemed to be broken.

"We've failed," I said. This time, we agreed—we would go through with the divorce. Within days of that tearful conversation, the headlines hit the newswires.

Unfortunately, my attorney was with the same firm as one of the lawyers involved in the endless Kim Basinger–Alec Baldwin custody

battle—whenever Baldwin and Basinger showed up in court, the newly spawned tabloid cameras followed them and usually caught Scott and me and our relatively tame little drama in their wake.

On October 27, on Scott's thirty-sixth birthday, long after midnight, he hit a parked car somewhere in Hollywood. He was arrested again. The judge from the May case sent him to detox again and residential rehab, with four hours a day allowed out to finish working with VR on the band's first album, *Contraband.* Once again, the holidays came and went without the storybook picture of the young couple and their babies under the Christmas tree. Daddy was in lockdown again. The divorce went on; the lawyers piled up the billable hours.

For years, Scott and I spent a lot of money getting into trouble, and even more money than that trying to get out. Rehab back then cost anywhere from $30,000 to $50,000 for thirty days (and you didn't get a refund if you left early, which I did every single time until the last one). Nowadays, it's upward of $100,000 a month. We were sporadic about insurance, and in any case, when we were covered, it was only for a portion of the cost. I had a Screen Actors Guild membership from my limited adventures in acting, and Scott had his AFTRA (American Federation of Television and Radio Artists) coverage—but add lawyers (many of them) for Scott's divorce from Jannina, then for every arrest, every court appearance, the hotel-hopping (especially with the paranoia of the Chaos Tour), room service, bar tabs, staff, business managers, assistants, and the list went on for pages and pages. The bills piled up; the money disappeared. Worse, when we were high, we shopped. A good run, on the days we

could get ourselves out of the house, would find us on Rodeo Drive in a delusional spending spree, collecting an inventory of clothing that mostly found its way to the closet floor. We ran through millions. I did a little bit of modeling while I was pregnant with Noah, and a little bit more with Lucy, but it was clear I was going to have to take a page out of my mother's book and figure out some other way to get crafty.

I met Dave Kushner's wife, Christine, at Lucy's first birthday party, and as she reminds me, I was hugging the wall that day. I didn't know who to trust anymore or who to talk to. Christine and I hit it off immediately. We are alike in many ways; most important, we have the same sense of humor.

We developed our business, Double Platinum, as we began going to award shows and events together. Nearly every event featured either a gift bag or a "gifting suite"—an insane concept. You walk into a room that's been converted to a free shopping mecca for celebrities. Different companies line up tables and display their products—designer jeans, jewelry, watches, spa products, imported food, leather goods, sound systems. The intention is to put a product into a celebrity's hand and benefit from whatever press comes with that exposure. The results are seen in everything from the answers to the red-carpet question "Who are you wearing?" to the detailed captions in magazines in a celebrity photo shoot.

Christine and I were both seasoned shoppers; we decided that with our experience and the people we knew, we might be able to create the ultimate gift bag. For our first big job, we were hired by the Diamond Information Center in 2005 to create a gift bag for an Oscar Week event in Los Angeles. The DIC created a hideaway where celebs could hang out, get their nails and hair done if

they wanted, get a camera-friendly spray tan, and walk away with everything from Converse shoes to diamonds. It was a success, and it led to others—the Grammys' MusiCares event, the Boys and Girls Club Christmas Gala. The charity events were the most gratifying, because each of them was about more than taking home a suitcase full of stuff you didn't need, wouldn't use, and would likely regift. We then moved into product branding—attaching a particular artist to a particular product. One of the most fun was pairing an upscale robe company with Ozzy Osbourne. The robe, a leopard print, was the official aftershow robe for Ozzfest. Stranger matches have happened in show business, I guess.

As much fun as the challenge of putting Double Platinum together was for me, what I loved was working with Christine and seeing our efforts actually pay off. I liked making money, of course. And I really liked discovering that maybe, just maybe, I would be able to take care of the kids and myself.

Something happened to Scott in the last court-ordered rehab stint in 2003: He finally kicked heroin. I don't know how or why, and I certainly hadn't put any bets on a positive outcome. If anything, I'd have bet in the other direction. Maybe it was just his time. Maybe it was working and creating with a band of guys who'd gone down that same road and learned how to finally stop the *Groundhog Day* effect. Whatever it was, the run that had begun the day after Noah was born was finally, officially over. And so, we decided, was our second try at divorce. Maybe we hadn't yet mastered being together as a married couple, but we agreed we were pathetic at being apart. Scott was filled with resolve, and we had two little children to raise.

We'd been through our parents' divorces—didn't we have an obliga-tion to our kids to do better, to get it right? And God knows we weren't out of love.

We sold the house in Coronado to pay the lawyers' bills for the divorce that didn't happen, and once again, I went house hunting. We found the perfect little *Ozzie and Harriet* house near Toluca Lake: a simple, white, ranch-style house with black shutters. It was not a childhood fantasy; it was a real house, in a real neighborhood. Of course, we'd barely moved into our new home when it was time for me and the kids to hit the road with Daddy. Velvet Revolver's first re-lease, *Contraband,* had a great reception—ultimately, the first single, "Slither," would go on to win a Grammy for Best Hard Rock Perfor-mance in 2005—and the band was going out on tour to support it. I really wanted us all to go—Noah and Lucy weren't in school yet, and we knew there'd be a time when we wouldn't be able to do this with them. Even more important, Scott didn't want to be separated from them. And I didn't want to be separated from him.

Before the VR tour—while Scott began working with the guys putting together the new album—I had been so occupied with Noah and Lucy, as well as with Scott's and my personal issues, that it really didn't hit me that when Stone Temple Pilots hit the rocks, I lost part of my family. I knew them before they were Them, and we'd all been through a lot together. Because of the old connections to Guns N' Roses, the Velvet Revolver guys had relationships with one another that went as far back as STP's did. They had their own personalities, their own way of working and touring. It wasn't a matter of better or worse. It was just different. Once I became aware of that difference, I realized that I wasn't quite convinced that Scott and STP were fin-ished with each other.

This tour wasn't the old days; it was the new days. Some days Scott wasn't obligated to do anything besides a sound check at the venue or an interview with a local radio station or newspaper, so after a late breakfast, he was free to hang out with us—maybe a swim in a hotel pool, maybe a museum or renting a movie. It was an easy yet regulated life—the kids were tucked in early at night, the trusted nanny was with them, and I would go off to the gig with Scott. Six weeks out, a couple of weeks home, then back out again. We'd fall asleep in one city, and the buses would drive all through the night to the next. The trek to Australia was too long for the kids, but we did take them on the European leg of the tour and to Japan as well. Tokyo and Osaka looked and felt far different to me than when Model Mary was living there. Noah and Lucy traveled well on the ground, not so well in the air. Lucy's midnight rendition of "Twinkle, Twinkle, Little Star" in the first-class section of the airplane only minutes after she'd thrown up didn't charm the other passengers as it did me; the flight attendant on American Airlines, a grumpy crab cake of a woman, sternly requested that I make her stop singing. You cannot make Lucy stop singing.

Scott actually wrote the song "Fall to Pieces" the day after he was arrested, after STP had fallen apart, after I'd filed for divorce the first time. I agreed to be in the Velvet Revolver video because once again, we'd put it all back together. I trusted both him and the director, Kevin Kerslake—it was their creation. I never even read the storyboard, because I didn't want any additional anxiety over what I would have to do. I was flattered that Scott asked me to be in it, even more so that the band was okay with it. Christine and Susan played

the band girlfriends, which made that day so much easier than it might otherwise have been.

For weeks before, I sweated the two-babies-all-carbs weight gain, training like a marathoner. One morning I was on the treadmill running (okay, walking fast) next to Dave Navarro, who was fit and lean and barely breathing hard. "I am as big as a house," I gasped. "The camera adds ten pounds. What's my excuse for the rest of them?"

"It'll happen," he said. "Nobody sees themselves honestly—I think you look just fine." And then he gave me a tip. Before filming each of his own videos, he said, he always worked out like crazy, promising himself that once the shoot wrapped, all the food he loved and had been craving would be right there and ready for him to eat. (I may have overdone it after the "Fall" shoot was over; I pigged out so enormously that my stomach protested for two days.)

Once on the set, I remembered: Mary, you can't act. You never wanted to act. But I had to act in that video (and I was supposed to be playing myself). What did come surprisingly easy were my scenes with Scott. We had fun together, reliving the time when he was my driver. There was only one scene that he struggled with. We were in a bedroom, supposed to be having a big blowout of a fight. He just could not yell at me. I suggested that we each pick a word and continuously repeat it with an upset expression. We chose the words *black* and *white* and said them over and over. Weirdly, it worked, raising the intensity between us.

What I still like most about that video is Scott's honesty. He never hid his struggles, not only with drugs but with me as well. Unlike most videos (in my opinion, anyway), this one was genuine and authentic. That said, the drug scenes, the overdose scenes, were horrific. The love between us was there, but the memories

those scenes were based on were so sad. The video itself lifts into some kind of redemption for the central character at the end, but the opening guitar riff in that song still tears at my heart: "I've been alone here / I've grown old. . . ."

Full disclosure: I've never been much amused by the Grammy Awards. Aside from the live music, it's basically a giant clusterfuck. Watching in comfort at home, it's all lights and excitement, but when you're actually there, it's more reminiscent of a high school assembly. Half the audience is students hired as chair fillers; during every commercial break, a wave of artists run for the exit. Next time you watch, carefully scan the audience at the beginning and then again at the end of the show—the only talent left are the ones in the front row, which the camera catches every single time, and those whose awards haven't been given out yet. Noah was only a few months old the first time I attended with Scott. I painted on a black Rick Owens dress and tried hiding much of the night. My experience the second time around was not much better, in spite of Scott and VR being nominated for Best Hard Rock Performance, Best Rock Song, and Best Album. We'd flown in from Japan the day before, and I landed in L.A. with a massive ear infection. My head felt like it was going to blow off my shoulders—the doctor actually had to stick a crazy long needle in my ear and pop my eardrum to relieve the pressure. It didn't work. I was in so much pain that most of the night was spent lying on the floor between awards, holding my head and missing Vicodin.

At some point, some of the guys went out for a smoke; about

two minutes later, their category was up and they won. When Scott finally strolled back in, I whimpered, "Congratulations, honey, you won—can we go home now?"

Somewhere between the VR tour, potty training the kids, and trying to settle into the little ranch house, I came up with the idea of a reality show and actually pitched it to VH-1. It would be about a rock star's family, the life on the road, the life at home—former model makes sugar cookies, crazy reformed drug dad drives kids to preschool; Lucy sings, Noah wants to wear his Spider-Man costume to bed and to school and to Grandma's. Riveting stuff, no?

To tell the truth, I was mad at the media's depiction of addiction—my husband's in particular—and wanted us to be able to tell our side of the story. At the end of every year, a local FM station hosted a segment called the "Dead List," where they predict who will die in the next year. Scott was on the list every damn year. One time, Lucy overheard it before I could dive for the Off button, and I explained to her that it was the Red List—the names of everybody who had red hair that year, which at the time, Scott did.

It galled me that no one seemed to understand the seriousness of the disease we were both fighting and that addiction was fodder for a constant running joke. We had our own jokes, thanks—there's often a lot of laughter around our house and in a twelve-step meeting as well. And addicts are far better at laughing at themselves than anybody else is—but would you laugh at someone with cancer? Or heart disease? Seriously?

I thought that we had a chance to change some people's minds.

In the years since, of course, I've seen what reality TV has done to families—and to addicts—but I believed, in those first few months of Scott's new success with VR and with our renewed life together, that maybe we could shine a light on addiction. And I was thinking, too, of the addicted man or woman sitting in a dark room somewhere, needing to see somebody's victory. Maybe Scott, in his stage clothes, joking with the kids and taking out the garbage, would do it. I wanted to call it *Irreconcilable Differences*.

To my surprise, VH-1 was actually interested. They did a short pilot, following us around with cameras. But it turned out that the network didn't want to go on the road with a rock band; they wanted more domestic conflict. They wanted us to fight. I think they even wanted Scott to have a slip or two.

I learned a lot about how a TV program works, and my old bosses at UTA would've been impressed at my negotiations—I worked for a long time on that contract, and fortunately I wrote myself a very tight out clause so that we could control content (or take a walk if we couldn't). I wasn't going to volunteer for putting my family in any further jeopardy. The Weiland Project didn't go forward.

Years ago, Scott renamed May "Mary Month" because my birthday, Mother's Day, and our anniversary all came within days of one another. Most of my birthday celebrations have been dinner with my closest girlfriends, but in 2005 we decided that my thirtieth was going to be different. I was going to throw a prom. I'd never gone to a high school senior prom; I didn't have a Sweet Sixteen party. Now I would have both, only bigger. My thirtieth birthday was a *Pretty in Pink*-themed prom, at Sportsman's Lodge on Ventura Boulevard, in Studio City.

I chose Sportsman's Lodge over something fancy because it's a leg-endary old place, and the ballroom had a high school vibe. My friends Brent Bolthouse and Jen Rosero, along with their team, helped me pull it together. The invitations were pink and over-the-top fancy; the requested attire was eighties' formal wear. I chose a pink frilly dress with a Molly Ringwald feel to it, and Scott wore a tacky tux. I was a vision in green eyeliner, but when Scott walked in, I nearly fell off my chair. He had added bleach-blond extensions, and had new-wave bangs that would've impressed Jon Cryer's Duckie. When we walked into the ballroom, *Pretty in Pink* was being projected onto the walls, and the room was so pink it felt like we were in a big bubble-gum bubble that expanded as more people came in the room. Anthony Kiedis was there in a red *Thriller*-type jacket; Slash came as Slash, which worked. Steve Jones wore an eighties' Adidas track suit that was very Run-DMC. All my girlfriends—Ivana, Kristen, Charlize, Jody—came, along with Ione Skye, her brother Donovan Leitch and his wife, Kirsty Hume, Justine Bateman, and Tony Kanal and Adrian Young from No Doubt. Everywhere I looked, I saw old friends dressed as though it were sophomore year in Coronado and somebody was going to stick us with a math test on Monday. Over in the corner, a photographer was taking prom-style pictures, and everybody went right into character, making lame I'm-an-awkward-teenager poses. We had big cans of Aqua Net hair spray in the bath-rooms and lots of eyeliner for anybody who felt the need for more.

Scott and Donovan Leitch got up and sang with the band; Scott sang Modern English's "I Melt with You" (and because I overdid it in the vodka department, I don't know for sure what Dono sang; I think it was either Berlin's "The Metro" or B-Movie's "Nowhere Girl"). My mom took home videos that I wish didn't exist. In a

serious lapse of judgment, I took the stage and broke into "Like a Virgin"—even worse, I reenacted Madonna's MTV performance, rolling around the floor in my pink lace dress.

As the party wound down, Scott told me he had a surprise for me. We went back to our room and he put in a DVD he'd made of home videos and old family snapshots—it was called *This Is Our Life*. He'd been working on it for weeks, and all of our friends and family were in on it. It opened with a series of pictures of me and my girlfriends before Scott and I were together, then our time before we got married, our wedding, Noah's birth, and then Lucy's. Nothing was missing: touring as a family, every Christmas and birthday, every moment that anyone had been carrying a camera. I cried like a baby—and so has everyone who's ever seen it.

In July 2001 after six years of marriage, we renewed our wedding vows. I was working against the old waves of sadness, and objectively, when I looked around and counted my obvious blessings, I couldn't figure out what was wrong. Scott was restless and tired, and staying sober—for both of us—was becoming difficult. To be perfectly honest, we'd hit some kind of emotional wall. Between therapy sessions, marriage counselors, twelve-step meetings, and the endless family groups through outpatient rehab, we were just tired of talking. You turn your mind and will over to sobriety, over and over and over, and you sometimes wonder what of "you" really remains. Maybe all we needed was just a simple promise to be better at it this time, to do better, to do it right. Maybe without work, without the band, the babies, the cast of hundreds who were in and out of our lives all the time, maybe we could get it back to just the two of us.

Some couples take the flowers-and-candy route, some might use a weekend away or a sweet gift—at one point or another, Scott had given me all these things. But addiction is always accompanied with grandiosity; for us, nothing would do but the big gesture. So we flew off to Bali for ten days to renew our vows and start over. Again. Sunshine, sand—like Marbella, like Maui before we were married. We kept believing that peace was to be found in a place. Always another place.

In Bali we had a private bungalow overlooking the ocean, which we could hear at night, rhythmically rolling into the shore and back out again. We spent the majority of that trip in one of three places: bed, beach, or eating our way through the buffet.

For the renewal of our vows, we arranged a simple ceremony. This time, our promises to each other wouldn't be for family and friends. We wouldn't fuss about what to wear, or what to eat or drink, or what our guests might think. This was our solemn promise to each other that although we'd made mistakes, we could begin again and not look back. I was going to let go of my resentments and distrust. In return, Scott was going to give my "crazy" a free pass.

We walked down a path of rose petals toward the ocean and exchanged our vows, not in a church but in a little structure resembling a cabana or a tiki hut. We had an actual minister, too, whose English was so fractured that we could barely make out what he was saying. We had wanted to be serious, but the laughter kept sneaking in; I'm sure that everything we repeated was incorrect (maybe this explains why those vows didn't stick). Afterward, a photographer took pictures, and we toasted each other with glasses of local fruit juice. We finished the night with a private lobster dinner on the pier, under the stars. The only other people within half a mile were

our waiter and a musician playing traditional Balinese songs. It felt like this time we had done the right thing. We headed home, reconnected and happy.

On the way back to Los Angeles, we stopped in Hong Kong for a few days, and I began to feel a kind of dread about what would happen once we got back into the real world. The trip to Bali had been like a fairy tale, which would've been fine if we were fairy tale characters, but we were real. I'd asked Scott to stop drinking before we'd made the trip; he left one afternoon to "take a walk," and I thought I'd jump out of my skin. Our love for each other may have been intact, but my head was not. Before my tan could fade, I was back to being edgy and distrustful.

Once we got home, all bets were off. I went with him everywhere, including the studio. I was so scared to let him out of my sight. At first Scott liked it—who doesn't like the post-honeymoon phase? But it didn't take long before that glow wore off. He was a grown man, and I wasn't giving him any room to work. I wasn't giving him any room to breathe, unless I was standing right beside him breathing the very same air.

TWELVE

en fuego

Once home I began to lose track of time. I would wander out of the house with a to-do list, and find myself hours later at the mall, dreaming over a Cinnabon and a cup of coffee that had gone cold.

With Scott on the road and Ivana and Kristen leading their single-girl lives—and me having two babies, which made it tough for us to do our old fly-by-the-seat-of-the-pants routine—I often went for whole days without talking to another adult unless Christine and I were planning an event.

Happily, Jody Britt and I had gotten back in touch, and since her freelance work gave her some flexibility, we began to spend time together. Jody had known me for years, and she noticed things. She wondered why I didn't answer my cell—had I turned it off? Half the time I forgot to put it back on the charger in the house or the car, and the battery simply wore down. "I don't know what's the matter with me," I told her. "I have so much now. I should be happy. I thought I was happy."

She shook her head. "I've known you for a long time, Mary. Everything around you right now feels heavy, incredibly dark." She stopped, as though deciding whether to go further. "It's like you're drowning, just trying to keep your head above water."

"No, really, I'm okay," I assured her. "I just need to get it together a little bit."

For a while, I threw myself into decorating the house. And then I decided that the problem *was* this house. What we needed was another, bigger house. It started out as our *Ozzie and Harriet* home, but somehow had turned into *Nightmare on Elm Street*. So I started shopping again—for houses, for new clothes for the kids, for something to do. I planned birthday parties, holiday parties. I read and reread all of Scott's contracts, all the financial statements and royalty reports, and I arranged his schedule. I worked for ten, twelve hours at a stretch. Then I fell into bed with a crashing migraine, leaving a message on Jody's machine, begging her to come and help me with Noah and Lucy. I didn't know who I could trust. Was this real life?

One day, a few months after Bali, when Scott was in L.A. between tour gigs, I just got in my car and drove off. I didn't know where I was going or why. I drove and drove and ended up in Palm Springs. I checked into a five-star hotel, thought about getting a spa

treatment or ordering room service, and just started sobbing. How spoiled, how worthless I was. Why did I think I deserved any of those luxuries, the ones I used to take for granted? I didn't deserve them. Suddenly I couldn't get out of there fast enough.

But I wasn't ready to go home. So I checked into the nearest Best Western; once I made sure the bed was clean, I lay there for the next two days. I never ate, and I never picked up my cell phone, which simply rang until it stopped. Unbeknownst to me, Scott had called his mother for help—he had to get back to work. Velvet Revolver was finishing up their second album, *Libertad,* plus he had a solo album in the works. He couldn't just stop everything. I cried and slept, and woke up and cried some more. Nobody is going to forgive me for this, I thought.

Finally, I called Scott, and he came to get me. He'd been drinking when he got there. But I'd been missing for three days. Giving him a lecture on responsibility didn't seem timely. And besides, I was really glad to see him.

I promised him I'd find another doctor when we got home; I promised to straighten up. Christine and I had some upcoming jobs for Double Platinum, so of course I had that to look forward to and work on. I could do this. I could pull myself out.

A friend recommended a woman psychiatrist, who was very professional in our first meeting. I didn't want to get into an endless recitation of my drug history or my marital history, or make a commitment to months of analysis. I just wanted some help with how I was feeling. I explained my history with certain meds: Ativan, prescribed after Noah, had made me jumpy and irritable, and Xanax had never relaxed me—it just made me feel impatient, even angry. She prescribed both Prozac and Xanax, thinking that maybe they'd

work better together. I was skeptical—it felt like she wasn't listening to me—but okay, I'd give it a try. I didn't want the black cloud back in my life. I had too much to do.

We'd found a new house, in Sherman Oaks. It was massive, on a big lot, with a big pool. We'd never had a pool before. The antidepressants will kick in, we'll move, and everything will be all right.

In the first week of March 2007, VR drummer Matt Sorum's little brother Daniel, then only eleven years old, died after a brutal battle with brain stem cancer. Scott and I could not conceive of the pain Matt and his family were going through at the loss of this child.

A week later, I was in Park City, Utah, at the Sundance Film Festival with Christine, hosting a swag suite for Double Platinum. We'd rented a house and set up companies like Tommy Hilfiger and BCBGMAXAZRIA in the different rooms. At night we'd scheduled parties with live music. It was going to be a big week, and we were expecting a lot of celebrity traffic.

The first day we were there, I received a phone call from Scott. In his hoarse and choking voice was an agony I'd never heard before: His brother Michael was dead. "Baby, come home."

I got to the airport as soon as I could, knowing, as I sat waiting for the next flight to Los Angeles, that Scott was on his way to identify Michael's body. He'd died in his sleep. We assumed it was drug-related, but nobody knew for sure yet. Ultimately, the cause of death was given as hypertrophic heart disease—cardiomyopathy—exacerbated by the effects of multiple drugs.

Michael had two little girls—all I could see in my head were their faces. I sat with a perfectly stiff posture, clutching my boarding

pass, taking deep breaths, trying to focus my eyes on the back of a man's laptop across from me. I thought of that long-ago awful morning in the Mondrian Hotel, Scott and I beating on Michael to wake him up, soaking him under the showerhead. Michael fought, he fought as hard as Scott did, and now he'd lost. What if it had been Johnny, my brother? How could I ever live through the rest of my life without my brother? I ran to the ladies' room and hid in a stall, rested my head up against the cold metal partition and began my own hysterical cry. It took everything in me not to fall to the floor. Every possible version of how I could lose everyone I ever loved flew through my mind like a slide show. I'm not sure how I made it back to the gate on my own.

I don't remember actually walking onto the plane or sitting in my seat. I couldn't release the visual of Scott standing beside his dead brother's body. This wasn't anything like what I'd seen on TV; this was real. Two broken boys. Only my broken boy would still have to get up every day, make coffee, and brush his teeth. I couldn't imagine how he would actually do that. I thought of the scabs on my arms in the heroin days, never healing, the skin never really becoming new again. How does anybody ever heal from this? Scott's parents and stepparents, Michael's widow and their two little girls—there wasn't enough scar tissue in the world to cover this wound or make it whole again. Something in Scott died that day, too. There was nothing here I could fix. There was nothing anyone could fix.

Families are weird machines sometimes. All of the different personalities, the mix of memories, the who-said-what-to-whom, the arguments, the old scripts we play in our heads when we're together

and when we're apart. The food, the joy, the silliness. All of that, and something more, connects us even through the years we're doing our best to get away. And then comes loss or grief—the big cosmic magnet that pulls us back together.

Scott's family spent the majority of the following week at our house—they were actually staying a couple of blocks away from us, within walking distance, at the Graciela Hotel. I had no idea how to help, and in the deepest part of me, I knew there was no help to be given. But in my mother's family, all occasions call for food, so that was my first priority—pounds of Sees candies and an insane amount of baking. I always make pumpkin pie. People like it, it makes the house smell good while it's cooking, and it's one of those foods that just feels good to eat. So I started making pie. I also made a major Costco run and brought home wine. Not just a bottle, but cases, all varieties of white and red. I uncorked the first bottle and didn't stop until Scott's grief-stricken parents got back on the plane for Colorado.

My relationship with Scott's parents will never be anything but fractured, but Michael's death brought the cousins together. Noah, Lucy, and Michael's daughters, Sophia and Claudette, spend more time together now than they ever did. Kids are more straightforward than grown-ups, more basic somehow. They were sad, but they were also little enough to play, and to get lost in whatever game occupied them at the moment. Noah found a large picture of Michael and hung it in his room. I can sometimes hear him telling his guests that it's a picture of his uncle who died.

Not long after Michael's death, I took the four kids to Chuck E. Cheese. Before Michael died, for some reason he'd taken the family's little Jack Russell, Kobe, to stay with Scott's parents in Colorado. Jack Russells are notorious escape artists and faster than lightning;

the dog made a break one day, went missing for a few hours, and was eaten by a mountain lion. On our trip to Chuck E. Cheese, the kids had been chattering away, and then suddenly one of those silences fell where you brace yourself for whatever's going to come next. And then Claudette, then only four, announced in her sweet little voice, "My daddy died, and Kobe got eaten by a mountain lion."

I wasn't sure what to say, but before I could come up with anything, all of the kids started laughing. It was that kind of rolling, helpless, exhausted laughter that doesn't stop, even when little kids are hollering "I'm going to pee!" We laughed all the way to Chuck E. Cheese, we had a good time, and then we laughed again on our way home. I pulled into the driveway and looked back at all the sleeping kids and felt for the first time that maybe everyone would be okay. Everyone but Scott.

He'd started drinking somewhat heavily even before Michael's death, but that loss was too much for him to carry without medicating. He felt guilty and responsible, and he felt like an actual part of his physical body was missing. It brought back a kind of paranoia that I hadn't seen in years. He was convinced I was cheating on him, accusing me of being with every man and sometimes woman I came in contact with. He was so certain I was unfaithful that at times he even had me followed by private investigators.

I saw them tailing me, but until Scott actually confirmed who they were and why they were everywhere I looked, I just thought that L.A. was crawling with creepy guys. Once he explained what was going on, I told him that whatever he was paying them, he was being hosed. They were not particularly skilled in the "private" part of "private investigator." And the excitement of my daily round of chores probably put them to sleep in their cars.

To be fair, there were some random incidents that might've sparked anyone's curiosity. On one occasion Scott went to pick up a prescription for me, and the pharmacist handed him birth control pills with my name on it. I'd never had a prescription for birth control meds. It was an error on the part of the pharmacy. But Scott was livid and would not believe that it wasn't mine. To this day, I can't convince him otherwise. There were so many of these *Three's Company*–type misunderstandings—he was like Jack Tripper overhearing part of a conversation, filling in the blanks, and taking it for the truth. I have never cheated on Scott or any other man in my life, and it made me angry for him to believe that I would. Didn't we have enough on our plates without his unwarranted distrust?

And I didn't much like the effect the Prozac and Xanax were having on me, either. I felt jacked up and angry all the time. I was going for chill, and it was not happening. This new shrink was just not working out, I thought. I decided to stop going to her and to stop taking the drugs, too—once the move to the new home in Sherman Oaks was over and we were settled in, I'd go back to Bernie and figure it out.

Scott was going into the studio every day working with VR; Noah and Lucy were six and four, wanting attention, needing reassurance and affection, surrounded by packing boxes and the chaos involved in being half out of one house and half into another. I could feel a rage building inside me at the messes under the two roofs, and finally insisted that Scott take the kids and go away for a couple of days. "Just go, go," I said. "Please take them someplace. I need to do this alone, and I can't think." He took Noah and Lucy to the Graciela Hotel, just minutes away from our house, and they settled in for a Dad-and-kids sleepover.

If I can just sleep for a while, I thought, I can start all over again. I climbed under the covers and couldn't calm myself down. Sleep wouldn't come. I closed the blinds, tried again—nothing. I reconsidered my decision about taking the Xanax—I always hoarded pills, I never threw them away, and the prescription bottle was still in the medicine cabinet. I got up, took a handful, and nothing happened. I decided to go see Scott and the kids. Uncombed, unshowered, I got dressed, putting on a beautiful deep-red Marc Jacobs dress. Looking in the mirror, I realized it was the one I'd been wearing when I ran away to Palm Springs. I thought I liked that dress; now I hated it. I picked up a pair of scissors and began to cut the dress to shreds— while I was still wearing it.

I drove to the hotel, valet-parked the car, and stomped into the lobby. I got Scott's room number from the guy at the front desk, who had an odd expression on his face. My dress had obviously been torn to pieces; it probably never occurred to him that I'd done it myself.

When I got up to the suite, Scott was in one room; his assistant was in the other with the kids. Scott looked up at me in surprise.

I was sobbing and out of breath. "You need to fix me! I can't fix myself. I don't know what's wrong. Make it stop. You need to fix me! Now!" I was yelling and crying. It was the language of the Chaos Tour, but hard drugs didn't offer the kind of fix I was begging for. I didn't know what I meant, I only knew that he had to do something, and he had to do it as soon as possible.

He tried to talk me down. I told him I'd taken a couple of Xanax, but they weren't having any effect. "You can't be like this in front of the kids," he said. "You're too jacked up, you're not making any sense. Maybe you should stay here and get some rest, calm down

some. I'll take the kids home." He sent his assistant downstairs with Noah and Lucy.

I ran to the minibar and started opening the tops of every little bottle. I drank vodka, bourbon, scotch, and gin. I found a stash of Vicodin in my purse and took those, too. I was moving so fast Scott couldn't stop me. "I'm leaving," he said. And then he did. At which point, I picked up a TV remote and threw it into the mirror. I tossed the bedside lamps into the television set and pitched the clock radio into the wall. Anything in the room that could be broken, I broke. I threw a glass into the bathroom mirror, and the shards flew back at me, cutting my hands. I tried to clean the blood from myself, gave up, and dumped the trash cans on the floor. And then I passed out.

I woke up to see two policemen staring down at me. The blood-colored dress was shredded; there was blood on the walls and on the bedsheets. Would I like to explain to them exactly what had happened here? Then I heard the old familiar words: We're going to have to take you down to the station. I learned later that soon after Scott left me there, his attorney had called the hotel to pledge that we'd pay for all damages, immediately. Then the hotel called the Burbank Police Department.

When I got to the police station, I discovered that the police had summoned Scott and the children as well. That just made me angry—why drag the kids into this? My hour of drug sleep had barely dulled the rampage I was on, and instead of answering the cops' questions, being properly ashamed, and doing whatever it'd take to get myself out of there, I started mouthing off at them. For one thing, let's talk about those ugly polyester pants and sports coats that passed for cop civilian wear. "How am I supposed to take you seriously when you're dressed like this?" I asked. "Is this casual Friday?

Or maybe you're not really professional detectives. I don't have to answer any questions if you're not professional detectives."

They put me at a table in a little conference room with Noah and Lucy so that they could question Scott separately. Scott had brought his attorney along. In retrospect, I might've done the same, but it made me even angrier. I tried to focus on my babies, but my insides were rocketing around like I'd swallowed bullets.

"Mommy, what happened to your dress?" Lucy asked. There was something very small and quiet in her voice. Noah just stared at me.

"I never liked this dress," I told her. "Now I won't have to wear it anymore." The cops brought the kids burgers and fries, as well as coloring books.

I knew decisions were being made about me in the other room, but no one was consulting me, and I didn't know what was going to happen next. Someone came and took away my children—they left the station with their daddy and his lawyer. "We hope you're going to calm down now, Mrs. Weiland," I was told. "We've settled up here for the time being. We'll take you back to the hotel to retrieve your car, then we strongly advise you to go home and sleep it off."

When I drove into our driveway at the *Ozzie and Harriet* house, there was no evidence of anyone being home. Sure enough, the house was empty. Scott had taken the kids to his manager's house and headed for LAX for a prescheduled trip to Chicago. I finally got him on the phone. "How can you leave me now?" I asked. "Something's clearly wrong here, I can't fix what's wrong—and you're leaving town—why?"

"I have to finish my solo album," he said flatly.

"Please come home," I pleaded. "I need you."

"I can't," he said. It was as though I could hear him backing away from me.

"If you don't come home right now," I shouted, "I'm going to set fire to every single piece of clothing in your closet."

"Go to bed, Mary," he said. "The kids are with my manager; they'll be okay there. Calm down. We'll talk later." And he clicked off his phone. I called and called, and he never picked up. The idea of my children being taken from me made me insane.

I headed back inside and straight for Scott's closet. I grabbed every expensive designer piece of clothing he owned—Louis Vuitton, Yves Saint Laurent, Christian Dior, Armani. Suits, jackets, vests, shirts, sweaters. I knew which items he truly loved, and I knew almost to the nickel what he'd paid for them. Load by load, I dragged them all out onto the driveway.

I had the spark lighter in my hand when I called Scott one more time. Straight to voice mail. Then I called Christine Kushner. "I'm standing in my driveway with all of Scott's clothes," I told her. "He's on a plane. I can't believe he left me all fucked up like this. I can't get my head to work, and he left me. I'm gonna set fire to all of this shit!"

"No, Mary!" she said. "Come on, you know better. Setting fires is not a good form of conflict resolution. Hang on, I'm coming over. Dave's gonna bring me over. Don't do anything. Hold on, I'm on my way."

I paid some attention to her words—I went into the garage for a fire extinguisher, just in case. Then I came back outside and lit everything up.

The bonfire was huge and very pretty. Everything went up in smoke quickly, except the shoe leather; the Guccis took the longest.

The news reports said I'd torched ten thousand dollars' worth of Scott's clothes, which was wrong by a factor of eight. He was somewhat insulted at their estimate. "Eighty thousand dollars, Mary," he said later. "Eighty thousand."

Christine and Dave Kushner came around the corner just as the flames were dying down. She was eight months' pregnant at the time—going to a crazy lady's fire was not her husband's idea of what she should be doing today. But Christine is a Jersey girl: She does not back down for anybody, and she'd come to rescue me. I was squirting everything with the fire extinguisher, turning the smoldering ashes into a damp pile of smelly mud. "Calm down," Christine said. "Come on, calm down."

"Don't you get it? I CAN'T calm down. If I could calm down, I'd calm down!"

My bonfire had gotten the attention of the neighborhood; one by one, neighbors came out into their yards, and people driving by in their cars slowed down to spectate. No doubt somebody had called the police. Frantically, we scrambled to clean up the mess. Christine brought pots of water from the house; we got the gooey debris into the trash can, then hosed down the driveway. I was rushing around like I was on speed, and my mind was still racing—Scott was on that damn plane. Wasn't he going to be surprised when he heard the news!

I was in the house when Scott's assistant drove up with the kids—I have no idea whose idea it was to bring them back at exactly that moment. According to Christine, they got out of the car big-eyed and scared, and she and Dave tried to talk them into coming into the house. They'd had a god-awful day. Dave hurriedly took them into the house, into Noah's room.

I don't remember doing this, but Christine tells me I jumped into my car and drove away; minutes later, the cops pulled up.

"Why are the policemen here?" Noah asked.

"Because Mommy got mad and burned all of Daddy's clothes, that's why," Scott's assistant helpfully informed them. Idiot.

While I was driving around, Christine was frantically calling me, telling me to come home, that the cops were there, and they were poking through the mess. I turned around and drove back to the house.

When I got out of the car, I was reminded by the looks on everyone's faces that I was still wearing the shredded red dress I'd been wearing at the station house earlier that day. "Mrs. Weiland," said one officer, "we've had just about enough of you for one day."

"No, really?" I said. "Well, guess what. I've had just about enough of you, too."

They explained that it was against the law to set fires in a driveway. "It's my driveway," I said, "and those are my private possessions!"

Christine was doing her Jersey Hammer thing on my behalf, explaining that she and I had everything under control now. "Everything's okay now," she promised.

"And anyway, there's no fire anymore," I said, "just a lot of wet crap in a trash can. I just don't see what the problem is."

"Do you want us to arrest you?"

"Want you to arrest me? What kind of idiot do you think I am? Sure, what the hell, arrest me." The expression on Christine's face told me I'd just crossed the line. But I was still in the look-at-me-now-I-can-fly stage.

They slapped the cuffs on me—literally, slapped them on. I still have a little scar on my right wrist. A few days later, I looked at it

and thought, Well, there goes the hand-modeling career. "You can't arrest her," Christine pleaded. "She's sick, there's something wrong with her."

"She said she wants to be arrested."

Christine called my mother—she and Mark now lived in Texas—and Mom told her that my sister Julie and her now-husband Ian were in Los Angeles. Dave and Christine stayed with the kids until Julie got there, and then went home, as scared as I was.

At the police station, I was bouncing off the walls of the cell. I couldn't sit still, I kept walking in circles, I couldn't stop moving. A voice came on the intercom: "Mrs. Weiland, please sit down." I can't, I can't. It was three o'clock in the morning. Who could I call at three o'clock in the morning?

A woman at the jail told me that there was a bail bondsman across the street—did I have any money? Did I have any property? Because if I didn't have a previous criminal record, I could probably bail myself out. Sure enough, the bail guys said they'd cover $50,000 bail if I could produce a nonrefundable deposit of $5,000. I could, I said, but everything was in my wallet—could somebody drive me home? They were a full-service setup; in half an hour, I was home, the bail bondsman had my credit card information, and I was walking around in circles in the house as the sun came up, wondering what the hell had happened.

Scott got home the next morning. The news headlines were loud and ugly: "Burn Baby Burn." "Bipolar Made Me Do It." "This Is How Betty Broderick Began." "Scott Weiland and Wife's Bonfire Blowout." Child Protective Services arrived to investigate the status

and safety of our kids. My head was still speedy and muddled, but I had the presence of mind to change my clothes. We scheduled a meeting in the CPS offices for later that afternoon, where I was going to be expected to explain why they shouldn't believe I was an unfit mother.

Scott tried to explain that I'd been ill, that he suspected I'd had a bipolar episode but had not yet been treated for it, that I had no previous record of doing anything like this, and that the children were not at risk. This didn't appease CPS—they were in our lives now, and they were going to stay there while we dealt, item by item, with a list of requirements. More therapy for me; couples therapy for me and Scott; therapy for the kids; and a thorough psychiatric exam for me, ideally inpatient. In other words, I was going to the psych ward. And the sooner it all happened, the sooner I would be back home with my children.

Scott explained to them that he had been in touch with a psychiatrist he knew, a Dr. Timothy Pylko, and with his help, they were finding me a good place to stay and get treatment. He promised me it would be a day, maybe only two—they'd get me on the right meds, we'd figure this out, it would all be all right. CPS agreed to the plan, and we left.

Scott drove me to Las Encinas, trying to soothe me. There'd be little cottages, he said. They'd be nice to me, he said. Admission was purely voluntary, he said. "This is up to you, Mary. You need to do the right thing. You need to get well for the kids. Don't you want to get well?" Couldn't I please just get well at home? Did I have to go into an institution and be locked up? We sat in the parking lot and talked, and I cried for two hours; in the end, I would not get out of the car. I wouldn't even unfasten my seat belt. Some staff members came out to

assure me that everything would be okay, but I put my hands over my ears and wailed. Locked up, locked up, locked up. Alone. Paralyzed with fear, I could feel my eyes bugging out of my head.

"Mary, I've got to go to band rehearsal," Scott said. "I've got to go, and you've got to stay. If you don't do it on your own, CPS can force you, and the place they'll send you won't be like this." We went back and forth for hours—and then, inexplicably, we drove off to a dive bar and proceeded to drink. And drink.

It was close to midnight when I finally signed myself in. I was full of alcohol, but still pacing and wired. We got the paperwork filled out, I agreed I'd stay for three days, and then Scott got up to leave. "Where are you going?" I yelled. "You can't leave me."

"I'm just going out for a cigarette," he said. "You'll be fine."

Once out of earshot, he told the staff that under no circumstances should I be allowed to check myself out. They told him that since I'd checked myself in, they couldn't go on his word alone, and had no authority to keep me there against my will. "She's suicidal," he told them.

That changed my status. I was now officially in lockdown, in a room off a long corridor, with the famous hospital overhead lighting, and I was to be taken somewhere else—four guys were coming to get me. I panicked. I spotted a pay phone just on the other side of the room.

I picked up the phone and called 911. "Help me, please. I'm being held here against my will. My husband's had me locked up, and I can't get out. Please, you can hear that I'm okay, right? I mean, this is a perfectly normal conversation, right?"

The operator said, "I'm sorry, miss, I can't help you. I see on caller ID that you're in a psychiatric ward. And we can't assist anyone in a psychiatric ward." I clung to the telephone long after she hung up.

"Mrs. Weiland, we have to go now," said my attendants. "If you don't come on your own, we're going to have to carry you, and then we're going to have to strap you down."

I'd run out of options. "Okay, I'll walk."

They walked me into a building that was completely fenced in. The roof even had a fence around it—no jumpers from there. There was coded security at the door; they had to buzz in. Only moments before, they'd offered me a tranquilizer shot, and I'd refused it because I didn't want to be doped up and drooling in a mental hospital. Now I was in an institutional room with bars on the windows and beginning to rethink the decision not to have the shot. I was in the loony bin.

You know the way an animal looks when it's cornered—a mouse cornered by a cat, a little dog bullied by a big dog? Their eyes widen, their shoulders come up around their heads, and they freeze their bodies so tight that every muscle twitches in protest? That was me. I share a birthday with Salvador Dalí, and my clock was beginning to melt.

After the gate and door were locked behind me, I sat on the couch in the main room and tried to pull myself together. I think the nurse took pity on me after I told her what happened, so she let me use the pay phone to call my mom. It was five in the morning when she picked up. Thank God she's a light sleeper. Through my tears, I told her how scared I was and that I needed her to get me out. "Mom, they put me in a cage."

I gave her the main office phone number, and she told me she would figure something out. Waiting to hear from her again felt like

an eternity. I called her back about twenty minutes later, and she broke the bad news—I was stuck there until the next doctors' shift began at nine A.M.

I could no longer handle the goings-on in the main room. A man who kept unbandaging and examining his bleeding foot and an old guy wearing a hospital gown with his ass out and a catheter dangling at his knees was just too much. I went into my room and sat on the bed. I was so run down, nothing would've made me happier than sleep. But I was afraid that if I slept I would lose control of the situation. Which is kind of funny, because how much control can you have when you're locked in a cage and you're not holding the key?

At nine the next morning, the troops arrived: my dad, my brother, my aunt. And a psychiatrist I'd never seen before. Not Dr. Pylko. "I want Dr. Pylko," I said. "Scott said I would have Dr. Pylko." I thought about digging in, but it became clear to me that this doctor was the one who would get me out of there.

With my family around me, we finally talked him into releasing the seventy-two-hour hold, which he did only on the condition that I take a sedative and someone stay with me at home until I could see Pylko. My dad said he'd do it and that there would be no time I was alone or unmonitored.

Thankfully, we'd gone outside to sit at a picnic table while the doctor looked at my chart. I looked at the fence surrounding me and above me and felt like I'd been admitted to a bird atrium. For liability reasons alone, it was a major struggle to inch my way out the door. Finally, I was released into the custody of my family, who promised to keep me settled and make sure I showed up for my appointment with Dr. Pylko. We crammed into the front seat of my dad's truck and started the thirty-minute drive back home.

I'm sure Dad and Johnny were wondering whether or not they'd made the right choice, springing me from the funny farm. I'd like to know who coined the term *funny farm*. True, you are treated like an animal, so I get the farm bit—but where's the funny?

When we got home, we all fell on the couch. Now that I no longer had to play normal, my head dropped the flag and I started racing again. What anyone said or did at that point, I have no memory of. My sister Julie and her now-husband Ian came back to the house to help out. The sedative slowed down my body, but it had no effect on my mind at all. I tried sleeping but got nowhere, so I just laid in my room staring at the wall. My dad, brother, and aunt left after it was obvious that Julie and Ian had it covered, and I wasn't going to go bananas again.

When Scott finally came in, I surfaced. "You had me locked up," I said.

"I know," he said. "And you had me locked up once, too. You knew it was for the best that time, and so was this. You need to give in to the medication now, Mary—I'll stay with you. Tomorrow, we'll go see Pylko."

I was as far down into a black hole as I'd ever gone. As I finally fell into something like sleep, I wondered if anybody existed who could truly dig me out.

On April Fools' Day *2001*, Scott went with me to my first appointment with Dr. Pylko. I couldn't see myself from the outside. I wasn't able to sit still, I needed Scott's hand to hold me down, and I was scared. I didn't want to go anywhere without him. I needed him to explain to the doctor how I was acting, why I was acting like that,

what was wrong with me. I couldn't remember half of what I'd done (I couldn't believe half of what I heard), and I could not make any connection between my body and my mind. It seemed as though each part of me was making its own decision about what it wanted to do without asking my permission.

Many other doctors, therapists, and addiction specialists had passed through Scott's and my life—at rehabs, in family groups, in hospitals. On some basic level, even through my fog, I felt that I could trust Dr. Pylko. If all I'd wanted was a quick diagnosis and a prescription for painkillers, it wouldn't have mattered to me if a doctor was good at his job. But I'd come to the end of some kind of road and instinctively sensed that competence mattered a lot. Dr. Pylko seemed tall to me that day (of course, I felt very small), with graying hair and beard, rimless glasses, eyes that held no criticism. Not an "egghead"—more like the cool science teacher you wish you'd had. Hanging on to Scott as though he had custody of the lone oxygen tank, I struggled to focus on Dr. Pylko's calm voice and what it was saying. I knew my life depended on it, and I knew my children's did as well.

He gave me a test called the Young Mania Rating Scale (YMRS). It's not named after young maniacs—it's a clinical questionnaire. The doctor asks the questions, the patient answers. Eleven questions, asking me about things like "flight of ideas" (I had many of them) and "incoherent communication" (I had a lot of that, too) and "disruptive-aggressive behavior" (check). The highest rating is sixty, the lowest is zero. Anything between zero and twelve is considered in the normal range of response; between twelve and twenty is hypomania—elevated manic state, but still functional. Anything above twenty is mania. I scored a thirty-one. God knows what I would've scored the day before.

"That's serious, Mary," said Dr. Pylko. "In almost any circumstance, it would require hospitalization."

And then slowly, he began to help me unravel the mystery of what had gotten me into so much trouble. I would like to explain it myself, as I've attempted to do in earlier chapters of the book, but at the point at which we met, I wasn't taking notes or reading books on my own various disorders—I didn't know what they were. I knew about addiction, and Bernie had worked with me endlessly about the issues that Scott and I had together. But this was different.

"That day I first met you," Dr. Pylko tells me now, "you were what we call 'floridly psychotic'—manic, but somehow composed, despite a lot of psychotic symptoms. You wanted relief from the symptoms, but you didn't want to be drugged into unconsciousness—you were fighting for clarity, not surrendering. You had suffered inordinate stress that year, and for years before that, and what happened to you was a culmination of an accumulation."

Humans are rhythmic beings, like animals, he tells me. Our bodies and brains are calibrated for certain activities at certain times (like, say, sleep once it's dark, and nutrition once we're hungry). But there is very little that is rhythmic or organized about our contemporary lives. There was nothing rhythmic about my life that first day. "Loss, grief, the houses, being on the road, swinging back and forth between a picture of a life and the actual realities of your life," he says. "And finally you broke.

"An easy way to think about bipolar disorder is to consider allergies," he told me.

"Allergies are a disorder of the immune system, misidentifying antigens as toxic and then attacking them—it's not the pollen that makes us sick, it's our body's reaction to pollen. Bipolar disorder is

cellular, but it can become a kind of allergic reaction to stimulus. In disorganized thinking, you perceive yourself as attacked, so you react—but that may not be what's going on at all. In a downswing, you feel worthless, hopeless, and at the end of possibilities, in spite of all the objective truth of everything good you see around you—children, home, material comfort. You can't make it carry any emotional weight. In an upswing, you feel bulletproof, smart, tireless, and brilliant—you work long hours, you don't sleep, your mind races. You had all of this, and the side effects, too: substance abuse, compromised judgment about decisions. You were spinning in ways that literally threw you off center."

The meds for depression went to the wrong part of my brain, which is why they only made things worse. And then, when I abruptly stopped taking them, that made the worse even worse. Like speeding in a car, which is risky, and speeding on an icy road, which is even riskier. If I'd gotten a correct diagnosis—or, to be honest, if I'd paid attention when the possibility of bipolar disorder was mentioned years before—I might've avoided both the bonfire inside my head and the one in my driveway. No way to know.

This is information from Dr. Pylko about the genetic component of bipolar disorder, which, before I understood it, scared the hell out of me in terms of my future and the future of our children. It's what explained Bernie's remark about being "front-loaded" for addiction:

The Human Genome Project has identified more than thirty thousand genes that code for all kinds of behaviors, and no one gene codes for only one thing. There is no single "addiction" gene per se, there is no single mental illness gene, any more than there is one

"artistic" gene, or a gene that makes it easier for some people to balance their checking accounts or obey the speed limit. But there are genes that show distinct strengths and weaknesses. Some genes code for multiple uses: a genetic predisposition to substance addiction might also carry with it a genetic predisposition to creativity, or athleticism, or perfect pitch. But if that person is never exposed to baseball or music, or heroin or cocaine, that aspect of that gene set may never turn on. The child of a diabetic will not automatically become diabetic, but might inherit a vulnerability. Genes are not destiny, they are information, and when we have the information, we can usually (to the best of our abilities and resources) make our choices accordingly. But often, we don't have the information. Just as often, the information isn't enough. It's the difference between having a shopping list of items and having a recipe to put them together. As much as we've learned about the brain, we've learned that we are just beginners.

I was caught in what Dr. Pylko called a "perfect storm" of vulnerability: a genetic predisposition to addiction, a great deal of emotional disorder and trauma in my young years, the early drug-and-alcohol experimentation that tripped me right into addiction, and the ongoing daily craziness of our lives. That doesn't mean that the life of a model or a rock star is automatically wired for disaster—it simply means that if all the ingredients are there, the odds for disaster go up. He also told me that there was ongoing research into genes that might code for resilience—that just as I might be predisposed or vulnerable to bad things, I could also be predisposed for good ones. Creativity, maybe. My love for music. My sense of humor. Maybe that was all genetic, too.

I asked him why it was only the depression that the other doctors kept seeing, and that I kept feeling, when this other half of me

existed and nobody really seemed to have pegged it correctly. "With some manic episodes, people don't remember, or they're not reliable witnesses about their own behavior," Dr. Pylko said. He told us of a patient some years ago who bought three cars in a day. The man was wealthy, so his big buys didn't seem extreme or manic to him; in fact, he had to be reminded that he'd done that. I'd been having intermittent manic episodes for years—for example, much of the chemical charge I got from the drug-run years was from the risk, the edge of it. That was as much about mania as it was about addiction: the chronic sleeplessness, the constant arranging/rearranging, and, of course, the trip to Palm Springs.

Yes, he said, there were drug therapies for bipolar disorder, and we'd begin trying them, but I couldn't just grab the meds and run—I had to have a plan. Talk therapy was going to be a part of it; trying to make my life consistent would be another part. And I had to take my health seriously. Bipolar patients have a significantly higher risk of cardiovascular and respiratory disease, cerebrovascular (stroke) and endocrine (diabetes) disorders as well. This isn't just self-indulgent neurosis we're talking about—it's about my wanting to be around when my children have children. I had to get going on that plan immediately.

In addition to the meds and the talk therapy, he said, there were "side" prescriptions: common-sense stuff. "If you want to have optimal stability, you've got to have an optimal life," he said. Regular bedtime, regular wake time, nutrition that works, a routine that keeps all the machinery in working order. Is this how normal people lived? What would I have to give up? Staying up all night, evidently. Vodka-water with a slice of lime, probably. Drama, maybe. Did I have to be bored, or boring, in order to be well?

"Even in 'normal' life," he said, "ambition or circumstances can work against the stability prescription. I don't sleep eight hours—I barely get six, and nutrition goes to hell for days at a time. Then I oversleep on weekends, and we pay a price for that, too, especially as we age. I eat on the run; the cell phone's always at me. But once you become aware of what it costs you, you'll start to make small adjustments. It won't feel like giving things up; it'll feel like taking your life back into your own hands. In the meantime, the meds will help you get the calm and focus that you need to make these changes. It'll take time, but I believe you can do it."

It wouldn't all be roses, he cautioned me. Addiction recovery, or accepting a diagnosis of a mental disorder, both often require what he called "the mourning of the healthy self." I thought I was this person, it turns out I'm that person. The sorrow of that can be a relapse trigger in addiction recovery, and it can kick off depression again as well. It's humbling. Ultimately, in order to take care of myself, I had to accept my life. If I didn't, I'd stay sick. It wouldn't be as simple as that, of course—figuring out the right treatment and strategy for me might take years. I might be fighting for it for the rest of my life.

"Ultimately, it's not about defining yourself as 'defective,' Mary," he said. That was reassuring, since I'd been defining myself as defective all along. "It's not about surrendering—it's about claiming. It's about figuring out how to live your life. Which is ultimately the goal for everyone, isn't it?"

After this first meeting, I saw Dr. Pylko as often as I could and spent the rest of my time at home, trying to reconstruct the events that I'd been the center of. The faces of my kids tore at my heart.

Noah and Lucy were both very sweet—they would bring me food in bed and check on me. They were so little. I didn't want them to feel like they needed to take care of me. I told them that I loved them very much and that it was my job to take care of them—I would be well soon, so they didn't have to worry. How could I not have protected them from this ugliness?

One day, I found Noah's letter on my desktop:

Dear Mommy, I love you. I hope you feel better very soon. I'm going to take care of you. I love you because you do nice things for me. Love, Noah W.

Every morning when I woke up, I hoped that it was over—then I'd realize how far I had yet to go. Some days, the mania was so intense that trying to relax felt like running a marathon and being told to stop and meditate right at the finish line. My heart raced, my head was spinning, yet lifting my eyes or even a pencil required full concentration. I was supposed to sleep as much as possible, and I wanted to. I really tried (I remembered when I used to like sleeping), but because my head was in overdrive, I couldn't completely shut down. Thinking about the headlines, about frightening my children, about putting our lives in full reverse (when for months, even years, I'd been convinced that we'd finally made it through the worst of it) made me feel like a fool. I'd worked hard to better my life. Now I was just seen as a spoiled psycho.

And then I informed the health team of something that they didn't want to hear and absolutely did not support: Velvet Revolver was going to South America to promote *Libertad,* and I wanted to go.

There are too many reasons to list why it was a bad choice and

why no one should've allowed me to make it. I went anyway. I shook all the way through Argentina, Chile, and Brazil, where VR was greeted by such a crowd of fans at the airport that we had a police motorcycle escort to the hotel. It was a spectacle; Christine described what the bikes were doing as "sling-shotting" from the front of our vans to the back, escorting us through intersections while stopping traffic. I had a sense of watching everyone and everything from very far away. If handcuffing myself to Scott was an option, I would have signed up and thrown out the key; if there was a BabyBjörn for adults that would have let me strap myself to him, I would have. The meds were starting to work, I knew I was coming down, but I feared that if he left I would fall apart again.

My doctors gave me a long list of rules to follow while in South America. I was to stay on the same time zone as L.A. I wasn't allowed to go to the band's shows. I couldn't go out at night. I needed to take naps. I had to be consistent with my meds and avoid stress. I tried following doctors' orders as much as possible, but staying on L.A. time was difficult—the band traveled throughout the continent, and South American fans are amazing. Passionate, involved, they stayed up late and often congregated in front of the hotel or greeted us in the lobbies. Paying attention to food, getting enough sleep—I kept losing track. Even naps were hard. I would tremble in bed and be afraid to close my eyes. Sometimes I needed Scott to crawl in bed and hold me.

I missed the majority of the shows. I'd watch the first song or two and then go backstage to Scott's dressing room and rest. Lying in bed in beautiful hotels, I mouthed profanities at God for keeping me in lockdown when I should have been out and about seeing

the countries. Mainly, I waited for the meds to kick in, as though I was in a holding pattern circling the planet waiting for clearance to land. Five minutes at a time, it happened. I wasn't back to myself for weeks (actually, I'm still not back to myself, thank God), but as confounded as I was, I began to look forward to going home and putting it all back together.

october winds

California's Santa Ana winds often begin in late September. They blow in from the ocean, with what at first feels like relief—but then, in some weird meteorological marriage with the winds off the Mojave Desert, they get hot. By the end of October, the Santa Anas have hijacked your serotonin. I struggle with this every year, much as people in the Northeast battle seasonal affective disorder and need to buy special lamps to get them through fall and winter. Even after Dr. Pylko stabilized me on my meds, I was still

scared of October. It's not a coincidence that so many of Scott's set-backs had begun in October, from the beginning of the month when the breeze starts to blow, then to his birthday, then to Noah's, and then to the holidays. Not everything can be fixed with pumpkin pie.

Addiction can reach out and grab you when you least expect it. One minute you're drug free, the next minute you're a player in your own drug deal. It's as though you simultaneously lose con-trol of your body, your carefully reconstructed mind, and, in all likelihood, your car, which for some reason decides to drive through neighborhoods you wouldn't cruise through during a bright sunny day, let alone after dark.

One night, Scott came home hours past the kids' bedtime; rather than give him the third degree, I went to our room and started get-ting ready for bed. He followed me there, leaned up against the wall, and said, "I have to tell you something, but I don't want you to freak out." Uh-oh, too late, I thought.

Driving home from the studio, he'd passed a metro bus station and watched a drug deal go down, he told me. Watching that deal basically blew the cobwebs off the coffin of the voice we both hoped had died. He bought the coke, did it in the car, got high, then drove around in despair. He came home to ask me for help. He promised that it was just this once and asked me not to worry.

This was a first. He'd never asked me for help after a relapse. It would've been nice if I could've responded in a patient, compassion-ate way—I knew about relapse, I knew that both of us were vulner-able to it, always. But I went ballistic. There had never been a "just once" before. All I could think about were the kids. "How could you do this to us?"

We had struggled so hard to put this behind us, we'd been given so much help, so many second chances. Noah and Lucy weren't babies anymore, and even before their uncle Michael died, I spent endless sleepless nights wondering how I'd tell them of their father's death.

In the following weeks, if he called to say he was leaving the studio and on his way home, I would check the clock and start the countdown. God forbid he needed to stop for gas. I didn't want to be this nervous, minute-counting person. I didn't want to be responsible for clocking him from point A to point B. But I just couldn't help it. My ability to trust him evaporated.

Scott had a dream from the time he was a little boy about making music and earning his living doing it. As rocky as the road was, he worked hard and made that dream true. He made a lot of money doing what he loves; for a while, I made a lot of money, too. Along with those resources and our very privileged life had come a team of people who arrived initially to help him, and help us. Scott had a payroll, and most of the people on it were more than happy to cast votes on our marriage. There were employees who used with Scott; there were employees who got drugs for him. Once again, I was back to the Trust No One place. The difference was, I was in treatment and on medicines that were working. I was determined that nobody was going to knock me over again. The simple truth is, a marriage doesn't require a committee, a manager, a business manager, or a tour manager—it requires only the two adults who are in it. Maybe I should've been on his payroll as well. Maybe then my voice would've counted.

He promised this relapse was a one-time thing. I knew how difficult it was to make such a promise when you were deep in the middle; as I watched him struggle, it was clear to me that the one night drive-by wasn't the end of it. He kept promising to drive directly home from the studio, but he was always late. Very late. I'd find him passed out in the pantry or outside on the deck. He rarely came to bed.

I couldn't believe that we were living this life again. It was so much work covering up this disaster with the kids and everyone around us. There's no end date for a relapse, but I was fairly certain that I couldn't live through another round.

Scott finally fired one particular employee whose presence not only enabled Scott to continue using, but made it easy. In exchange for firing this fool, Scott wanted me to come to Chicago, where Velvet Revolver was playing. Management only cared that he was able to stand up and hold the mic; what he actually did while he was standing there didn't affect them—they got paid regardless.

When I arrived at the hotel, I couldn't get the door open. Scott had barricaded the door with furniture. He didn't even remember that I was coming. He finally let me in, and I couldn't believe what I walked into. The drapes were all closed and the room was littered with little bottles from the minibar. He swore there weren't any drugs, but I couldn't believe this level of paranoia came from booze alone. He was convinced that someone was out to get him. I made my best effort at attempting to calm him down. I tried holding him and kissing him, which worked to a small degree. Whenever he left the room, I would empty as many bottles as I could from the minibar into the sink. I did this until they were all gone. We both finally

fell asleep late in the afternoon, and when Scott woke up, he didn't remember what happened. Or wouldn't.

Like any good codependent, my time in Chicago was all about watching Scott like a hawk and trying to make sure he was happy. We went shopping and watched movies in our room. Everything looked fine and my presence was much appreciated by the band. I'm sometimes the only one who can get Scott to step on stage at showtime (not always, but my stats are above par). My drill sergeant routine is taxing and annoys the hell out of Scott, but everyone is happy when they see him walking on stage. Chicago ended up not being as bad as I'd anticipated. Okay, I said to myself, maybe I can do this. And then we got home.

I spent the month of October 2007 in a constant state of panic. Six months after Michael's death, four months after my own breakdown, and I was working nonstop with the designer-jeans company Rock and Republic, creating what I thought would be Scott's most memorable birthday. He was turning forty and I wanted it to be special—a roller rink transformed into Studio 54. The theme matched Rock and Republic's new line, so it all had a kind of symmetry. I had a to-do list a mile long. Work *works* for me, I kept saying. Work *works*.

I turned my attention to Scott's party, and he went back to his pre-Chicago self. I saw Dr. Pylko, and made appointments with Bernie for double sessions. Going back to her now, I no longer felt like the dependent "enmeshed" girl I'd been when we first met; it was a mature relationship. I needed her to help me with the obvious—sobriety under stress. It had been such a horrible year, with so much loss and fear for Scott and me, I wanted to end that chapter and begin a new one and reaffirm that beginning with him. But he wasn't interested.

My frustration grew as the days passed, and I felt guilty not sharing my anxiety about Scott's current situation with Rock and Republic. But I convinced myself that if I could get him onstage in Chicago, then I could damn sure get him to his own birthday party. I was beginning to release the denial that things would get better and felt a great deal of sadness knowing that our marriage was most likely at its real end. I would have to continue the cover-up until Scott's party. October 27, 2007, would be my final day if things didn't get better. We were too old to deal with this shit any longer.

The night of the party, everyone dressed the part, and the roller rink was transformed into a Studio 54 vibe. It was the first time the guys in Stone Temple Pilots and Velvet Revolver were all in the same room, and everybody seemed to actually be having fun. I put on a smile and made the rounds to make sure everyone was happy. Scott and I were followed by photographers, and we smiled for the cameras. Scott had been drinking and was making trips to the limo. I knew what he was doing.

When the party ended, we walked out to the limo together, and I braced myself for the tenderness that I knew was not coming. We sat in silence on the drive home. I finally worked up the nerve to speak and asked him if he liked his party. His reply was my final blow. "Why are you so fake?"

I cried the entire way home and then I cried some more. First because of the hurt and the weight of my own expectations, in spite of what I'd known during the whole time I'd worked on the party. Scott and I were definitely, finally, lost to each other.

When we got home, my sadness turned to anger. So much so that I punched myself in the face for being so stupid. I hadn't punched

myself, or anyone else, in a long time. It wasn't a habit I was inter-
ested in reacquiring.

Capping off the year from hell, in November 2007—the night
before Thanksgiving, in fact—Scott was arrested for DUI. In a sick
coincidence, we'd arranged to have our family picture taken for our
Christmas card on Thanksgiving Day. I'd thought it would be funny
if we did fake mug shots. Scott never made the cover of that card—
his mug shot was the real deal. We did the best we could for the kids
over the holidays, and with Michael's kids as well, but we knew we
were at the end.

We officially separated for the last time at the end of November;
since then, we have been negotiating both a legal divorce (which in
fact may be final by the time this book is published) and the new
emotional, day-to-day terms of a relationship that has bound us to-
gether for so many years. Taking a family apart, then figuring out
how everyone fits back together after a divorce, is like unwinding a
ball of twine. There's no way through it but to do it.

Sentencing for Scott's Thanksgiving Eve DUI wouldn't be held
until spring of 2008; until then, he would be preparing to go on the
international leg of the VR tour to support *Libertad*. But when the
headlines broke again, the bookings began to fall apart. The gov-
ernment of Japan issued an official pronouncement, which in the
simplest translation said, "You guys can't come here anymore." The
dates for Australia were postponed by the band for "personal rea-
sons." Tensions rose backstage, among the various managements and
the guys themselves.

In March, Scott actually said onstage—in Glasgow, Scotland—

that fans were witnessing the last Velvet Revolver tour. However dif-
ficult the tour had been to that point, his announcement caught the
other guys completely off guard.

On April 28, 2008, he was sentenced to 192 hours in county jail
for the November DUI. He had to complete an eighteen-month
alcohol program and pay a two-thousand-dollar fine. Once again,
he was on probation for four years. He actually checked into jail on
May 12, but was released later that same day.

Duff said something that echoed my own feelings, although
for an entirely different set of reasons, and with a heavier price for
us to pay. "He's a really good guy and funny. I know that guy is
in there somewhere—he just got lost again. We tried to pull Scott
back, but we couldn't. When he's into that other side, it's not cool,
it's not friendly. You try to help, but then after a while you realize
you can't."

My suspicion—and, I admit it, my hope—that STP wasn't
quite finished actually came to be fact just as VR was dissolving.
Christine and I were working with Rock and Republic, putting
together a beach-party event in Santa Monica for their fifth an-
niversary. They wanted a band—thankfully, every band I went to
was already booked. I'd like to say that it was impulse that led me
to call Dean DeLeo, but that would be a fib—I'd been plotting.
I called him and explained what we were looking for; he said he
was interested, but wanted to talk to Scott first. Ultimately, the
guys didn't play the beach-party date, but they did start the re-
union conversation. They played a few dates through the summer
of 2008, made it official, and as I write, they're on tour again and
working on a new album.

———————

Throughout much of that year, Scott worked on a solo album; in fall of 2008, *Happy in Galoshes* came out. It was inevitable that there would be songs about the end of our marriage and the loss of his brother. I prepared myself for the sadness that would come with those lyrics. But what I wasn't prepared for were the interviews he gave, in particular one on *The Howard Stern Show,* when he said I'd been unfaithful and that I'd left him for another man. My cell phone rang, the house phone rang—Howard Stern has a big audience. Evidently with the presidential election safely resolved, it was time for the Scott and Mary show to make noise again. Inexplicably, he said I'd left him for Joe the Plumber—"not *the* Joe the Plumber, just some guy"—while he was in rehab. "I don't want to know anything about it . . . it'll eventually come out," he said. "It definitely drove me crazy—my biggest addiction was my wife . . . I'll always love her . . . whenever she needed help, I was there at home to detox her. Whenever I needed help, it was all, 'He can't be around her.'" He went on to say that the breakup inspired a lot of the songs on *Happy.*

Scott had asked if I'd take the kids to a show here in Los Angeles. They love watching him perform, and I've always tried to take them whenever possible, both to STP and VR. On this occasion, we were late (as I often am). I grabbed their little headphones and we ran for the stage. We made it just as the show began.

Scott sometimes uses a teleprompter when he performs new songs, and I set the kids up right next to it. I didn't know the lyrics of the new material (which was a first—I'd always known all his other

songs by heart). As the words began to roll on the teleprompter, my heart sank. He had written, and he sang, about what a sham he believed the entire length of our marriage to have been. It was one of the saddest moments in my life. I stood in front of a crowd of thousands and tried to hold back my tears.

I won't suggest that I was the perfect wife, or even, for a long time, a good one. No question, living with me was not a picnic. But *Happy in Galoshes* was just cruel. It was a school night and I used that excuse to drive the kids home. Once they were safely tucked in, I let the emotions come.

FOURTEEN

bye bipolar

The name of this chapter is courtesy of my son, Noah.

I use *TV*'s *Law & Order* series (all of them) as an escape in much the same way that others use a bag of Cheetos. (Okay, I'll be honest, I use the Cheetos, too.) Recently, I was left feeling sad, angry, and very frustrated at the end of an *L&O* episode. How many story lines about bipolar killers are they going to come up with? There are headlines about grim new ways to off people every day, and this is the best they can do?

L&O killers never take their meds, are delusional, and talk to themselves. Even during my greatest unmedicated lapse into insanity, the thought of murdering someone never crept into even the darkest part of my mind, unless you count my wanting to karate chop Dick Wolf, *Law & Order*'s producer.

Statistically, mental illness rarely equals mayhem and murder, especially when it's diagnosed and treated. Most times, the person whose mind is wracked by the illness is far more frightened (and helpless and vulnerable to someone else's abuse) than anyone on the outside looking in. The words *mental illness* carry a terrible weight. Lurid headlines notwithstanding, all schizophrenics do not push people off train platforms into the path of oncoming trains, all manic-depressives do not burn their husbands' clothing, all addicts do not sleep under bridges or rob little old ladies. It's a human truth that some people, no matter if their personality types are in the *Diagnostic and Statistical Manual of Mental Disorders* or not, behave badly toward others. But not all of them.

We are capable of social change—we've done it before. Three generations ago, a dignified pregnant woman rarely even came out of her house after the fourth or fifth month; in our grandparents' generation, few people with cancer spoke of their illness, sometimes not even to a family physician. And nobody ever acknowledged, let alone embraced, the family drunk. These days, moms-to-be walk on the beach in bikinis, showing off the baby bumps that celebrate new life. Many cancer survivors who've lost hair due to chemo walk baldly and proudly on the street, demonstrating a fierce, defiant courage that humbles the rest of us. Politicians, astronauts, actors, doctors, teachers, fathers, mothers, sons, and daughters—these are

the people who stand up in twelve-step meetings, struggling to heal and take responsibility for their behaviors and their futures. We've worked hard to change our attitudes (with different degrees of success) toward Down syndrome and autistic kids, high-functioning Asperger's professionals, and people of many different ethnicities and religious beliefs. It might take some longer than others, but people can change their minds about people who have mental illness.

I'm not equating pregnancy or cancer with addiction or bipolar disorder. I'm simply saying that knowledge and empathy can change the way we treat one another. And I'm certainly not asking that everything on television or in the movies be a very special episode in which we are "instructed" in political correctness and the happy ending is wrapped up in a big yellow bow. That would be beyond boring. But in my humble, medicated, therapized opinion, repeatedly flogging (and perpetuating) a stereotype isn't creative, it's just lazy. And if you're on the receiving end of it, it eventually hurts.

As I write, it's been more than two years since the Great Bonfire of 2007. As time passed and my meds began kicking in, denial of my diagnosis slowly slipped away—like friends from school, I'd see it less and less. But like old friends who pop up out of nowhere and Facebook me, denial occasionally rears its ugly head. This is when people I love and trust step up and do that "ahem" thing: Mary, pay attention.

I've grown surprisingly comfortable with BIPOLAR stamped on my forehead and am committed to staying with my docs and my meds. That said, I really wish I didn't have to down two handfuls of pills

every day. Right now I'm on Lamictal (a mood stabilizer especially for the depression cycle), Abilify (a mood stabilizer specific to the mania), Concerta (a slow-release version of Ritalin for my ADHD), and Provigil (what Dr. Pylko describes as "wakefulness-promoting agent"—it helps with the ADHD and with keeping me out of my comfy bed in the daytime). The occasional visit from denial reminds me that I was far more creative and productive without them. The darkest parts of me are gone, but so is some of the light. My mom thinks I'm not as funny as I used to be, and many days I feel like I should file for creative bankruptcy. The deciding factor is that the kids don't give a shit whether Mommy can write poetry. They just want to know that crazy ain't coming back.

I wish I'd understood early on how my dad's struggle with addiction might have predicted my own. Maybe that knowledge would've made no difference at all—given my stubbornness and will, my life may well have proceeded exactly as it did. But as Dr. Pylko says, "Genes are not destiny—they're information." For someone who believes there's no such thing as a stupid question, information is like oxygen.

There's another crucial piece of information I've recently discovered: My grandma Rosa, hospitalized now with advanced Alzheimer's disease, is bipolar, too. I was visiting her one day after my bonfire breakdown, and snuck a look at her chart (medical charts have become like road maps to me). Listed on that chart were all the medications she was taking; I recognized one of them immediately—Lamictal, a mood stabilizer that was in my own medicine cabinet. "Why is she taking this?" I asked her doctor.

"Because she's bipolar," he answered.

I found out that she'd been diagnosed well before I was. This, too, would have been helpful to know. I'm not sure what I would've done

with the knowledge, but I'm fairly certain I would've liked to have it, especially the first time a doctor said those words to me. Maybe it's not as pretty a picture as "Oh, you have your grandmother's eyes," but it's part of who I am.

Not long ago, I asked Scott, "If you'd never gone to that barbecue in high school and seen your friends in the band—and decided you wanted to do that, too—would you still have struggled with addiction?"

"I'm pretty sure that drugs would have been over for me after high school," he said. That's not to say he would never have touched a drug again, and he knows drinking likely would have still posed a problem. But heroin, needles, and everything that goes with that? No way. When I heard him confirm my suspicion, for a minute I wanted to go back in time and cut him off with my bike before he could walk into that backyard barbecue. How different our life together might've been.

Sporadically through the years I've continued to take an occasional college course, first at Santa Monica College, then at San Diego City College. Just as I did with the baby books, I've read everything I could find about addiction and co-occurring disorders, and especially bipolar disorder.

Dopamine is a neurotransmitter in the brain that releases when we're happy. It's a major part of feeling pleasure—in babies, in sunshine, in sex, and love. With addiction, the brain becomes confused about which is the "high" reaction and which is a legitimate reaction to nice stimulus—so it stops producing dopamine on its own. Reduced dopamine can create or accelerate ADHD; at the extreme

end, it may also contribute to Parkinson's disease. This is the kind of hangover that aspirin won't touch.

An inability to produce dopamine is also one reason why becoming sober doesn't ensure instant happiness—the little factory inside your head that produces happy has been shut down. It takes a lot of time to rebuild those pathways and turn on production again. For many addicts, sadness lingers for a long time after recovery begins, and that's where the traps lie in wait. Steve Jones once said he believed Kurt Cobain could have made it into recovery and be alive today if only he'd had the help to get through the first year after he tried to quit heroin. The brain, which is so elastic in childhood, loses that ability in adulthood. We have to help it heal. We put casts on broken legs. We can do the equivalent for brains.

Some of the books that have landed on my bookshelf in the past couple of years include *An Unquiet Mind, Manic, Electroboy,* Carrie Fisher's *Wishful Drinking,* Brooke Shields's book about postpartum disorder, *Down Came the Rain,* and Augusten Burroughs's *Dry.* In each of these, I've found parts of my story, but I haven't found myself. So many of the popular books on bipolar disorder primarily feature mania, or manic episodes. I struggled mostly with depression, and I couldn't find that book. The more I learn about my brain, the more I want to know. I realize I'll never live long enough to fully understand what happened to me. But I know what I need to do to take care of myself and my children. I hope, as does almost anyone who writes a memoir detailing her struggles, that a reader may see him- or herself in these pages, and not feel as isolated or as lost as I did for so long.

The cover of Carrie Fisher's book features the iconic image of

Princess Leia. Noah saw it one day and asked, "Is that a *Star Wars* book?" I told him no, that it was a book by the actress who played Princess Leia, who is bipolar just like Mommy. Some variety of relief passed over his face—there's much about the past couple of years that has confused or scared him. But Princess Leia is bipolar, too? It was as though my heavy little guy got somehow lighter at the news.

I never got the chance to be a full-time college student and I never will. But I can see myself still taking classes at eighty, and perhaps someday working in the field of addiction recovery. Addiction and mental disorders isolate us—we need one another. I'd like to help, as I have been helped. As I'm helped every day. Maybe I could be a sober companion to a woman who's beginning sobriety. And it doesn't matter to me if an addict is ready to get better or isn't quite there yet—I've been both and received guidance at every step. No one made my character or morality or worth a condition of helping me. They just kept reaching out. I fell, got up, fell down again—and still they reached out. I have seen some of the worst in human behavior, but I have also been blessed to see, and be healed by, some of the best. Hope is a key word when you are feeling helpless.

Guilt leads to relapse, so I work hard not to make guilt a traveling partner. Through it all, I never lost the sense of right and wrong I was raised with—it was simply buried temporarily and I couldn't hear it. Regardless of where I am now and what I've learned, my parents will always have a former junkie for a daughter, and because I married a public figure, there is no place to hide from that. Gratitude rolls over me when I realize I've been blessed with parents who don't engage in denial. We are a family that finds humor in everything, no matter how crappy and embarrassing the topic may be. We don't

hide behind forced smiles and consistent good moods. It boils down to anything from "Eh, what are you gonna do?" to "Sweet Jesus, this is a load of shit!" In fact, a friend gave me a pen called the Sweet Jesus pen. The first time I tried to write with it, it didn't work. I looked at it and said, "Sweet Jesus, will you work?" and it did. A lesson in "ask for what you need."

It's amazing how it feels to finally let go of resentments. I'm not going to toot my grown-up horn and tell you that I've mastered this, but I'm getting better at it. I can almost guarantee my progress in this department comes from laziness—it requires too much energy to hold on to negative feelings. Dealing with depression, mania, and addiction has made me a more compassionate person. Everyone has a sadness. I try to forgive based on that.

I have bad days and good days, but everybody does. There is no such thing as happily ever after, or riding into the sunset—that's not a life, that's a romantic comedy, and it's fiction. I continue to see Bernie Fried and Dr. Timothy Pylko. I suppose there will come a day when I no longer do, but I can't imagine my life without their wisdom and counsel in it. And I go to AA meetings, two years after giving up wine-thirty, although I don't go every day, and I don't go as often as I should. It helps that I've made sober friends. Addicts are knee-deep in negative thoughts, which is why I try to go to meetings where the speakers are funny. Living in L.A., many times I get lucky and get an actual come-dian. By and large (in my opinion), comedians are a mess. Every time I crack a joke, I think, No wonder I'm a disaster—I'm a comedian. Humor is the only way I can work through the basic bad day or even a tragedy. Ever since I torched Scott's wardrobe, I have friends who call every time there's a California wildfire to ask me if I was respon-sible. If I took that personally, I'd collapse like a cheap umbrella.

Anonymity in a twelve-step meeting has never been an issue for me. I'm not a celebrity and I don't hold much back. Writing this book is the opposite of anonymity, though, so maybe that will change. I have great compassion for people who are well known and struggle for their sobriety in public. There is so much pain, shame, and recrimination involved in the beginning days of sobriety, and most of us would rather not have witnesses for a while. While it's not required, it's suggested that if you are in your first thirty days, you stand and identify yourself. It's not to embarrass you—it's just so people can get to know you. This is so difficult, and for repeat "beginners," it feels like an admission of yet another failure. Fortunately, I never cared much what anyone thought about my failures. I think that attitude helps me stay sober.

There are so many reasons why couples divorce, and there are so many ways to bring a marriage to an end. I'm not sure there is any one right way, but there are an infinite number of wrong ways. It turns out divorce isn't fair—as children of divorce ourselves, I guess Scott and I should've known that.

I cannot deny that we've changed the course of Noah's and Lucy's lives. I'm hoping, with the passage of time and greater health for both of us, we will come to a truce that we all can live with. We go to Legoland together, we try to have dinner together, we celebrate birthdays and anniversaries and holidays together, we've spent the kids' school vacations together. We fired our first round of divorce attorneys, because we figured out one day that they were talking to, and dealing with, only each other—neither one of them was paying attention to us. After a marriage is over, a family still

remains. It would be nice if divorce attorneys remembered that more often.

When Scott is fully present, he's a good dad. The kids adore him, and that kind of adoration is going to be hard for him to lose when they move into the parents-aren't-perfect-and-ours-are-occasionally-jerks phase that every kid goes through. They love what he does for work, and they both want to follow in his footsteps. When Noah was very small and we took him on the road, he had his own mini-microphone set up at the side of the stage. He could see the audience, but they couldn't see him. There he'd be, jumping up and down in a little Spider-Man costume, duplicating Scott's moves. There's no question in my mind that Lucy will be a musician or a singer. Her voice is pitch-perfect, and she's fearless. She has a mic stand, too, and two guitars—she loves to go to the studio with Scott and record songs. If you ask her what she's going to be when she grows up, nine out ten times, you'll hear "Rock star!" We call her Scottalina—she looks just like her daddy, and she works a microphone exactly the same way he does.

Noah went through a time when he was obsessed with the Power Rangers. Lucy didn't share that particular obsession, but she could get into anything that her big brother was into. A friend of ours, Nina, is married to Adrian Young from No Doubt, and she found me an actual Power Rangers costume from a friend who'd worked on the show. It wasn't a Walmart imitation or a knockoff from the Halloween Store—it was the real thing. Scott and I came up with what we thought was a genius plan. He went to pick the kids up from school and on the way home he shouted, "Oh my God! Did you see that? It looked like a spaceship!" He signaled me with his cell phone just before they pulled in the driveway. When they stepped around

to the backyard to look for the spaceship, they found me—the Pink Ranger. I immediately acted shocked and frightened at being discovered. Of course, when you're from another planet and you've just been found out by earthlings, you must defend yourself. I started in with all the moves I'd seen the Rangers do on the show, and Scott hurried them into the house to safety. And then the plan fell apart.

Once inside the house, Scott was supposed to take Noah and Lucy to their rooms so I could sneak in and change. Only problem was, he locked the door and I couldn't get in. So I stood in front of the house for what seemed like forever in my skintight pink spacesuit while people passed by.

I'm going to let you in on a secret—spacesuits are not comfortable and helmets weigh a ton. I couldn't take it anymore, so I put my helmet back on and knocked on the door. We couldn't outweasel the kids. When they found out it was me, Noah asked if I was a real Power Ranger. Scott and I looked at each other and decided to go with it. We told them that yes, Mommy is a Power Ranger and so is Daddy. One day, when they were older, they, too, would be Power Rangers.

"This is a family secret, guys," we warned them in our most serious voices. "You can't tell anyone, okay?" They nodded.

To this day, they still believe we are a family of top-secret Power Rangers. I can't bring myself to tell them the truth. There are so many other pieces of hard information they've had to handle, it seems okay to let this one be for a little while longer.

I recently asked Steve Jones if there was actually a difference between old Mary and new Mary. "You're calm now," he said.

I never knew I wasn't calm until the day I was in handcuffs. I

knew once I had children, I would never go back to a life of drugs. I
have no clue where that certainty came from, because there was noth-
ing in my life before Noah and Lucy that instilled the certainty in me.
I don't know if I've been able to stay away from drugs because I'm a
good mother, stubborn, or flat-out scared of my own mother. Once
she learned the truth, she said (and I believed her) that she would
kick my ass if I slipped for one minute. Noah and Lucy are growing,
changing, learning, vulnerable beings, and my job is to see that they
make it through. Maybe once they're both grown and gone, I'll look
around to see if there's any more trouble I can get into. But probably
not. One day at a time. I'd like to be around to see them graduate
from college, find work they love, find partners they love, get mar-
ried, and have kids. With luck, it will all happen in that order.

When someone's talking about twelve-step programs and addic-
tion recovery, questions about God, a higher power, and faith
always go on the table. Having a spiritual connection has saved
me from self-hatred. I grew up Catholic, but I've altered my faith
a bit to suit my circumstances. I think God is cool with this. Like
me, I'm sure He takes a sick day on occasion. I talk to Him in the
shower, in bed, and in the car. He lets me call him "dude." He's
just all around rad and laid-back. Unlike Scott and the majority
of Catholics I know, I somehow managed to move forward in life
minus Catholic guilt. When we sent Noah off to Catholic school,
we sent him with a twelve-step mantra: "Take what you need and
leave the rest." Humans are so fallible, so breakable. Nobody knows
this better than the One who dropped us here—otherwise, light-
ning would've taken us all out long ago.

I once asked my friend Guy Oseary why I never saw him go to temple and his answer was, "My home is my temple." I'd never thought of it like that. Realizing that it was possible to be close to God in my living room ushered the spirituality in. As I've come to understand faith (not religion, but faith), it's gradually changed the way I think about what my higher power might be and how I can connect to it. I find it by making a safe, comfortable home for my children, being a good friend to my friends, a good daughter to my parents, a good sister to my sisters and brother, and the best mother to Scott's son and daughter that I can possibly be.

My favorite instructor at school shared the following phrase and I wish more people were familiar with it: "In recovery, we're looking for progress, not perfection." There is no cure for addiction and it requires a sometimes overwhelming amount of work, but every attempt is a step in the right direction. The other great advice of my life came from Mark, my stepfather: "When it comes to stupid people, fuck 'em. Stupid situations: fuck it." "Fuck it" is not a replacement for "I give up." It's another way to say, Step back, give it a rest, take a break. Why add more stress to what's already there? I'm too vain for premature gray hair and wrinkles. I no longer seek perfection. I don't think it exists, and if it does, it sounds boring.

When both parents have bipolar disorder and full-fledged addiction issues as well, there's no arguing with the odds their children confront. There's no way around those statistics. But the more genetic research identifies the markers, the more neurologists and addiction specialists have to work with as they look for prevention, treatments, and maybe, someday, cures. Scott and I have two factors

in our favor that our own parents never had: knowledge and experience. I pray that our children never suffer the way we have. God forbid we ever go down that road with them, but if we do, we'll be able to recognize the symptoms and fight back with what we know and what we've learned. In the meantime, one of my most important jobs as their mother is to show Noah and Lucy how amazing life can be, how full of hope and opportunity and promise it is, and that there is no reason to ever give up. You can take a nap, but you can't quit.

It never occurred to me then (and honestly, I'm baffled by it now), but nobody ever asked me whether marrying Scott was the right choice. It may have been that everyone knew how deep our love was. It may have been that there was no use—it's hard, if not impossible, to change my mind if I've set it on something. Only recently, my mother told me that a relative had asked her before the wedding, "Are you really going to let her do this?"

"I've never been able to talk her into or out of anything," Mom replied. "I'm not about to start now."

My family adores Scott, and this has annoyed the living hell out of me on more than one occasion. I would lock him out and they would let him in. What I believe Scott knows is that they love him not because of his success, but for himself.

Is this the whole truth and nothing but the truth? Probably not. So much of what I've done and experienced in my life, I wasn't really present for. I've asked everyone I know, and I've woven together memories and images as best as I can. I've used many of my journal entries (most of which were written when I was loaded), and there are certain moments that have stayed indelibly printed on my mind while many others

have disappeared. I have protected or not mentioned many people who deserve private lives and kindness, and I have tried my best to own—and take responsibility for—the part of this history that is mine.

I am no one's victim. I made no mistakes being with Scott, loving him, staying with him as long as I did, or having his children, who are the center of my life. I'm not sure I would've learned as much if we hadn't spent those years together. I regret ever having hurt anyone, but I cannot regret anything that has brought me to where I am. I only have to look at the kids to know I didn't make a mistake. The fact is, no matter who I loved or who I married, I still would've been crazy. He was the love of my life—but I have a long life ahead, so maybe another great love is out there. In the meantime, I can look at the part of my life that has been cursed or I can look at the part of it that's been blessed. I can *choose* where I look, and where I put my hope and my heart. Mostly, I look forward to living a life that is a hundred percent me. As long as my home is filled with music and the sound of my kids laughing, I will love it regardless of size or location.

A couple of years ago, I cleaned up the green velvet couch and gave it to my brother; he recently sold it on Craigslist. Somewhere, somebody's sitting on it today, maybe watching a baseball game or reading a book or cradling a baby in strong, healthy arms. I would like that to be true.

What a good life would look like: happy, healthy kids. And health for me, too, please—I promise to take better care of it this time. The exercise I like most is kickboxing, and I hope to win the ongoing

fight with my mind. Whether it's shutting down the committee in my head, not giving in to my reluctance to take these damn meds, or resisting a relapse that would keep me from any true happiness—I want it. The girl who wanted MORE still wants more, but the wish list is different from what it was.

What I want my kids to know: That they came from love and that they are loved. That making Mommy smile is at times a hard job, and yet they do it every day, and I count that as a priceless gift from them. They are an extension of Scott and me, but they are not us. Their lives will have different paths, and although we have struggled and, at many times, failed, I hope our ability to recognize darkness will keep them in light.

Acknowledgments

Thank you to my editor, Kate Hamill, for your soulful guidance and dedication.

To my little Noah and Lucy, for letting Mommy live in a cave while writing this book.

To my mom, for being my best friend and mentor. Thank you for giving up your dreams so that I could have mine.

To my dad, for all things great and small, and for taking this journey with me.

To Mark, for loving and accepting me even when I was a teenager.

To my brother, John—I'm not just saying this because you are my only brother, but you are the best brother a girl could ask for.

To my sister Julie and Ian—thank you both for your many swift rescues and the countless hours of much-needed recuperation.

To my sister Suzy, for making me laugh. I never thought I'd meet someone funnier than Mom.

Mirna, you are an angel. Without you this book would have been five pages long.

Thank you to all my BFFs: Kristen and Ivana for the countless best times ever; Jody Britt for holding me up (sometimes literally) through the toughest years of my life; Julie Kramer, the Weiland family historian; and Christine Kohout Kushner, for making the road a fun place to live. Randall Slavin, you've earned a spot with the ladies.

To Dr. Pylko—I'm just plain grateful for everything about you: your knowledge, your time working with me on this book, and, most important, your fixing me. I don't think anyone thought I was fixable.

To Bernie Fried, for the years of guidance and encouragement. Your words in this book mean so much to me.

To my silent costars Jimmy Iacobelli, Jennifer Slattery, and Nancy Tan.

And to my not-so-silent costars: Ashley Hamilton, for allowing me to be honest; Dave Navarro, for your kind words and memories (thank God someone remembers); Steve Jones, for constantly challenging me (at a buffet); Charlize Theron, for giving me the green light to open my trap; and Anthony Kiedis, for years of girlhood friendship.

To Candice Westbrook, Jeff Kolsrud, and Luis When—without your guidance, I can't imagine I'd be the mother and woman I am today.

To Dr. Drew Pinsky, for your support over what seems like a million years.

To Terri Cheney—the honesty you shared with your own story encouraged me to do the same.

To Sarah Durand, Kirby Kim, Allen Rucker, and Michael Harriot, for giving me wings and a push.

To Neal Preston, Davis Factor, Franco La Costa, Mitch Schneider, Kristine Ashton-Magnuson, and Angela Villanueva.

To my epic and rad guy from the 619—I know we are brain, but without your half cheering and showing me the finish line, I would have never made it to the end. Finally, I have my very own muse.

To Dean and Robert DeLeo, Eric Kretz, Dave Kushner, Slash, Matt Sorum, and Duff McKagan—thank you for the soundtrack to my life.

Larkin, you are a warrior for depth and heart. Thank you for our collaboration.

Monkey, you've given me so much. I don't know if I could have made it without you and the kids. Thank you for your encouragement, praise, and understanding why I needed to write this book. This is part of our story, but the memories that only you and I share are the sweetest. You will always be my teenage boyfriend.